AMERICAN ART

Author: Mike O'Mahony Foreword: Virginia Mecklenburg

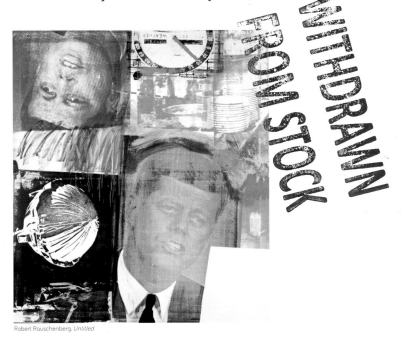

Robert Rauschenberg, *Untitled*

**FLAME TREE
PUBLISHING**

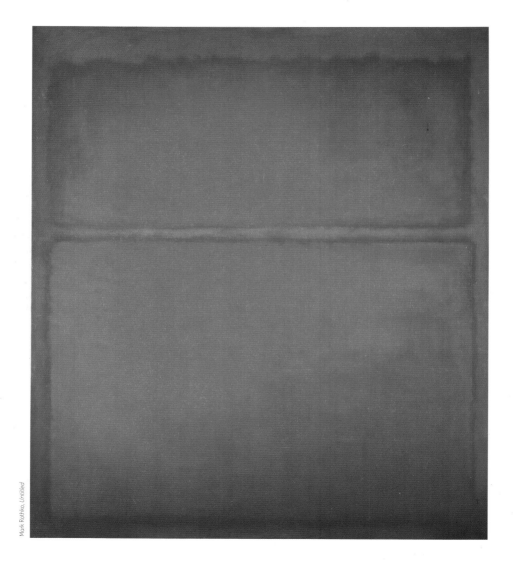

Mark Rothko, *Untitled*

Contents

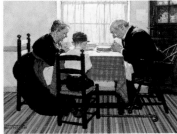 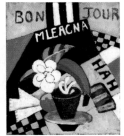 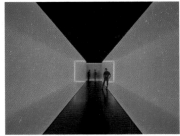

Norman Rockwell, *Saying Grace*; Marsden Hartley, *A Nice Time*; James Turrell, *The Light Inside*

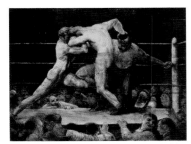 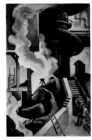

George Wesley Bellows, *Stag at Sharkey's*; Thomas Hart Benton, *The Steel Mill*; James Rosenquist, *Untitled*

Places

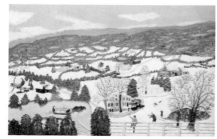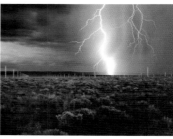

Grandma Moses, *Help*; Joseph Stella, *The Bridge*; Walter de Maria, *Lightning Field*

Influences

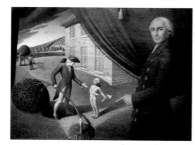

Grant Wood, *Parson Weems' Fable*; Ellsworth Kelly, *Nine Squares*; Robert Indiana, *The Figure Five (Five Star)*

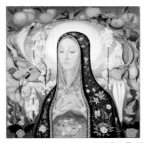 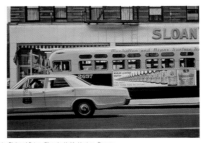 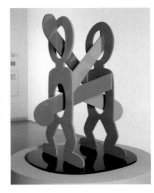

Joseph Stella, *The Virgin*; Richard Estes, *Sloan's*; Keith Haring, *Boxers*

How To Use This Book

The reader is encouraged to use this book in a variety of ways, each of which caters for a range of interests, knowledge and users.

- The book is organized into five sections: **Movement Overview**, **Society**, **Places**, **Influences** and **Styles & Techniques**.
- **Movement Overview** broadly covers the whole movement of modern and contemporary American art, providing a snapshot of the people involved and the different styles that evolved throughout the twentieth century.
- **Society** shows how the wider world in which the artists of this period lived had a bearing on their work, and explores their different interpretations of it.
- **Places** looks at the different locations across the United States in which the artists lived and worked, and how their feelings about these places are represented in their works.
- **Influences** reveals who and what had the most influence on American artists of this era, and how they in turn were a source of inspiration for one another.
- **Styles & Techniques** looks at the different methods and mediums American artists used for their works, as well as the changing styles.
- The text provides the reader with a brief background to the work, and gives greater insight into how and why it was created.

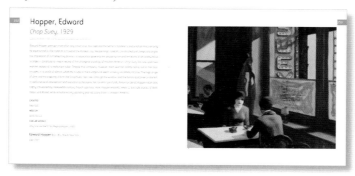

2. Name of artist, by surname then forename

3. Date of work (if known)

1. Title of work

9. Picture credit

4. Information about the work and the context in which it was created

8. Place where the work was created (if known)

7. Medium in which the work was created

6. Similar or related work to the one shown

5. Artist's birth and death dates

252 **Hopper, Edward**

Chop Suey, 1929

Edward Hopper, perhaps more than any other artist, has captured the sense of loneliness and isolation that can only be experienced in the midst of a crowd in the modern city. His paintings, carefully constructed and composed to give the impression of a momentary glance – a voyeuristic gaze into the private space and emotions of an anonymous stranger – constitute a unique record of the changing sociology of modern America. Chop Suey focuses upon two women seated at a restaurant table. Despite this company, however, each woman seems alone, lost in her own thoughts in a world of silence, while the couple in the background seem similarly uncommunicative. The high angle of view and the cropping of both the 'Chop Suey' sign, seen through the window, and the female customer on the left, all add a sense of strangeness and alienation to the scene. Yet, for all its specifically American detail, Hopper's work was highly influenced by nineteenth-century French painting. Here, Hopper explicitly refers to the café scenes of both Degas and Manet, while simultaneously updating and relocating them in modern America.

CREATED
New York

MEDIUM
Oil on canvas

SIMILAR WORKS
Why Not Use the 'L'? by Reginald Marsh, 1930

Edward Hopper *Born 1882 Nyack, New York*

Died 1967

Foreword

The styles and influences that characterize twentieth-century American art are myriad. In no other period and, arguably, in no other country, were so many modes of expression experimented with, so many techniques used, or so many mediums exploited.

This was a time of unprecedented social change in the United States. The Civil War (1861–65) had changed the face of the nation, and the process of rebuilding and healing took decades. The first half of the twentieth century wreaked further havoc, as the First World War was followed by the nationwide Great Depression, instigated by the Wall Street Crash of 1929 and succeeded by the Dust Bowl of the 1930s. President Franklin D. Roosevelt's New Deal promised new hope to a desperate people, but that hope was snatched away when the Japanese bombed Pearl Harbor in 1941, dragging America into a global war.

In the post-war years, however, there rose from the ashes a new America, in which rock and roll shook the airwaves and glamorous Hollywood gave the people icons to envy and imitate. In art, this new popular culture was reflected in perhaps the most familiar of all art movements of the twentieth century: Pop Art, that inherently American style characterized by the bold colours and commercial subject-matter of Andy Warhol and Roy Lichtenstein.

The changing face and fortunes of the United States were reflected contemporaneously and nostalgically in art throughout the twentieth century. As the nineteenth century drew to a close, European influences still held sway in the minds of many American artists. The works of the French Impressionists in particular inspired artists such as Mary Cassatt and Childe Hassam, and for many, a sojourn in Europe, and especially Paris, art capital of the world, was essential for their artistic education. Alongside this, though, artists like Charles Marion Russell and Frederick Remington looked to their own country and its history, painting romantic visions of the old American West. This rendering of a national identity, however nostalgic its roots, took a new shape as the century progressed. The fascination with European art changed as the continent was scarred by battle and Paris itself fell under occupation. While modern European styles such as Cubism showed their influence, American artists began to look to their own country for inspiration and subject-matter.

The New York-based Ashcan School began the trend for realist painting, and their depictions of everyday American life, without frills or ambiguity, spawned a later generation of modern Realist artists that included Edward Hopper and Charles Burchfield. An extension of this was Precisionism, a detailed, almost photographic style most evident in the works of artists such as Charles Sheeler.

The antithesis of such Realism, Abstract Expressionism was perhaps the farthest-reaching of all the movements to arise from this period. In its purest form, exponents such as Jackson Pollock and Willem de Kooning created bold, symbolic pieces in a style that infiltrated global art, and continues to do so into the twenty-first century. Others took the principles of Abstract Expressionism and pushed the boundaries further, resulting forms like the Colour Field paintings exemplified by Mark Rothko.

In the twenty-first century, no single style dominates American art. It remains innovative, ever-changing and constantly challenging. Objects of daily life have found their way into gigantic sculptures. Technology opened up a new artistic world of Video Art, Light Installations, and huge Earthworks, created as part of a real, three-dimensional landscape.

This book offers a snapshot of the thousands of pieces that came out of America from the late nineteenth and twentieth centuries. From the early realism of the Ashcan School, through the vivid pieces of the Harlem Renaissance, Abstract Expressionism and Pop Art, to the adoption of Photorealism and the dramatic, multi-sensory experiences of Installation and Land Art towards the end of the century, it provides a fascinating journey through the dramatically different interpretations and expressions of a particular time and a particular place. The developments that occurred throughout this period combined to draw America out of the wings and into the spotlight of the world art stage.

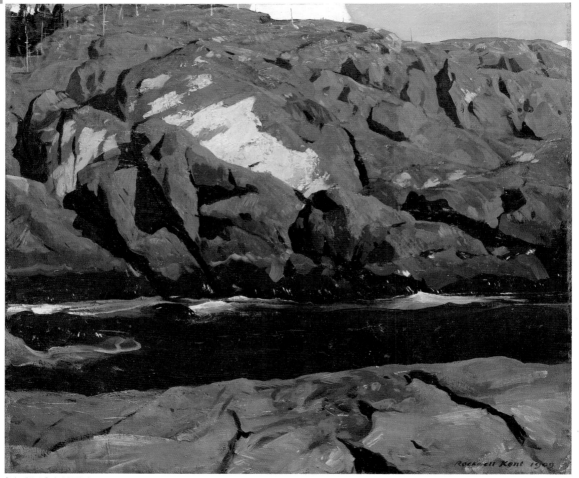

Rockwell Kent, *Rocky Inlet, Monhegan*

Introduction

Just over a century ago, the United States of America was widely regarded as a cultural backwater, a nation that still largely depended upon its European roots for artistic guidance. Today, it stands as a world leader, not only in political and economic terms, but also for the unique artistic culture that it has generated. Similarly, where Paris was the undisputed artistic capital of the world for the first half of the twentieth century, that mantle has now largely been inherited by New York. This book offers an overview of some of the finest achievements in American art, from the late nineteenth century to the present day. It charts the sheer diversity of cultural production throughout this period and considers how factors such as social change, regional identity and an awareness of a host of other cultural practices have all contributed to the unique stylistic developments that have shaped American art.

In the late nineteenth century, the United States was still widely regarded as a youthful nation. The completion of the Transcontinental Railroad, connecting New York in the east and San Francisco in the west had occurred as recently as 1869 and, indeed, the frontier itself was not officially declared closed until 1890. America's subsequent victory in the Spanish-American War (1898) and the expansion of new territories in Cuba, Puerto Rico and Hawaii gave the nation a confidence frequently associated with young adulthood as it strove to make its mark on the world stage. In cultural terms, however, the Neoclassical style from the Old World still dominated – a factor perhaps not surprising as a significant proportion of the population, especially those who were benefiting most from growing economic prosperity, had a European heritage.

By the first decade of the twentieth century, however, some artists supported the notion that America should reject this heritage and seek to develop its own unique artistic identity. Chief amongst these were the painters associated with the Ashcan School, who revolted against the idealism of the art academies and turned instead to everyday subjects, depicting the run-down neighbourhoods and poor quarters of America's ever-growing cities. However, whilst artists including Robert Henri (1865–1929), John Sloan (1871–1951) and George Bellows (1882–1925) doubtless caused a storm amongst the genteel upper classes of the Gilded Age, their works still reflected artistic traditions that had already been established for some time in mainland Europe, most notably in the works of Gustave Courbet (1819–77), Edouard Manet (1832–83) and the French Impressionists. Indeed, European influences would continue to leave their mark on American art throughout the first half of the twentieth century, not least as so many American artists still regarded a study

trip to Europe as a prerequisite for an artistic career. Moreover, the increasing exposure of European modern art in the United States, culminating in the groundbreaking 'Armory Show' of 1913, which introduced movements such as Fauvism, Cubism and Futurism to the country, only served to reinforce the strong links between American and European artistic practices.

In 1914, the outbreak of war in Europe forced many American artists to return home and over the next quarter century, encouraged by the increasingly isolationist policies of the inter-war government, American art further developed its own identity. For example, the Precisionist works of Charles Demuth (1883–1935), Charles Sheeler (1883–1965) and Georgia O'Keeffe (1887–1986) all notably celebrated American industrial and technological achievements with their sharp-edged and brightly illuminated paintings of skyscrapers, factories and industrial landscapes. At the same time the works of African-American artists associated with the Harlem Renaissance, such as Aaron Douglas (1899–1979), William H. Johnson (1901–70) and Jacob Lawrence (1917–2000) brought a new, and largely non-European, flavour to modern American painting. Not everyone, however, was in favour of such modern stylistic developments. Indeed, some of the more conservative critics rejected all forms of stylistic innovation, associating such experimentalism explicitly with Europe. Since the late nineteenth century the east coast, and New York in particular, had been the main centre of modern art in America. As the city was widely associated with recent widespread European immigration some claimed that the traditional American identity, and true American values, resided more in the heartlands of the Midwest, in the grain belt and the bible belt. Thus, by the mid 1930s a new movement called Regionalism gained currency. Regionalism rejected stylistic innovations in favour of a highly detailed realism. It also emphasized the epic history of the United States and mythologized the Midwest as a rural Eden untainted by modernity. The key proponents of this style of painting were Thomas Hart Benton (1889–1975), John Steuart Curry (1897–1946) and Grant Wood (1892–1942).

One of the key catalysts for this return to traditional values was the Wall Street Crash of 1929 and the subsequent Great Depression. By 1933, when Franklin Delano Roosevelt was elected president, unemployment in the United States had risen to 16 million – a quarter of the American workforce. In such an economic climate the bottom inevitably fell out of the art market and countless artists joined the ranks of the unemployed. In response to this, in 1935 Roosevelt's government launched the Federal Art Project (FAP) as part of the wider New Deal relief programme known as the Works Progress Administration (WPA). The WPA art programme effectively offered artists a monthly wage in return for the production of works, many of which were designed for public arenas. Over the next decade thousands of artists registered with the programme, resulting in the production of over 2,500 murals, 108,000 easel paintings and 18,000 sculptures.

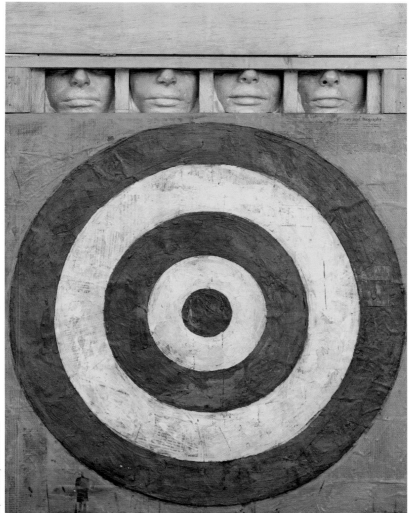

Jasper Johns, *Target with Four Faces*

Many of the artists who later became leading figures in the post-war period, such as Jackson Pollock (1912–56) and Willem de Kooning (1903–97) notably first cut their teeth working for WPA sponsored programmes.

The WPA art programme was implemented against a background of international tensions generated by the rise of Fascism in Europe. Despite the isolationist policies of the United States, this was to impact upon American art, not least of all as a consequence of Hitler's overt rejection of modern art. This resulted in many European artists, including Fernand Léger (1881–1955) and Piet Mondrian (1872–1944), seeking refuge in the United States. The highest contingent of European art exiles to reach the shores of America, however, were the Surrealists, including Max Ernst (1891–1976), Salvador Dalí

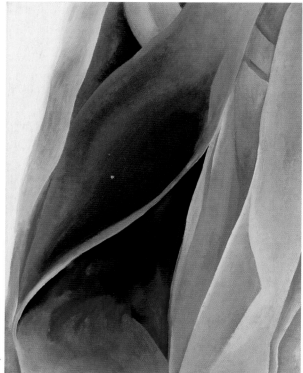

Georgia O'Keeffe, *Abstraction*

(1904–89) and André Masson (1896–1987). During the war years they formed a significant expatriate community in New York, published journals and contributed to many exhibitions. Their presence subsequently left its mark on the younger generation of American painters who, in the later 1940s, became Abstract Expressionists.

In the aftermath of the conflict, as the dust began to settle in mainland Europe, America's economic dominance began increasingly to take hold. The implementation of the Marshall Plan in 1947, offering economic aid to Europe, only served to highlight further the desperate financial conditions of a war-torn Paris that struggled to rebuild its reputation – and its art market – in the wake of the humiliating occupation by Nazi forces. By now, many looked to the United States, and New York in particular, as a livelier environment in which modern art could develop and flourish. Over the next 25 years, many of the major modern movements, such as Abstract Expressionism, Pop Art,

Minimalism and Earthworks originated in the United States, and the trajectory of innovation moved firmly from Europe to America. These movements, however, also addressed the pressing concerns of American society in the post-war epoch. Pop Art, for example, was very much a reaction to, and critique of, the post-war consumer boom in the United States, while Earthworks marked an early engagement with the ecological issues that have increasingly come to dominate the political agenda. The protest movements of the late 1960s also generated new attitudes towards race, gender and sexuality, all of which spawned a plethora of art movements in support of feminism, racial equality and gay rights. More particularly, these movements rejected the dominant modernist notion of art as an autonomous activity concerned solely with aesthetic, rather than socio-political, issues. In the Post-Modern era (post 1968) art has been more highly valued as a potential weapon of political intervention.

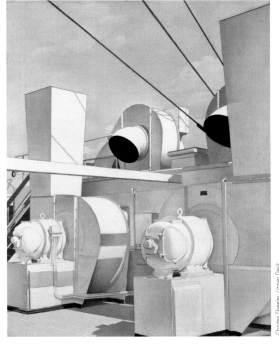

Charles Sheeler, *Upper Deck*

Since the 1980s, art in America has struggled, or resisted the temptation, depending upon the view one takes, to find a direction. A return to painting, in the works of Julian Schnabel (b. 1951) or Jean-Michel Basquiat (1960–88), has co-existed alongside the popular deployment of Minimalist forms for public monuments such as Maya Lin's (b. 1959) *Vietnam Veterans' Memorial* (1980–82). At the same time, traditional artistic practices such as painting and sculpture have been entirely rejected in favour of new media, including video and digital imaging, whilst so-called Conceptual artists have favoured Installation and Performance as modes of artistic communication. The boundaries of what constitutes art have never been so fluid as they are today. In the end, however, what really matters is the degree to which an artist's work engages intelligently and thoughtfully with the world it inhabits. At the dawn of the twenty-first century, the United States continues to provide an exciting arena in which such artistic interventions continue to be made.

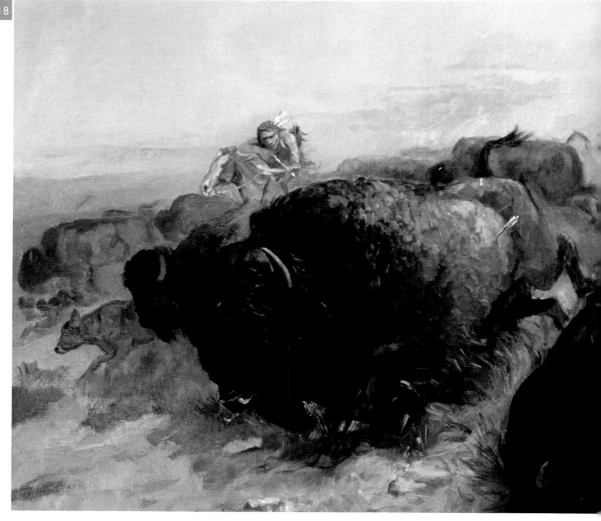

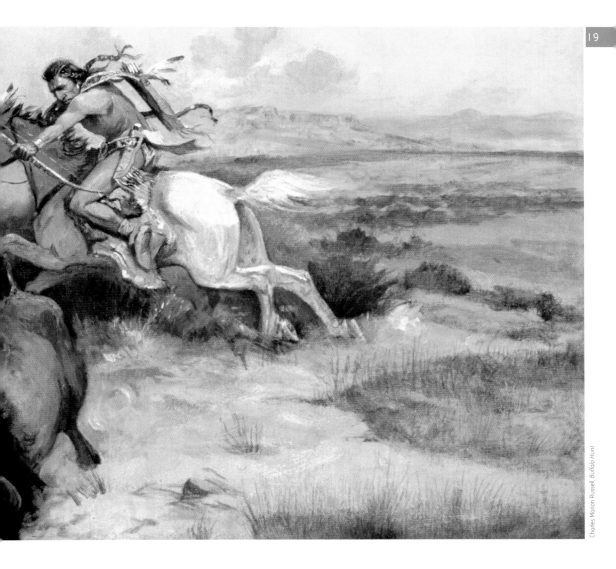

American Art

Movement Overview

Harnett, William Michael
Old Models, 1892

William Michael Harnett built a significant reputation as one of America's most interesting and influential still-life painters. Harnett is best known for his exquisitely detailed, highly illusionistic paintings, designed to fool the spectator into believing that he or she is looking at the objects themselves rather than a painted representation. This *trompe-l'oeil* effect also recalls the story of Zeuxis, the ancient Greek artist whose paintings of grapes were reputedly so lifelike that birds pecked at them, mistaking them for the real thing. Harnett's works, however, also offer a nostalgic vision of simple pleasures in an age when modernity and industrial production was increasingly impacting upon American society and economics. Every object in *Old Models* shows evidence of ageing, the signs of wear and tear contributing to the overall sense of illusion. It would seem, however, that this has been brought about by constant use rather than neglect. Harnett's *Old Models*, with its dented instruments, rusty hinges and flaking paint, signifies the passing of the old century, and its old ways, to make way for the coming of the new – the epoch of modernity.

CREATED

New York

MEDIUM

Oil on canvas, 138.11 x 71.75 cm (54 3/8 x 28 1/4 in)

SIMILAR WORKS

Old Time Letter Rack by John Frederick Peto, 1894

William Michael Harnett *Born* 1848 County Cork, Ireland

Died 1892

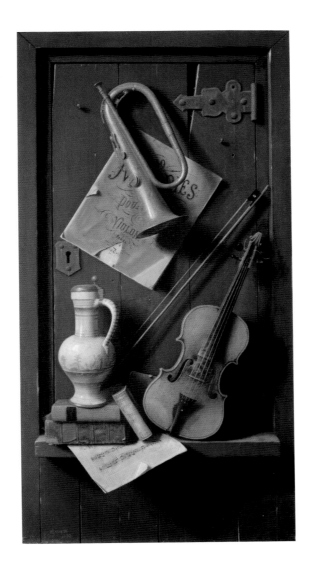

Cassatt, Mary
The Boating Party, 1893–94

Mary Cassatt originally hailed from Pennsylvania, where she was raised in a wealthy family and later studied art at the Pennsylvania Academy. However, she spent most of her career living in Paris. Here she worked alongside the French Impressionist painters and became a close friend of Edgar Degas (1834–1917). Although she mostly exhibited in Paris during the 1870s and 1880s, her works were eagerly collected in the United States and, in this way, Cassatt was largely responsible for bringing Impressionism to America. Her keen eye for modern artistic developments can clearly be seen in *The Boating Party*. Painted in the south of France, the image shows a woman, with a young child, taking a leisurely boat trip. The woman's urban attire – a fashionable hat and delicately decorated dress – contrast strikingly with the local costume of the oarsman seen almost in silhouette in the foreground. More importantly, Cassatt's use of solid blocks of colour, particularly evident in the intense blue of the water that forms a backdrop to the scene, recalls the widespread influence of Japanese prints, then highly valued by modern artists for their decorative treatment of surface and space.

CREATED

Cap d'Antibes, France

MEDIUM

Oil on canvas

SERIES/PERIOD/MOVEMENT

Impressionist

SIMILAR WORKS

John Biglin in a Single Scull by Thomas Eakins, 1874

Mary Cassatt *Born* 1845 Allegheny City, Pennsylvania

Died 1926

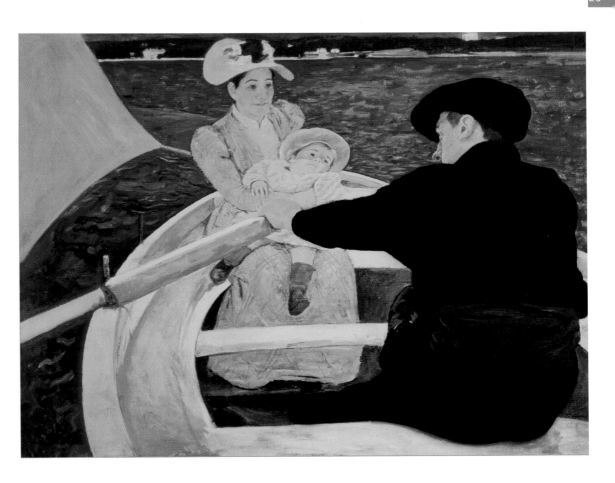

Henri, Robert

Jesseca Penn, 1908

Robert Henri proved to be one of the most important and influential American artists of the early twentieth century, and was the driving force behind the Ashcan School, a group of Realist-inspired artists who rebelled against what they regarded to be the excessive gentility of the American art establishment. In 1908 Henri and his fellow artists, including Arthur Bowen Davies (1862–1928), William Glackens (1870–1938), Ernest Lawson (1873–1939), George Luks (1867–1933), Maurice Prendergast (1859–1924), Everett Shinn (1876–1953) and John Sloan (1871–1951), staged a groundbreaking exhibition in New York. Henri and his colleagues – who dubbed themselves 'The Eight' – rejected the dominant Neoclassicism of the Academy in favour of depicting urban life in the raw. They adopted a sketchy style characterized by bright colours and bold brushstrokes, reminiscent of modern European painting. However, Henri was also aware of the portraits of fellow American artists John Singer Sargent (1856–1925) and James McNeill Whistler (1834–1903), an influence that can clearly be detected in this handsome full-length portrait of the model Jesseca Penn.

CREATED

New York

MEDIUM

Oil on canvas

SERIES/PERIOD/MOVEMENT

Ashcan School

SIMILAR WORKS

Portrait of Lady Sassoon by John Singer Sargent, 1907

Robert Henri *Born* 1865 Cincinnati, Ohio

Died 1929

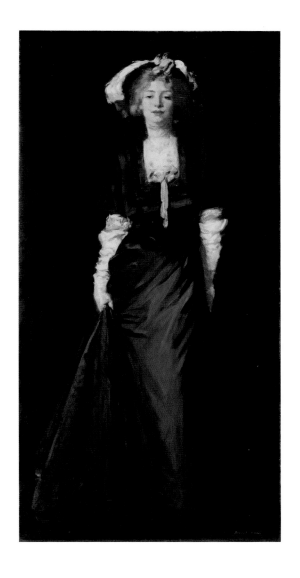

Davies, Arthur Bowen
Two Nude Figures

Arthur Bowen Davies was, in many respects, one of the least likely supporters of modern art. He initially fell in love with the work of the British Pre-Raphaelites and the French Symbolists during a visit to Europe in 1893. He was particularly influenced by the French painter Pierre Puvis de Chavannes (1824–98) and frequently depicted idealized female nudes in classical settings. In this small-scale sketch, Davies has adopted a frieze-like format, reminiscent of ancient Greek vase painting. The two figures strike dramatic poses as if engaged in a carefully choreographed dance. The inclusion of grapes, however, implies a more bacchanalian performance. Yet for all his classicism, Davies was a staunch admirer of the realism of the Ashcan School and of the more radical artistic experiments he witnessed in Europe. In 1912, together with fellow artist Walt Kuhn (1880–1949), Davies travelled throughout Europe gathering works for what was to be one of the groundbreaking exhibitions of modern art in the United States – the 1913 'Armory Show'. Davies was thus largely responsible for bringing the work of such iconic European modernists as Pablo Picasso (1881–1973), Henri Matisse (1869–1954) and Marcel Duchamp (1887–1968) to the attention of American art audiences.

CREATED

New York

MEDIUM

Watercolour and gouache on paper, laid down on board

SIMILAR WORKS

Young Girls by the Seashore by Pierre Puvis de Chavannes, 1879

Arthur Bowen Davies *Born* 1862 Utica, New York

Died 1928

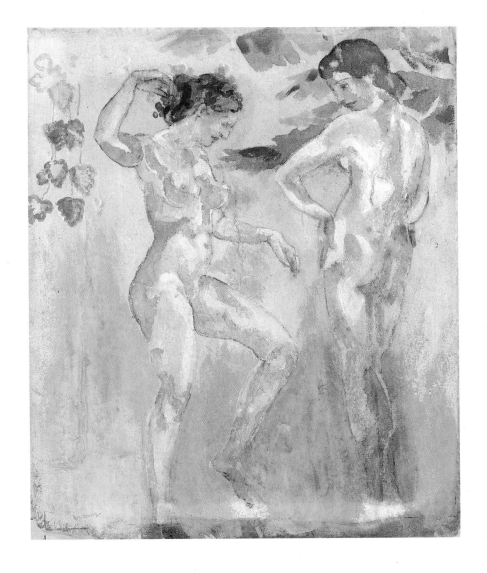

Hartley, Marsden
A Nice Time, 1916

Marsden Hartley's *A Nice Time* was produced shortly after his return to New York from war-torn Europe. Hartley had spent much of the previous three years studying in both Paris and Berlin, thanks to financial support from Arthur Bowen Davies and the photographer and art collector Alfred Stieglitz (1864–1946). In Paris he encountered Cubism and in Berlin, Expressionism. In the more liberal society of the German capital he was also able to express his homosexuality more openly, and he fell deeply in love with a young German officer who was tragically killed in the conflict. Hartley's *A Nice Time* makes reference to his European odyssey, adopting both the fragmentation and the use of words 'BON' and 'JOUR', typical of Parisian Cubism. However, other elements seem less easy to decipher. For example, the strange assortment of objects placed on the table – a teacup, a camellia, a tomato and a banana – seem to imply a symbolic significance that resists easy reading, and the inclusion of the word fragments 'HAH' and MLEAGNA' seem equally obscure. Here Hartley combines a personal symbolism with the formalistic aspects of European modernism.

CREATED

New York

MEDIUM

Oil on board

SIMILAR WORKS

Chinese Restaurant by Max Weber, 1915

Marsden Hartley *Born* 1877 Lewiston, Maine

Died 1943

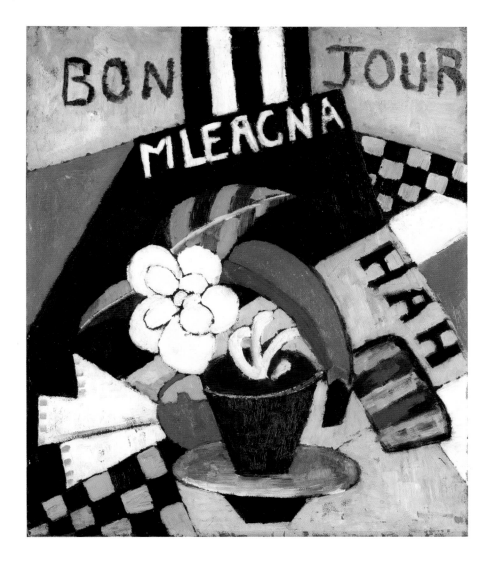

MacDonald-Wright, Stanton

Synchromy No. 3, 1917

Throughout the first decade of the twentieth century many American artists travelled to Europe, and particularly Paris, to experience first-hand developments in what was widely recognized as the art capital of the world. Among these was the painter Stanton MacDonald-Wright who, along with Morgan Russell (1886–1953), is recognized as the founder of the movement known as Synchromism, meaning literally 'with colour'. MacDonald-Wright moved to Paris in 1907 and, over the next few years, acquired a familiarity with the works of key avant-garde artists, including Frantisek Kupka (1871–1957) and Robert Delaunay (1885–1941). Like these artists, MacDonald-Wright explored the possibilities of an art that was entirely non-representational and that strove to link the visual experience of colour to the aural experience of music. In this way, many of MacDonald-Wright's paintings were given titles similar to musical compositions, such as *Synchromy No. 3*. Although many of his *Synchromies* were produced in Paris, MacDonald-Wright returned to the United States in 1916, where he continued to develop his particular form of abstract painting.

CREATED

New York

MEDIUM

Oil on canvas

SERIES/PERIOD/MOVEMENT

Synchromist

SIMILAR WORKS

Homage to Bleriot by Robert Delauney, 1914

Stanton MacDonald-Wright *Born* 1890 Charlottesville, Virginia

Died 1973

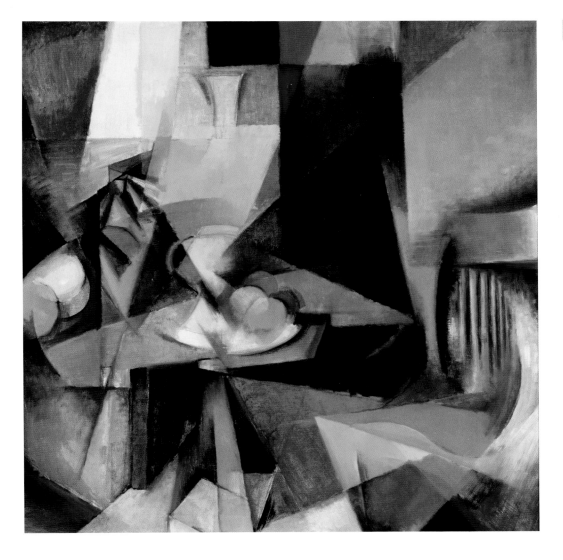

Sheeler, Charles

Upper Deck, 1929

Charles Sheeler was a major figure amongst a group of American artists called Precisionists. Other artists associated with Precisionism included Charles Demuth (1883–1935), Louis Lozowick (1892–1973) and Ralston Crawford (1906–78). Precisionism was very much the product of the machine age in America. In the aftermath of the First World War, the United States increasingly adopted a policy of 'Isolationism', distancing itself from what many perceived to be an unhealthy dependence upon European culture. In its place, the Precisionists celebrated what they understood to be the iconic cultural achievements of the United States: skyscrapers, factories, bridges, ocean liners and automobiles – the products of mass industrialization. As the painting *Upper Deck* reveals, however, it was not just in subject-matter that Precisionism celebrated technology and industrialization. Indeed, the very composition of this painting exudes sharp linearity, order and balance. Individual expression is avoided and the image is reminiscent of an engineer's blueprints. Sheeler frequently based his paintings on photographs, copying them to the smallest detail and replicating their sleek, impersonal surfaces.

CREATED

New York

MEDIUM

Oil on canvas

SERIES/PERIOD/MOVEMENT

Precisionist

SIMILAR WORKS

My Egypt by Charles Demuth, 1927

Charles Sheeler *Born* 1883 Philadelphia, Pennsylvania

Died 1965

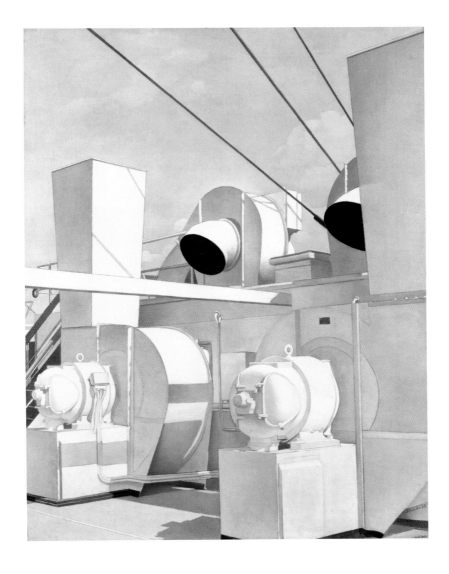

Marsh, Reginald

Fourteenth Street, 1932

Reginald Marsh inherited the mantle of the early American realists of the Ashcan School. Like his predecessors, he studied at the Art Students League in New York and spent much of his early career as a newspaper illustrator. He also wandered the streets in search of inspiration, watching people of all ages, races and classes commingling in the melting-pot that was New York City. His work *Fourteenth Street*, for example, comes straight out of the tradition of Luks' *Hester Street* and Sloan's *McSorley's Bar*. Here, Marsh depicts a broad cross-section of society gathered in front of a department store during a sale. The crowd is made up predominantly of shoppers of all classes and ages, here to snap up bargains. However, Marsh has also included a group of street musicians, a disabled man on a wheeled board and a sandwich-board man. The close proximity of this crowd adds a sense of claustrophobia to the scene, a factor exacerbated by the inclusion of parasols to suggest hot weather. The nervy, sometimes frenzied, gestures of the crowd also draw attention to the more desperate economic circumstances brought about by the Depression in 1930s America.

CREATED

New York

SIMILAR WORKS

On the Street (Fourteenth Street) by Isabel Bishop, *c.* 1932

Reginald Marsh *Born* 1898 Paris, France

Died 1954

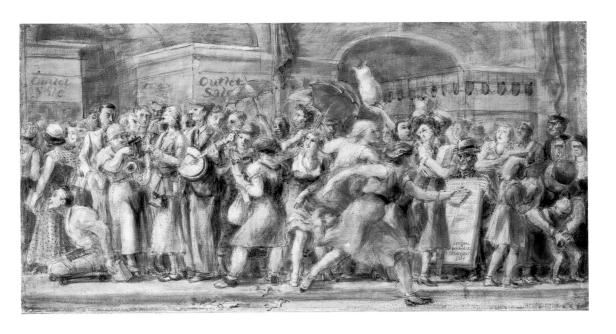

Douglas, Aaron

The Song of the Towers (from *Aspects of Negro Life*), 1934

Aaron Douglas was one of the key participants in the Harlem Renaissance, the cultural flowering that took place in New York in the 1920s and 1930s. In 1934, Douglas was commissioned to produce four murals for the 135th Street branch of the New York Public Library. The series, *Aspects of Negro Life*, charts the progress of African-Americans from their native roots in Africa, through slave-hood, emancipation and into the modern era. *The Song of the Towers* is the culmination of the series. At the centre of the image, a jazz saxophonist – symbolizing freedom and hope – raises his arms towards the skyscrapers and the Statue of Liberty. Behind him, a migrant worker narrowly escapes the green clutching hands of poverty and death, as he climbs on the metaphorical cog of industry and development. Douglas notably borrows both the elongated forms of Egyptian wall-paintings and African masks, and the clean, precise lines and colours of Precisionism.

CREATED

New York

MEDIUM

Oil on canvas

SERIES/PERIOD/MOVEMENT

Harlem Renaissance

SIMILAR WORKS

The Migration Series by Jacob Lawrence, 1940–41

Aaron Douglas *Born* 1899 Topeka, Kansas

Died 1979

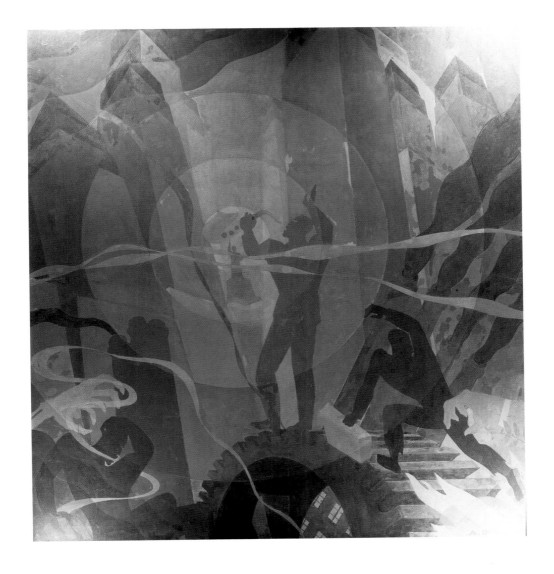

Hayden, Palmer

The Janitor Who Paints, 1939–40

Peyton Hedgeman acquired the name Palmer Hayden during the First World War, when the sergeant in his regiment was reputedly 'unable' to pronounce his real name. Under this name, however, he established a reputation as one of the pre-eminent African-American artists of the twentieth century. After the war, Hayden participated in the great African-American cultural awakening known as the Harlem Renaissance. In 1927 he travelled to Paris, where his work was exhibited at the prestigious Bernheim-Jeune Gallery. Hayden's pieces frequently incorporate African cultural artefacts. However, he is best known for his depiction of African-American subjects and experiences, as can be seen in the autobiographical work, *The Janitor Who Paints*. Here, Hayden emphasizes his status as an artist painting a portrait of a mother and child in a domestic interior. However, he also incorporates a bin, a mop and a duster – an indication of how he was forced to support his art throughout his early career by undertaking a series of low-paid jobs. Hayden's works have sometimes been criticized for pandering to racial stereotypes, but this painting – later reworked – captures the artist's dignity.

CREATED

New York

MEDIUM

Oil on canvas

SERIES/PERIOD/MOVEMENT

Harlem Renaissance

SIMILAR WORKS

Self-Portrait by Malvin Gray Johnson, 1934

Palmer Hayden (Peyton Hedgeman) *Born* 1890 Wide Water, Virginia

Died 1973

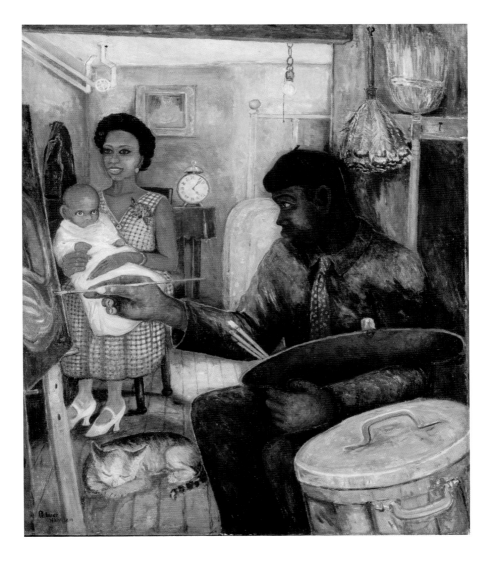

Pippin, Horace

Giving Thanks, 1942

Courtesy of © The Barnes Foundation, Merion, Pennsylvania, USA/Bridgeman Art Library/© Estate of Horace Pippin

Throughout the 1930s many American art critics looked to the vernacular tradition of folk culture as truly reflective of a national culture. As a consequence of this, many so-called 'primitive' artists were 'discovered', including Grandma Moses (1869–1961) and the African-American artist Horace Pippin. Pippin's work was first widely exhibited at the Museum of Modern Art in New York at the 1938 exhibition entitled 'Masters of Popular Painting: Modern Primitives of Europe and America'. Unlike some of the other so-called 'primitive' artists, Pippin was entirely untrained. He had served during the First World War, where he sustained an injury that paralyzed his right arm. Despite this limitation, however, he took up painting in the 1930s. Pippin's works, such as *Giving Thanks*, were executed in bright colours with flat forms, reminiscent of the French 'naïve' painter Henri Rousseau (1844–1910). His subjects, however, were reflective of his personal life and passions. These included memories of his war experiences, biblical themes, scenes from the history of African-Americans, and domestic interiors, as seen here.

CREATED

West Chester, Pennsylvania

MEDIUM

Oil on panel

SERIES/PERIOD/MOVEMENT

Primitive

SIMILAR WORKS

Cambridge Valley by Grandma Moses, 1942

Horace Pippin *Born* 1888 West Chester, Pennsylvania

Died 1946

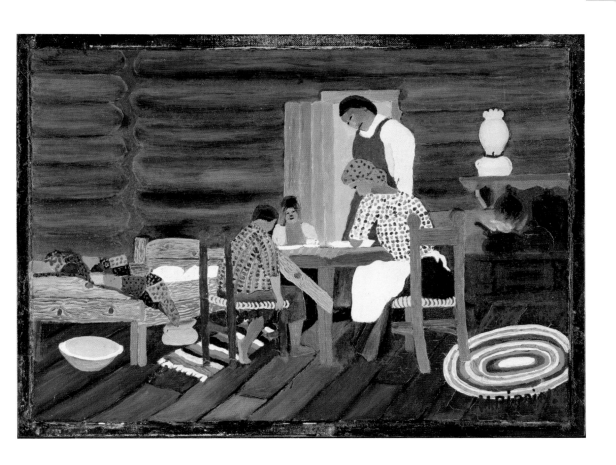

Benton, Thomas Hart
July Hay (sketch), 1943

In December 1934, *Time* magazine published an article reporting a new trend in American painting. It included, for the very first time, full-colour reproductions of the works of artists including Thomas Hart Benton, John Steuart Curry (1897–1946) and Grant Wood (1892–1942). The new trend was labelled Regionalism and was soon recognized throughout the United States as a major art movement. Regionalism was, in many respects, a rejection of the European avant-garde. Its artists embraced specifically American themes, usually based in the heartland of the Midwest, and adopted a realist, narrative style of painting. This inward-looking cultural practice reflected the increased isolationist policies of the United States in the wake of the Wall Street Crash of 1929. Thomas Hart Benton epitomized this new art. Originally a supporter of the avant-garde, and follower of MacDonald-Wright's Synchromism, Benton abandoned New York in the mid 1930s and spent the rest of his life in Kansas City, Missouri. Here he produced many paintings and murals depicting scenes from American history and the farming communities of the Midwest – for Benton, the true sons and daughters of the American soil.

CREATED

Kansas City, Missouri

MEDIUM

Oil on tin

SERIES/PERIOD/MOVEMENT

Regionalist

RELATED WORK

American Gothic by Grant Wood, 1930

Thomas Hart Benton *Born* 1889 Neosha, Missouri

Died 1975

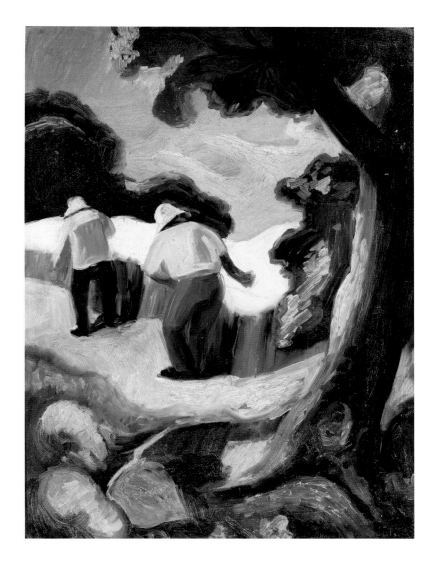

Johnson, William H.

Underground Railway, 1945

Courtesy of © 2004, Photo Smithsonian American Art Museum/Art Resource/Scala, Florence/© Estate of William H. Johnson

William H. Johnson arrived in New York in 1918, as the Harlem Renaissance was about to burst into life. Having studied under the Ashcan School artist George Luks, he quickly established a reputation as a Realist painter. In 1926, however, he travelled to Paris, where he first encountered the work of Vincent van Gogh (1853–90) and Edvard Munch (1863–1944). Johnson spent much of the inter-war period on the move, travelling throughout Europe and North Africa before returning to the United States in 1938. It was at this point that his art changed dramatically. At this time, Johnson adopted a simpler style, characterized by bold, flat colours and simple outlines. This style drew upon a multitude of sources, including children's drawings, early American folk art, and the local arts and crafts of Tunis and Tangiers. In 1945, Johnson began a series of works charting the history of African-Americans. His painting *Underground Railway* is a collection of portraits of the many heroes of the abolitionist movement in the nineteenth century. The title refers to the metaphorical railway – the vast network of secret routes used by abolitionists to assist slaves in their escape from bondage.

CREATED

New York

MEDIUM

Oil on paperboard

SIMILAR WORKS

The Migration Series by Jacob Lawrence, 1940–41

William H. Johnson *Born* 1901 Florence, South Carolina

Died 1970

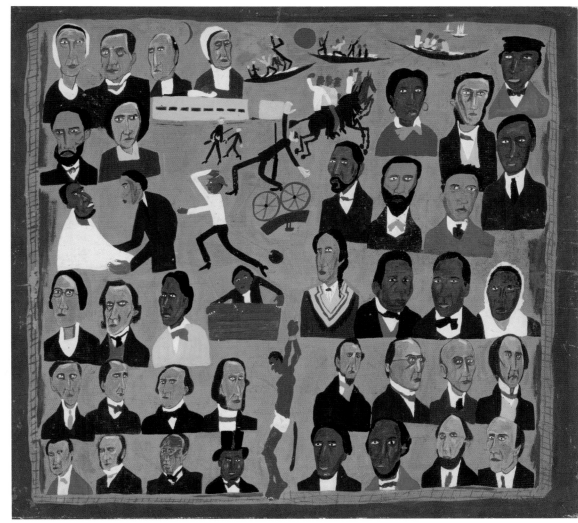

Lundeberg, Helen

Winter Pears, 1949

Courtesy of Christie's Images Ltd/© Estate of Helen Lundeberg

Surrealism first gained widespread attention in the United States in 1936, when the exhibition 'Fantastic Art, Dada and Surrealism' was shown at the Museum of Modern Art in New York. Surrealist painting followed two main strands: automatism, in which artists strove to develop a spontaneous style of painting that circumvented the conscious mind; and dream painting. By the 1940s, the former practice was widely followed by the American-based artists, who subsequently developed Abstract Expressionism. However, some painters, including Helen Lundeberg, pursued the latter path, producing highly detailed images that suggest mystery, metamorphosis and the incongruity of dreams. *Winter Pears*, produced in the late 1940s, bears some of the hallmarks of this style. Here two pears are placed on a simple table set before a bleak, winter landscape, the lush flesh of the fruit notably contrasting with the bare tree in the background. The rounded forms of the fruit, gently resting against each other, give the work a sensual air that is almost anthropomorphic. Here Lundeberg has transformed a conventional studio still-life subject into an evocative allusion to fecundity and barrenness, to life and death.

CREATED

California

MEDIUM

Oil on cardboard

SIMILAR WORKS

The Listening Room by René Magritte, 1952

Helen Lundeberg *Born* 1908 Chicago, Illinois

Died 1999

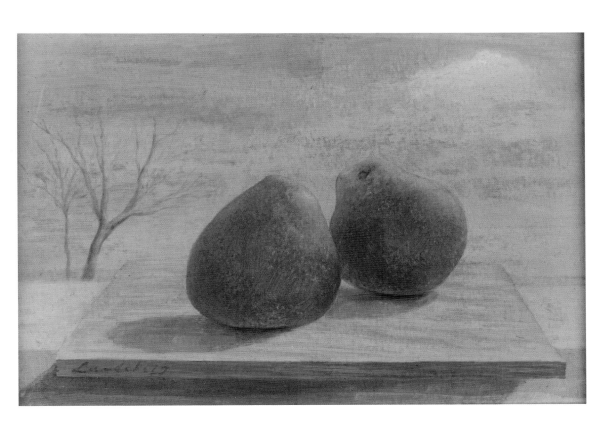

Pollock, Jackson

Number 12, 1949

The Second World War brought about a major change of fortune for many American artists. The occupation of Paris – art capital of the world – had forced the emigration of a whole host of European modern artists, many of whom settled in the United States. With the post-war European art market largely in tatters, attention was increasingly focused upon new artistic developments in New York. In many respects, Jackson Pollock was the first American artist to gain a truly global reputation. In 1947, Pollock began to develop his famous 'drip' technique, by laying the canvas on the ground and dripping paint directly on to the surface, frequently using a stick. The resulting paintings, often simply titled with numbers, were non-figurative, had no conventional compositional structure, and were regarded as entirely expressive of the artist's individual gestures. Pollock's style was soon dubbed Abstract Expressionism and, over the next few years, many American painters developed their own unique form of Abstract Expressionist art. For some critics, this style was seen as quintessentially American, reflecting what they saw as the true liberation of American art from its former dependence upon Europe.

CREATED

Long Island, New York

MEDIUM

Oil on paper, laid down on masonite

SERIES/PERIOD/MOVEMENT

Abstract Expressionist

SIMILAR WORKS

Untitled by Lee Krasner, 1949

Jackson Pollock *Born* 1912 Cody, Wyoming

Died 1956

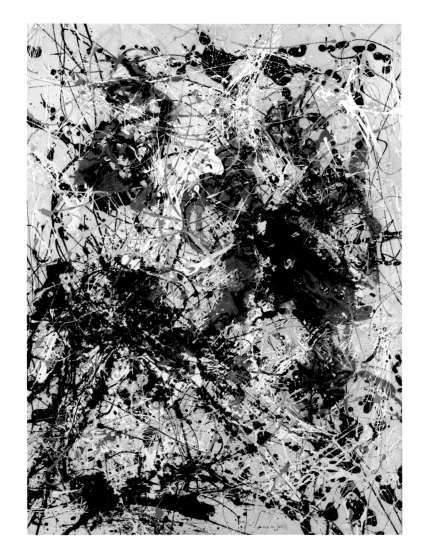

Rockwell, Norman

Saying Grace, 1951

Courtesy of Private Collection, © Christie's Images/Bridgeman Art Library/© Estate of Norman Rockwell

While Jackson Pollock and Abstract Expressionism gained wide press coverage in the late 1940s and early 1950s, Norman Rockwell remained for many Americans the quintessential American artist. Having started his career as an illustrator for the *Saturday Evening Post* in 1916, Rockwell continued to produce countless cover illustrations, charting the changing mood and society in the United States. *Saying Grace* shows Rockwell's meticulously detailed Realist style, representing a family at table, saying a prayer before the evening meal. It is a scene of quiet contemplation and spiritual reverie that extols the virtues of piety and family life. However, it also gently implies that all may not be quite as perfect as it first seems. The youngster is notably dining with his grandparents, raising the question of where his parents might be. Were they victims of the Second World War, when so many American servicemen and women lost their lives? Or did the constant anxieties, long absences and changing standards of social behaviour lead to the break-up of their marriage, as it did for so many at this time? Rockwell offers no answers, but his image certainly encourages us to ask the question.

CREATED

Arlington, Vermont

SERIES/PERIOD/MOVEMENT

Realist

MEDIUM

Oil on canvas

SIMILAR WORKS

Christina's World by Andrew Wyeth, 1948

Norman Rockwell *Born* 1894 New York

Died 1978

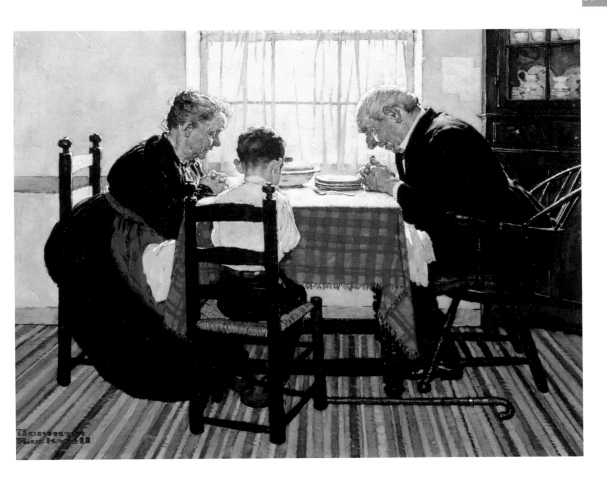

Rothko, Mark

White, Orange and Yellow, 1953

While Jackson Pollock's particular brand of Abstract Expressionism was largely based on the physical gesture, Mark Rothko, like his fellow painters Barnett Newman (1905–70) and Clyfford Still (1904–80), depended upon what were referred to as 'fields' of colour. Rothko's mature works all follow a similar formula: they are large in scale and represent nothing other than pure colour, arranged in floating, horizontal bands whose feathery edges dissolve into the background. Rothko intended his works to evoke profound, spiritual contemplation in the spectator, their sheer scale occupying the viewer's whole field of vision, whilst the absence of any figuration resisted the possibilities of narrative reading. The effect of standing before a Rothko painting is one of feeling dominated, even overwhelmed, by their sheer presence. To accentuate this effect, Rothko frequently produced works in series and insisted on them being displayed in specific spaces, such as the late series of black and maroon paintings originally intended for the Four Seasons restaurant in New York's Seagram building, and the works produced for the Rothko Chapel in Houston, Texas.

CREATED

New York

MEDIUM

Tempera on paper mounted on panel

SERIES/PERIOD/MOVEMENT

Abstract Expressionist

SIMILAR WORKS

Vir Heroicus Sublimis by Barnett Newman, 1950–51

Mark Rothko *Born* 1903 Dvinsk, Lithuania

Died 1970

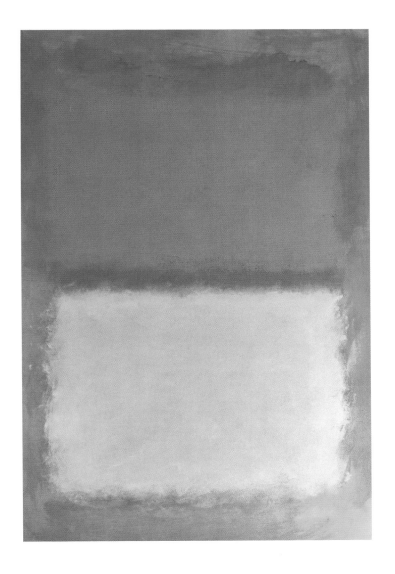

De Kooning, Willem

Sketch for *Woman*, 1953

In the early 1950s Willem de Kooning, a key figure amongst the Abstract Expressionists in New York, produced the first of a series of works entitled *Woman I*. At a time when many art critics in the United States were praising what they referred to as the 'purity' of abstract art, de Kooning's re-introduction of the human figure was roundly condemned as anathema to modern painting. Notably, de Kooning was not rejecting the gestural mark-making that had characterized the work of his contemporaries such as Pollock, Franz Kline (1910–62) and Robert Motherwell (1915–91). Rather, he was accentuating the links between modern painting and the European traditions out of which it had developed. For de Kooning, these strange and menacing creatures, emerging from their frenzied background, already apparent in this preparatory sketch, recall traditional representations of women from Rembrandt (1606–69) and Titian (*c.* 1485–1576) through to Matisse and Paul Gauguin (1848–1903). At the same time, however, they allude to the notion of female sexuality as threatening and destructive to men – a highly problematic presentation widely promoted in the popular culture of 1950s Hollywood movies.

CREATED

New York

SERIES/PERIOD/MOVEMENT

Abstract Art

SIMILAR WORKS

Untitled by Franz Kline, 1953

Willem de Kooning *Born* 1903 Rotterdam, Holland

Died 1997

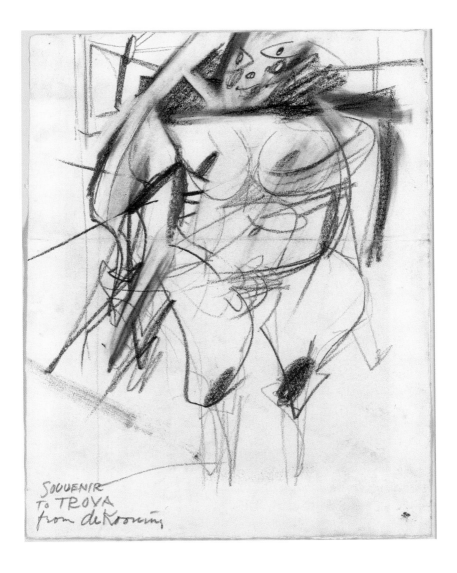

SOUVENIR
TO TROVA
from de Kooning

Frankenthaler, Helen
Mountain Storm, 1955

The success of Abstract Expressionism in both the national and the international arenas spawned a second generation of painters, who sought to develop further the experiments of Pollock and Rothko. A key figure here was Helen Frankenthaler. Frankenthaler's works, including *Mountain Storm*, combined the process of Pollock's work with the fields of colour generated by Rothko. Like Pollock, Frankenthaler used thin, liquid paints, which she poured and dripped on to canvases laid out on the floor. However, she was less interested in the gestural stroke of paint. Instead, she used unprimed canvas, so that the poured liquid paint seeped into the material rather than sitting on top of it. In this way her large canvases resemble watercolours, in which washes of colour soak into the surface, giving the effect of thin, semi-transparent veils and floating forms. This emphasizes the absolute flatness of the picture surface while simultaneously producing fields of colour that suggest infinite depth. The titles of Frankenthaler's pieces often allude to landscapes. Her works were to prove highly influential for the development of Colour Field painting in the 1960s.

CREATED

New York

MEDIUM

Oil on canvas

SERIES/PERIOD/MOVEMENT

Abstract Expressionist

SIMILAR WORKS

Autumn Rhythm by Jackson Pollock, 1950

Helen Frankenthaler *Born* 1928 New York

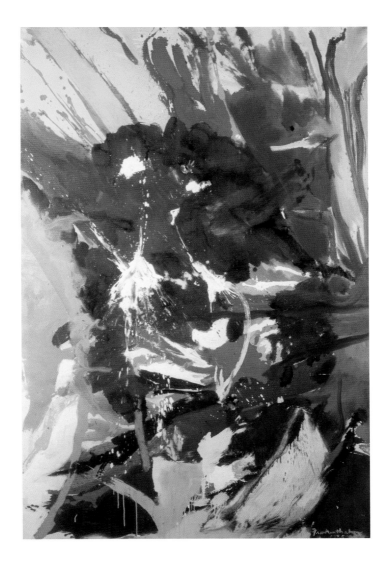

Rauschenberg, Robert

Monogram, 1955–59

Where Abstract Expressionists prioritized painting as a practice, Neo-Dada artists sought to reintroduce objects from everyday life into their works. This was hardly a new departure, recalling the earlier works of Duchamp, Kurt Schwitters (1887–1948) and Joseph Cornell (1903–72). Robert Rauschenberg first trained as an artist in the post-war era, studying at the experimental Black Mountain College in North Carolina. After moving to New York in 1949, he began to scour the streets for pieces of junk to introduce into his collaged and assembled works. For *Monogram* Rauschenberg purchased a stuffed goat that he saw in a local office-supply store. He then applied broad swathes of paint to the head as an ironic parody of the gestural surfaces of Abstract Expressionism. Finally, he placed a tyre around the goat's waist and stood it on a wooden plinth. Rauschenberg's goat, however, is no random juxtaposition of found objects. Rather, the goat penetrating the rubber tyre has been widely read as a homosexual symbol produced in the midst of the McCarthy era, when homosexuality was widely condemned in America.

CREATED

New York

MEDIUM

Oil and collage on canvas with objects

SERIES/PERIOD/MOVEMENT

Neo-Dada

SIMILAR WORKS

Floor Burger by Claes Oldenburg, 1962

Robert Rauschenberg *Born* 1925 Port Arthur, Texas

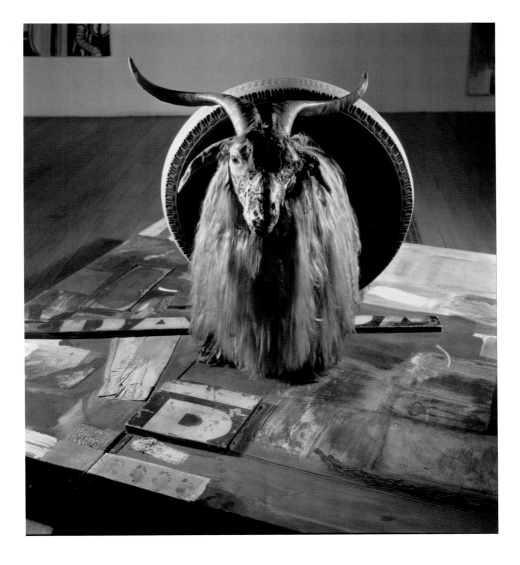

Johns, Jasper
White Numbers, 1959

For influential art critics like Clement Greenberg, Abstract Expressionism was valued for its emphasis on the individuality of the artist and the emotional and spiritual qualities that Abstract Expressionist paintings could notionally invoke. As such, Greenberg claimed, it was the complete opposite of popular or mass culture. However, some artists reacted to these claims by challenging this very individuality and by embracing, and frequently subverting, the signs and symbols of the everyday. The publication of Motherwell's *The Dada Painters and Poets* in 1951 generated a reassessment of artistic practices in the wake of Abstract Expressionism, and contributed to the emergence of a movement sometimes referred to as Neo-Dada. In the mid 1950s Jasper Johns started to introduce widely familiar signs, such as flags, maps and numbers, into his paintings. The emphasis on these formulaic signs diminished any sense of individual subjectivity. Sometimes, as in *White Numbers*, he would even drain all the colour from his images, leaving only the ghostlike traces of these familiar, yet now de-familiarized, signs. Johns' work set out to problematize the boundaries between the objective and the subjective, between what is real and what is represented.

CREATED

New York

MEDIUM

Encaustic on linen

SERIES/PERIOD/MOVEMENT

Neo-Dada

SIMILAR WORKS

Rebus by Robert Rauschenberg, 1955

Jasper Johns *Born* 1930 Augusta, Georgia

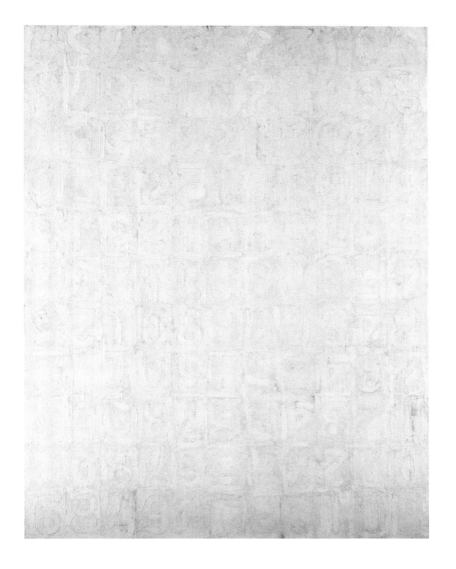

Louis, Morris

Gamma Epsilon, 1960

In 1953, the art critic Clement Greenberg invited two young artists, Morris Louis and Kenneth Noland (b. 1924), to the New York studio of the painter Helen Frankenthaler. Here they saw a work entitled *Mountains and Sea*. Both Louis and Noland were deeply impressed by the way in which her thin washes of colour, poured directly on to unprimed canvas, gave her works a flatness and luminosity that recalled the effect of watercolour, while still being executed on the monumental scale typical of Abstract Expressionism. Over the next few years all three artists developed what Greenberg came to call Post Painterly Abstraction. Louis embraced this process of staining the canvas with liquid paint and, over the next few years carefully developed his technique. In his early works he overlaid thin veils of colour to create a rainbow effect, each transparent layer of colour modifying the colour of the layer below. His signature style, however, as seen in *Gamma Epsilon*, consisted of rivulets of pure colour running diagonally down the sides of huge, blank canvases, their edges occasionally spilling into one another.

MEDIUM

Acrylic on canvas

SERIES/PERIOD/MOVEMENT

Post Painterly Abstraction

SIMILAR WORKS

Whirl by Kenneth Noland, 1960

Morris Louis (Morris Louis Bernstein) *Born* 1912 Baltimore, Maryland

Died 1962

Albers, Josef

Homage to the Square, 1960–65

Josef Albers was a key figure at the Bauhaus, the innovative German design school closed down by the Nazis in 1933. To escape the rise of Fascism, Albers moved to the United States and set up a new art school, called Black Mountain College, in North Carolina. This proved to be one of the most innovative schools in the United States, and attracted a number of key artists, including Rauschenberg, Noland, Frankenthaler, Motherwell and de Kooning. At Black Mountain, Albers strove to re-establish the art and design principles of the Bauhaus, promoting experimentalism and emphasizing the abstract qualities of colour and form. This approach is evident in Albers' own work, including the series of paintings he began in 1949 entitled *Homage to the Square*. In these works, Albers adopts a rigid, geometrical structure based on four overlapping squares executed in simple, flat colours. Despite their avowed simplicity, the works tend to highlight the tensions and visual illusions of expansion and contraction generated by the close proximity of these forms and colours. Albers continued to experiment with his *Homage to the Square* series right up to his death in 1976.

CREATED

New Haven, Connecticut

MEDIUM

Oil on card

SERIES/PERIOD/MOVEMENT

Homage to the Square series

SIMILAR WORKS

Green, Blue, Red by Ellsworth Kelly, 1964

Josef Albers *Born* 1888 Westphalia, Germany

Died 1976

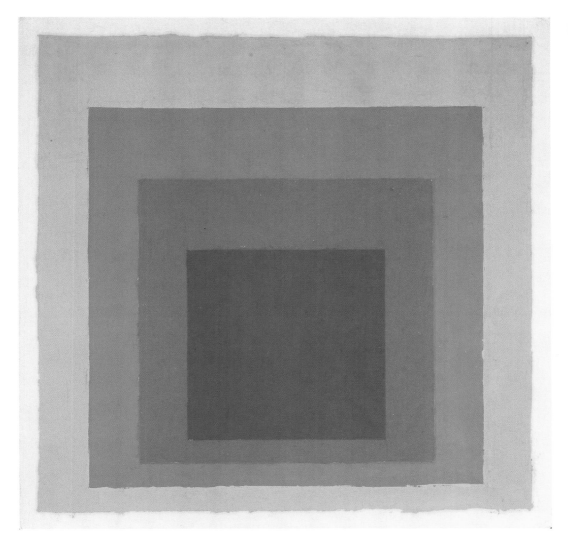

Stella, Frank
Island No. 10, 1961

Frank Stella's self-professed ambition was to 'eliminate spatial illusion' and to produce paintings that constituted 'a flat surface with paint on it – nothing more'. Stella was a pioneer of the movement known as Minimalism, though his adherence to using paint on canvas was soon to be rejected by many of the Minimalist artists who followed him. Stella gained notoriety early in his career when his work was included in the Museum of Modern Art's exhibition entitled 'Sixteen Americans' in 1959. Amongst the works exhibited were his so-called 'black pinstripe' works – large canvases that consisted of little more than a smooth black surface broken only by thinly inscribed geometrical lines. Stella's works are deliberately simple and systematic. They strive to undermine any sense of the individuality of the artist and resist metaphorical interpretation. As such they set out to challenge the then dominance of Abstract Expressionism. For Stella, a painting was nothing more than an object. As he himself claimed, 'All I want anyone to get out of my paintings, and all I ever get out of them, is the fact that you can see the whole idea without any confusion.... What you see is what you see.'

CREATED

New York

MEDIUM

Oil on canvas

SERIES/PERIOD/MOVEMENT

Minimalist

SIMILAR WORKS

Abstract Painting (Black) by Ad Reinhardt, 1960–66

Frank Stella *Born* 1936 Malden, Massachusetts

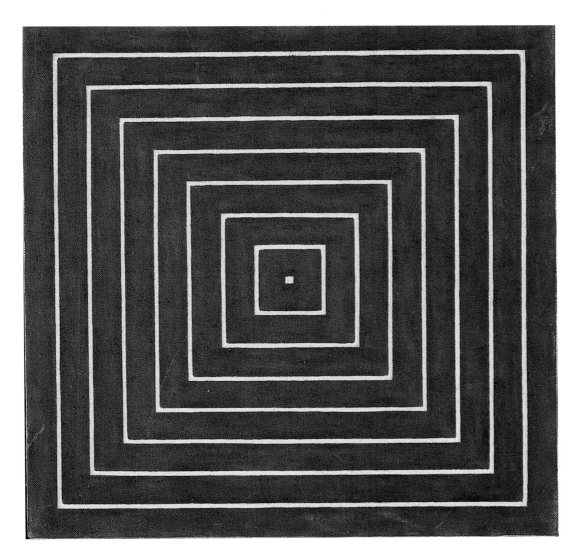

Lichtenstein, Roy
Eddie Diptych, 1962

Roy Lichtenstein was one of the chief proponents of the Pop Art movement that emerged in the early 1960s. Pop Art was, in many respects, a reaction against Abstract Expressionism. While the former movement celebrated the individual subjectivity and style of the artist, Pop Art sought to emulate the impersonal, mechanical forms of mass culture, thus undermining any sense of artistic individuality. Here, many soon-to-be Pop artists drew on the mid-1950s works of Johns and Rauschenberg. For Lichtenstein, this was achieved by embracing the throw-away culture of the comic book and elevating it to the status of high art. In *Eddie Diptych*, for example, Lichtenstein took an individual frame from a typical romance comic and enlarged it to monumental proportions. Divorced from their conventional narrative contexts and represented in the hushed spaces of an art gallery, these images deliberately challenge the viewer's preconceptions of what distinguishes the art of the museum from the artefacts of the streets.

CREATED

New York

MEDIUM

Oil on canvas

SERIES/PERIOD/MOVEMENT

Pop Art

SIMILAR WORKS

Superman by Andy Warhol, 1960

Roy Lichtenstein *Born* 1923 New York

Died 1997

71

I TRIED TO REASON IT OUT! I TRIED TO SEE THINGS FROM MOM AND DAD'S VIEWPOINT! I TRIED NOT TO THINK OF EDDIE, SO MY MIND WOULD BE CLEAR AND COMMON SENSE COULD TAKE OVER! BUT EDDIE KEPT COMING BACK...

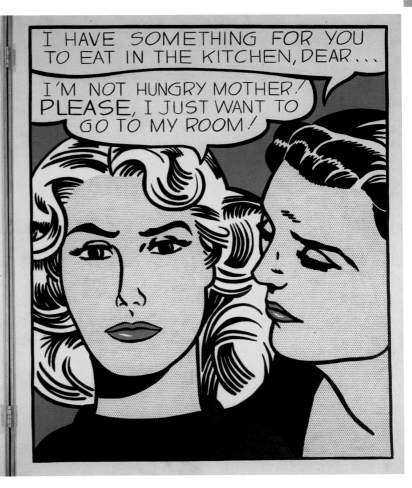

Flavin, Dan

Alternate Diagonals of March 2 1964, 1964

Dan Flavin's work is closely associated with the emergence of Minimalism in the 1960s. Flavin is best known for his light installations, in which he uses fluorescent light tubes to create sculptural works that are dependent upon both the physical structure produced by the light tubes and the immaterial effects of light generated. Flavin referred to an epiphanic moment in his life that took place on 25 May 1963. On this day, Flavin recounted, he took an ordinary fluorescent tube and placed it on the wall of his studio at a 45° angle. He entitled this work *The Diagonal of May 25, 1963*. Up to that point, he had been experimenting with small boxes mounted on walls and illuminated by coloured light bulbs, which he referred to as 'icons'. Flavin's light sculptures thus seem to refer to the dramatic use of light within religious ceremonies – he had spent time in a Catholic seminary as a young man. Over the next few years, Flavin produced variations on the original *Diagonal of May 25, 1963*, including this work combining red and yellow tubes. Flavin has subsequently produced large-scale light installations for Grand Central Station and the Guggenheim Museum in New York.

CREATED

New York

MEDIUM

Fluorescent lights

SERIES/PERIOD/MOVEMENT

Installation Art

SIMILAR WORKS

Catso Blue by James Turell, 1967

Dan Flavin *Born* 1933 New York

Died 1996

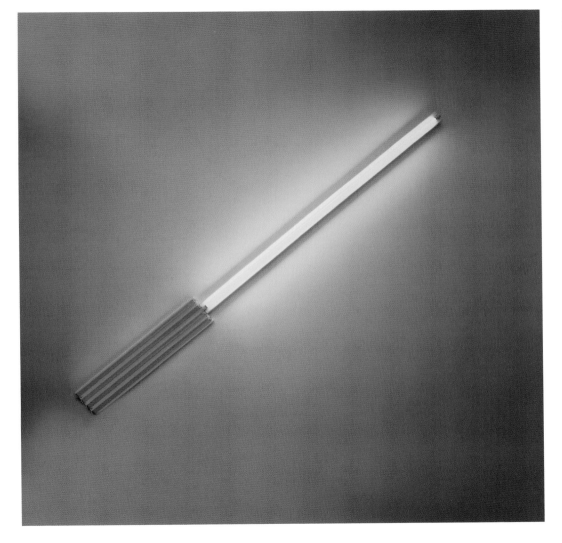

Warhol, Andy
Self-Portrait, 1966

No American artist, with the possible exception of Jackson Pollock, was more of a celebrity than Andy Warhol. And for Warhol the designation seems highly apt. He was the first artist to recognize, exploit, parody and critique fame, and his particular brand of Pop Art has both fed off and further generated the celebrity status with which it shamelessly engages. Like Lichtenstein, Warhol resisted the individuality and subjectivity of Abstract Expressionism. His use of the silkscreen technique, the foundation of his studio as 'The Factory', and his multiple reproductions of images of Hollywood film stars alongside consumer products like Coca-Cola bottles and Campbell's soup cans, all clearly reveal his desire to elevate the mechanical over the original. Even his own image was highly manipulated, manufactured and subjected to constant change. In the mid 1960s, Warhol produced a series of self-portraits reminiscent of his earlier series of portraits of famous film stars, which included Marilyn Monroe and Elvis Presley. With their deliberately poor-quality silkscreen printed surfaces, Warhol's self-portraits present the artist himself as little more than just another commodity for public display.

CREATED

New York

MEDIUM

Synthetic polymer paint and silkscreen inks on canvas

SERIES/PERIOD/MOVEMENT

Pop Art

SIMILAR WORKS

Retroactive I by Robert Rauschenberg, 1964

Andy Warhol *Born* 1928 Pittsburgh, Pennsylvania

Died 1987

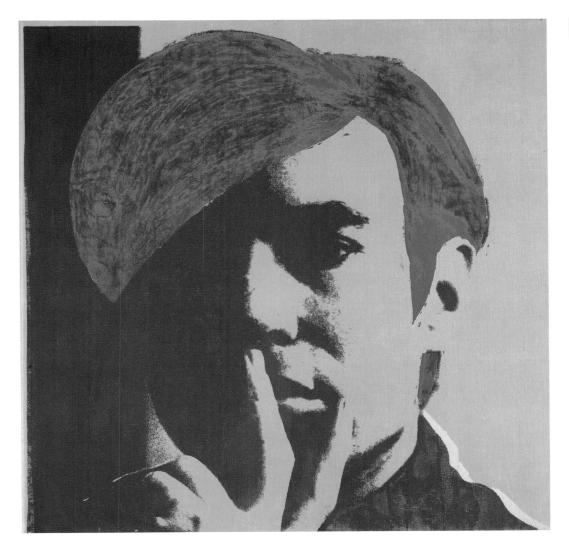

Oldenburg, Claes
Three-Way Plug, 1969

Few artists have combined the iconoclastic with the humorous as successfully as Claes Oldenburg. In many respects he is the epitome of the Neo-Dada trend established by Johns and Rauschenberg in the mid 1950s that fed in so successfully to Pop Art. Like Rauschenberg, Oldenburg embraced and celebrated urban junk. In 1961 he opened an alternative exhibition space in New York's Lower East Side, which he called 'The Store'. This was a deliberate parody of Manhattan's chic, modernist art galleries, and Oldenburg crammed it with papier-mâché sculptures of ordinary consumer products: hamburgers, slices of pie, shoes, sewing machines and underwear. Shortly afterwards, however, Oldenburg's celebration of the mundane objects of everyday life took a new turn. He began to enlarge objects to a monumental scale, as can be seen in his *Three-Way Plug* – 1.5 metres (5 feet) high, and suspended in the corner of an art gallery. From the 1970s, Oldenburg further developed his absurdist monumental sculptures producing, amongst other works, a giant clothespin for the city of Philadelphia (1976) and a 20-metre (66-feet) high matchbook for Barcelona (1992).

CREATED

New York

MEDIUM

Wood and masonite

SIMILAR WORKS

Brillo Box by Andy Warhol, 1969

Claes Oldenburg *Born* 1929 in Stockholm, Sweden.

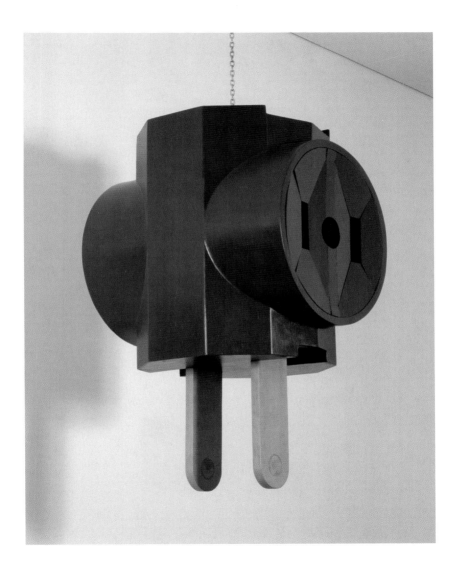

Judd, Donald
Untitled, 1970

Donald Judd's sculpture, unlike that of Oldenburg, showed no interest in the iconoclastic trend of the Neo-Dada movement. Judd was the chief exponent and most widely published theorist of Minimalism. Like Stella's paintings, Judd's sculptures sought to be nothing other than the thing itself. By using inorganic, industrial materials, such as polished aluminium or, as here, galvanized iron, his sculptures look like they have come straight out of a factory rather than an artist's studio – and in fact they often had. *Untitled*, for example, is a stark work, a metal component mounted on a wall. Its simple geometry recalls the Constructivist experiments of the early Soviet avant-garde, at that time being increasingly studied in the West, yet it purports to have no functional purpose, utopian or otherwise. Like many Minimalist sculptors, Judd became increasingly concerned to control the space in which his works were displayed, taking on the role of curator as well as producer. In some respects, Minimalism opened the door for a wide reassessment of how art was to be displayed and engaged with by the spectator, both inside and beyond the confines of the gallery.

CREATED

New York

MEDIUM

Galvanized iron

SERIES/PERIOD/MOVEMENT

Minimalist

SIMILAR WORKS

Equivalent VIII by Carl Andre, 1966

Donald Judd *Born* 1928 Excelsior Springs, Missouri

Died 1994

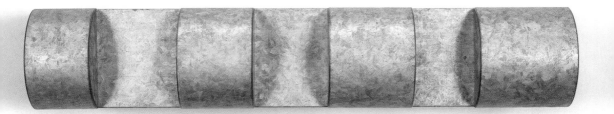

Smithson, Robert

Sketch for *Spiral Mangrove*, 1971

In the early 1970s, some artists not only rejected the conventional media of painting and sculpture, they also abandoned the museum altogether. Indeed, many of the most important works produced at this time were located thousands of miles from the city centres, in remote regions in Utah and Nevada. These works are referred to as Earthworks or Land Art, and Robert Smithson was the movement's chief proponent. His most famous work is his *Spiral Jetty* (1970), a 457-metre (1,500-foot) long spiral pathway projecting into the algae-rich, pink waters of the Great Salt Lake in Utah. Smithson knew that the work would rapidly deteriorate and sink beneath the surface. Indeed, this decay, or entropy, was a key aspect of Smithson's work. He also embraced the constant changes brought about by the forces of nature in his never-completed plan to build a *Spiral Mangrove*, as seen in this preparatory drawing. Here Smithson planned to plant seedlings in the shallow waters of a swamp in a spiral shape. As these seedlings grew, the form of the spiral would alter and, in all probability, entirely lose its form. Smithson's work notably developed at the same time that ecological concerns began to draw wider popular attention.

MEDIUM

Pencil and crayon on paper

SERIES/PERIOD/MOVEMENT

Earthworks

SIMILAR WORKS

Complex I by Michael Heizer, 1972

Robert Smithson *Born* 1938 Passaic, New Jersey

Died 1973

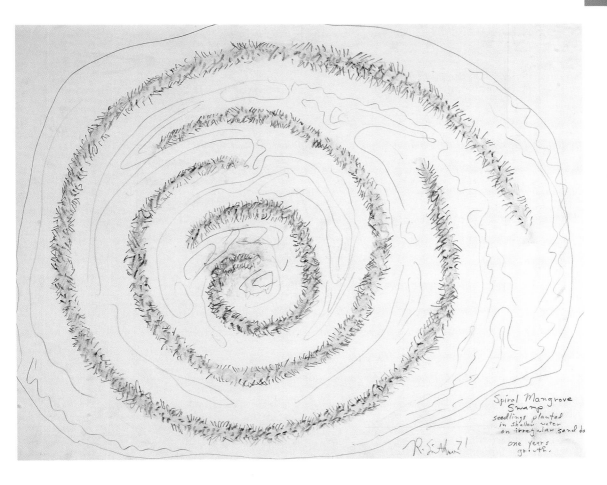

Spiral Mangrove
Swamp
seedlings planted
in shallow water
on irregular sand ba
one years
growth.

R. Smithson 71

Chicago, Judy
Dinner Party, 1974

The rise of Feminism in the late 1960s also led to the emergence of a Feminist movement in visual culture. Much as the Women's Liberation movement set out to challenge social inequalities for women, the Feminist Art movement strove to redefine the place of women artists both in history and in contemporary practice. It also set out to explore the notion of a specifically Feminist aesthetic. A key moment in the emergence of Feminist art was the establishment of the Feminist Art Programme at the California Institute of Arts in 1971, founded by Miriam Schapiro (b. 1923) and Judy Chicago. Chicago's most famous work is an installation piece entitled *Dinner Party*. The work features a large, triangular table placed on a white-tiled floor, inscribed with the names of women from history. The table is set for 39 places, each with a porcelain plate, as seen in this image, decorated with forms based on female genitalia, and set on an embroidered mat. Chicago's installation is simultaneously a celebration, and a reclaiming, of the female body. At the same time it embraces the traditions of decorative ceramics and embroidery, challenging the male-dominated art world's devaluing of these activities as intrinsically 'feminine'.

CREATED

California

MEDIUM

Mixed media

SERIES/PERIOD/MOVEMENT

Feminist Art

SIMILAR WORKS

Mary Cassatt and Me by Miriam Schapiro, 1976

Judy Chicago (Judy Cohen) *Born* 1939 Chicago, Illinois

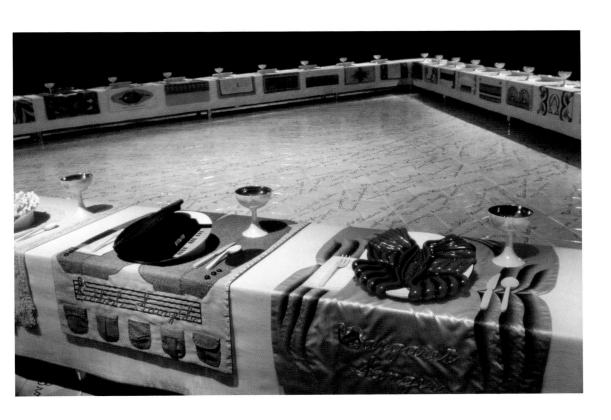

Motherwell, Robert

Elegy to the Spanish Republic, No. 131, 1974

Robert Motherwell was certainly the most erudite of the Abstract Expressionist painters. Born into a wealthy banking family, he studied both Philosophy and Art History at Princeton University. In 1950, Motherwell produced a painting entitled *At Five in the Afternoon*, a work inspired by the execution of the poet Garcia Lorca during the Spanish Civil War. Over the next decade he produced dozens more similar works, known as his *Spanish Elegies* series. These works are simple in form, consisting of two vertical black forms alternating with black oval shapes, silhouetted against a white background. Though abstract, these starkly monochromatic works, usually executed on a large scale, evoke a sense of struggle between good and evil, between light and dark, and between life and death. Motherwell's *Spanish Elegies* clearly recall the late 'black paintings' of Francisco de Goya (1746–1828), as well as alluding to the strictly monochrome palette of Picasso's *Guernica*, the ultimate icon of Spanish Republican sympathy and a work, at that time, on display at the Museum of Modern Art in New York.

CREATED

New York

MEDIUM

Oil on canvas

SERIES/PERIOD/MOVEMENT

Abstract Expressionist

SIMILAR WORKS

Guernica by Pablo Picasso, 1937

Robert Motherwell *Born* 1915 Aberdeen, Washington

Died 1991

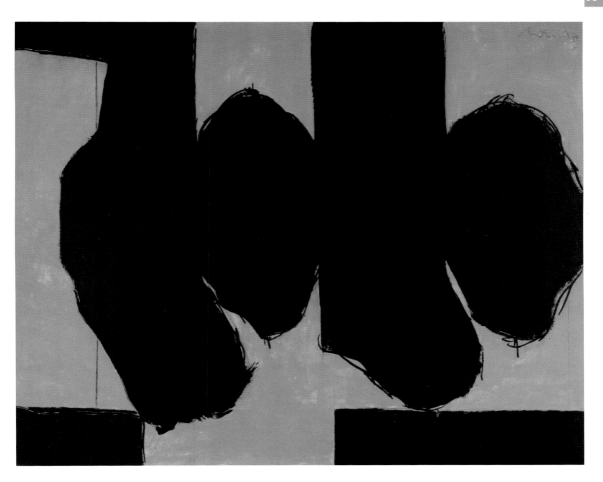

Close, Chuck
Linda, 1975–76

In the mid 1960s Chuck Close began painting in an Abstract Expressionist style. Like many artists of his generation, however, he soon rejected this and developed a new style that has subsequently been dubbed Superrealism (sometimes called Photorealism). Close worked directly from photographs, usually the poor-quality straight-on, head-and-shoulders portraits typically used for passports. He then enlarged these to a monumental scale and painted them with meticulous care, capturing every tiny detail and reproducing precisely the surface quality of the original photograph. Close's works thus aim to be style-less and impersonal, avoiding any sense of individual interpretation or artistic alteration from the original. In *Linda*, Close reproduces every wrinkle and blemish on the sitter's skin and every single hair. The face is sharply focused while the base of the neck and back of the hair are slightly blurred, replicating the shallow focus of the camera. Yet despite this notional neutrality, Close's monumental works appear confrontational, forcing us to look closely into the face of a colossal stranger, staring directly down upon us. Close's works influenced other American Superrealist artists, including the painters Richard Estes (b. 1936) and Robert Bechtle (b. 1932), and the sculptor Duane Hanson (1925-96).

CREATED

New York

MEDIUM

Acrylic on canvas

SERIES/PERIOD/MOVEMENT

Superrealist

SIMILAR WORKS

'61 Pontiac by Robert Bechtle, 1968–69

Chuck Close *Born* 1940 Monroe, Washington

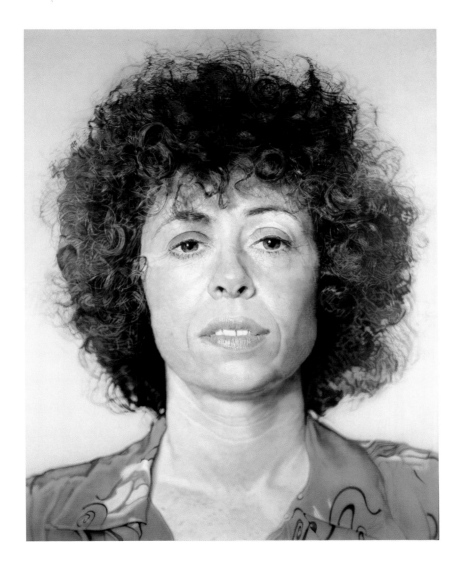

Basquiat, Jean-Michel

Profit I, 1982

The dominance of Conceptual and Performance Art in the 1970s led to a backlash in the 1980s, and the rise of a painterly movement called Neo-Expressionism, of which Jean-Michel Basquiat was one of the chief proponents. In an ironic reversal of the activities of many artists who had striven to take their works out of the gallery and into the streets, Basquiat's short career witnessed the opposite trajectory. His work first came to the public attention in an anonymous form when he participated in the graffiti craze that exploded in downtown Manhattan during the late 1970s. Together with his friend Al Diaz, he cultivated a pseudonymous character called SAMO and used the name to sign the public walls he spray-painted. In the heady economic boom of the 1980s, Basquiat's work was soon 'discovered' and his pieces, now executed in a studio and on canvas, were increasingly included in major exhibitions. They were celebrated for their immediacy, for the aggressive treatment of form and their starkly clashing colours. This was seen by some critics as capturing the dynamism and rawness of the street, and as an antidote to the control, precision and harmony of so-called museum art.

CREATED

New York

MEDIUM

Acrylic and spray paint on canvas

SERIES/PERIOD/MOVEMENT

Neo-Expressionist

RELATED WORK

Jungle Ism by Kenny Scharf, 1985

Jean-Michel Basquiat *Born* 1960 Brooklyn, New York

Died 1988

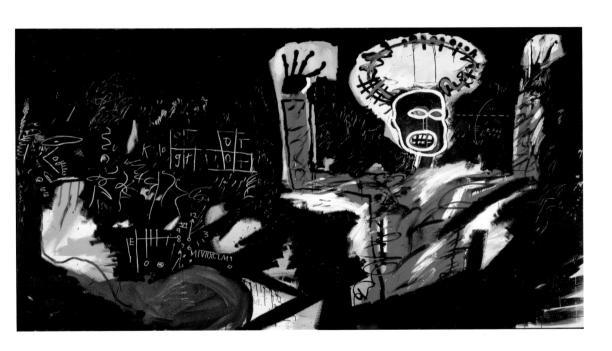

Nauman, Bruce

Etching for *Learned Helplessness in Rats (Rock and Roll Drummer)*, 1988

Bruce Nauman is renowned as one of the most experimental artists in contemporary American art. He has been a key figure in the development of Conceptual Art, Installation Art and Performance Art, and has engaged with a host of media including the use of his own body and new technologies such as video. His works frequently create whole environments, including sound as well as visual stimulation. They encourage the spectator to enter into spaces and interact with the work, yet often offer no sense of resolution as, for Nauman, the process, or the journey, is of far more interest than the destination. In 1988 Nauman produced an installation entitled *Learned Helplessness in Rats (Rock and Roll Drummer)*. The work consisted of a yellow plexiglass labyrinth with video cameras and monitors. Laboratory rats were studied in this labyrinth but not through conventional behavioural experiments. Instead, loud rock and roll drumming was video projected on to the wall. In this way, Nauman implied an association between our media-saturated culture and the containment of a labyrinth. Nauman produced a series of etchings, including this one, to accompany the installation.

MEDIUM

Etching

SERIES/PERIOD/MOVEMENT

Installation Art

SIMILAR WORKS

Room for St. John of the Cross by Bill Viola, 1983

Bruce Nauman *Born* 1941 Fort Wayne, Indiana

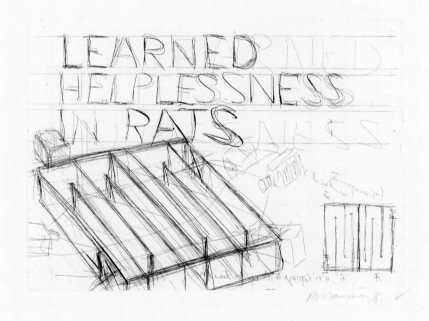

Smith, Kiki

Untitled (Arm and Leg), 1991

Since the 1980s many artists have conducted a re-examination and re-exploration of the human body, a key motivation behind the sculptural works of Kiki Smith. Many of Smith's works deal explicitly with the abjectness of the body, representing flayed or dismembered body parts. In one sense, Smith's direct engagement with the physical realities of the human form recalls the importance of anatomy to academic training in the eighteenth and nineteenth centuries. However, her works are far from scientific in their presentation, frequently alluding to brutality and trauma, perhaps influenced by the time she spent in the mid 1980s working with New York's Emergency Medical Service. In later works, such as *Untitled (Arm and Leg)*, Smith treats body parts as if they are nothing more than objects, components in a constructed sculpture. Here she has presented an arm and a leg, lying incongruously in a gallery corner. The work alludes simultaneously to prosthetic parts and severed limbs, both left discarded and lying around, whilst the connecting chain is carefully arranged on the floor to resemble spilt blood or intestines. Smith's work explores the baseness of the body, transgressing the conventional modes deployed by artists for the representation of the human form.

CREATED

New York

MEDIUM

Cast iron, bronze and chain

SIMILAR WORKS

Untitled by Robert Gober, 1991–93

Kiki Smith *Born* 1954 Nuremburg, Germany

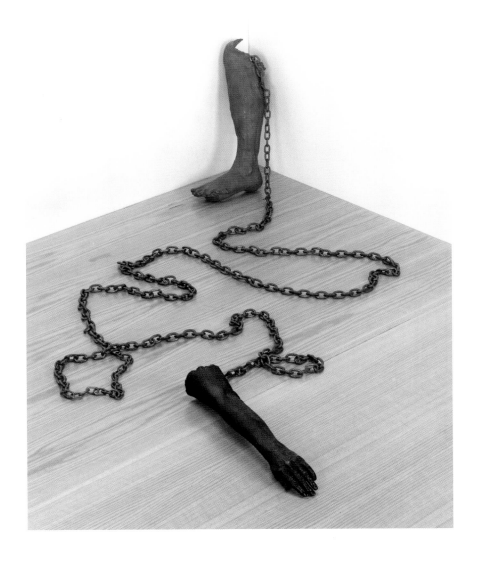

Viola, Bill

Incrementation, 1996

Courtesy of Christie's Images Ltd/© Bill Viola

From the first development of oil paints in the fifteenth century, to the invention of photography in the nineteenth century, artists have embraced technological developments and incorporated them into their art. In the 1960s, the development of video technology was also embraced by a number of artists. The Korean-born performance artist Nam June Paik (b. 1932) is usually accredited with being the founder of Video Art. However, Bill Viola has done most to develop the new medium. Throughout his career, Viola has used both video images and sounds to create installations that are contemplative and seek to address broader spiritual questions. Frequently invoking both Eastern and Western philosophies and religions, Viola has used video to explore the processes of thought and meditation in time. *Incrementation*, for example, consists of a wall-mounted monitor showing the artist's head. Alongside the monitor, an LED display counts off the artist's breaths in a never-ending sequence, thus drawing our attention to the stillness and simplicity of existence. Viola's most recent works are based upon Italian Renaissance paintings and utilize plasma screens and extreme slow motion to explore the very boundaries between the still and the moving image.

CREATED

California

MEDIUM

Laserdisc player, monitor and LED display sign

SERIES/PERIOD/MOVEMENT

Installation Art

SIMILAR WORKS

Global Groove by Nam June Paik, 1973

Bill Viola *Born* 1951 New York

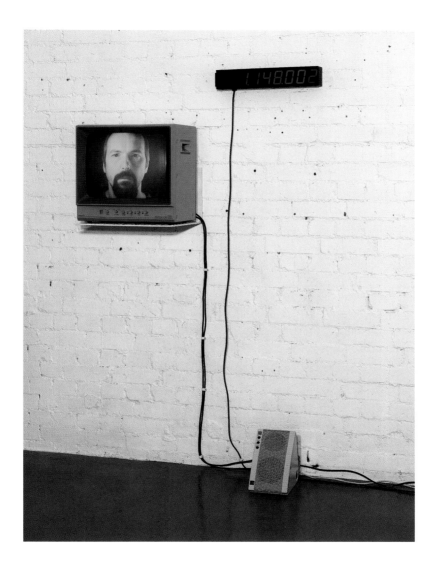

Turrell, James
The Light Inside, 1999

Since the 1960s, James Turrell has been creating works of art that have abandoned material form altogether. Instead he has focused upon the effects of light upon visual perception. Turrell originally studied Psychology at Pomona College, California. He also studied the effects of light on human perception with an experimental psychologist at the University of Texas. Turrell's early artistic experiments with light were conducted as part of The Light and Space Movement in Southern California. Artists associated with this created installations, often combining both natural and artificial light, that filled the spectator's field of vision and thus created a work of art into which the spectator could, literally, enter. Turrell's *The Light Inside* recreates an illusionary space that seems to entice the viewer into entering the work and experiencing it through time. It plays with the very processes of visual perception and, as Turrell himself claimed of his works, makes the spectator 'feel the physicality of light'. Turrell creates solid planes of light that are so palpable, you feel that you can reach out and touch them. As the critic Robert Hughes has evocatively described the experience: 'Turrell's art happens behind your eyes, not in front of them.'

CREATED

Houston, Texas

MEDIUM

Mixed media

SIMILAR WORKS

Line Describing a Cone by Anthony McCall, 1973

James Turrell *Born* 1943 Los Angeles, California

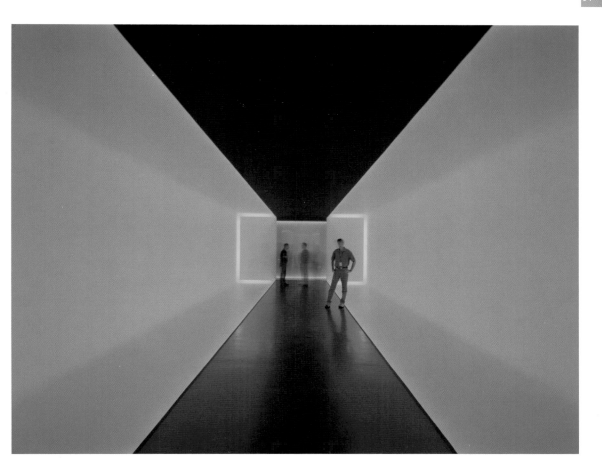

American Art

Society

Russell, Charles Marion
Buffalo Hunt, 1897

Courtesy of Private Collection, © Christie's Images/Bridgeman Art Library

When Charles Marion Russell was a child, he dreamed – like many of his contemporaries – of an adventurous life in America's Wild West. At the age of just 16 he left his native St. Louis to join a cattle ranch in Montana, before crossing the border into Canada, where he lived for a while with tribes of Native Americans. Initially Russell produced images of the West for popular journals like *Harper's* before turning to painting. Despite this first-hand experience, however, Russell's works offer a notably romantic vision of the West and yearn nostalgically for a life that was already passing. For example, when Russell painted *Buffalo Hunt* in 1897 – one of over 40 works produced by the artist on this subject – the sight of Native American hunters pursuing buffalo on the Western plains was a rare one indeed. In fact, the buffalo herds had already been largely decimated by white hunters, and the Native Americans were increasingly being forced on to reservations. Russell's vision was thus far from authentic, and conforms more to the mythical image of the Wild West that was widely disseminated throughout the United States at this time.

CREATED

Great Falls, Montana

MEDIUM

Oil on canvas

SIMILAR WORKS

The Buffalo Hunt by Frederic Remington, 1890

Charles Marion Russell *Born* 1864 St. Louis

Died 1926

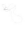

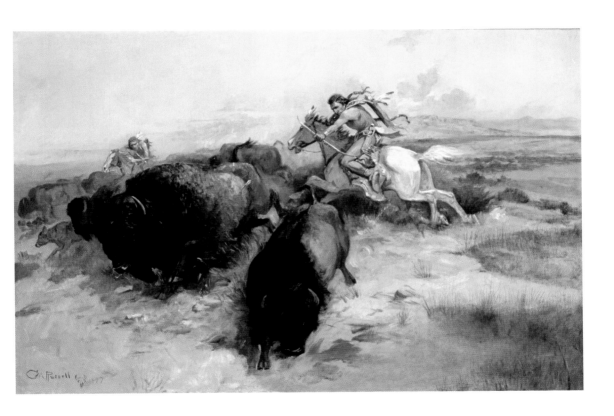

Eakins, Thomas

Between Rounds, 1899

In the late nineteenth century, the sport of boxing divided popular opinion and generated much debate in the press. For some, it was a noble sport, an appropriate 'manly' activity to be encouraged. For others, it symbolized a violence and brutality that had no place in modern society. Turn-of-the-century America has frequently been associated with a 'cult of masculinity', partly in response to a mythology of the Wild West and partly as a reaction against the emerging women's movement. Whatever position was adopted, however, boxing aptly symbolized one of the key anxieties of the era. Thomas Eakins was very much a supporter of masculine, physical activities and, in 1899, produced one of the classic boxing paintings, *Between Rounds*. Here, Eakins particularly focused upon boxing as a spectator sport, equating it with theatrical events, as can be seen by his emphasis on theatre posters and the tiered audience. He was also at pains to stress the orderliness of the contest, including both a timekeeper and a policeman in the background. Eakins' *Between Rounds* later inspired the Ashcan School artist George Bellows, whose boxing paintings focus upon the more brutal aspects of this controversial sport.

CREATED

Philadelphia, Pennsylvania

MEDIUM

Oil on canvas

SIMILAR WORKS

Both Members of this Club by George Bellows, 1909

Thomas Eakins *Born* 1844 Philadelphia, Pennsylvania

Died 1916

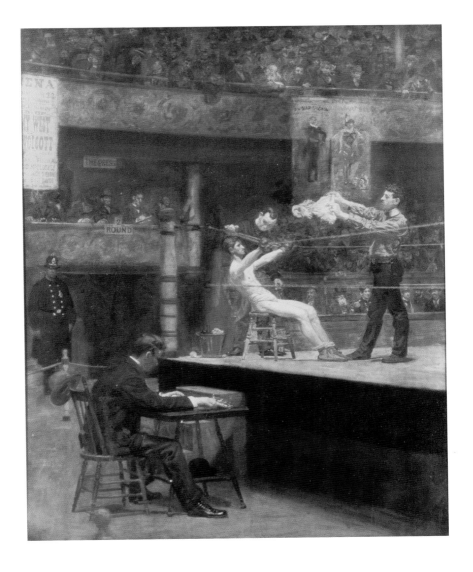

Maurer, Alfred

Carousel, 1904

In the early twentieth century, a trip to Europe was considered a practical necessity for any budding young artist, and Alfred Maurer was no exception. In 1897, after a decade of studies at New York's National Academy of Design, Maurer set off for Paris, where he briefly studied at the Academie Julien. The French capital was very much to the taste of the young artist and he remained there until 1914 when the outbreak of war forced his return to the United States. During his Paris sojourn Maurer gained success both abroad and back home, exhibiting at the Paris Salon and at exhibitions in Chicago, Philadelphia and New York. In Paris he produced many works depicting scenes of everyday life, including *Carousel*. Here Maurer depicts a crowd of men, women and children in one of the public parks in Paris, enjoying a leisurely day out and taking advantage of the new urban entertainments. Maurer's scenes of everyday life drew heavily on the work of French artists, including Edgar Degas (1834–1917) and Edouard Manet (1832–83). When shown back in the United States they forged a link between these European masters and the emerging realism of the Ashcan School.

CREATED

Paris, France

MEDIUM

Oil on cardboard

SIMILAR WORKS

The Picnic Grounds by John Sloan, 1906–07

Alfred Maurer *Born* 1868 New York

Died 1932

Bellows, George Wesley

Stag at Sharkey's, 1917

Throughout his career, the Ashcan School artist George Bellows was always attracted to the darker, grittier aspects of city life. He developed a particular fascination for boxing, and regularly attended fights at a local saloon run by an Irishman by the name of Tom Sharkey. Here he witnessed the sheer brutality of the sport as it was practised in the early twentieth century. In 1909 Bellows produced several boxing paintings, including one entitled *Stag at Sharkey's*. This later lithograph replicates the original composition. Here Bellows places the spectator in the thick of the action, at ringside amongst a motley crowd whose faces appear twisted and contorted in the low light of the boxing ring. The fighters themselves – anonymous, faceless combatants – are loosely executed with rapidly applied marks, thus capturing the immense physical effort of the battle. The rawness of their flesh resembles meat in a packing factory and Bellows abandons any sense of grace or dignity in this grim contest. For Bellows this Darwinian struggle for the survival of the fittest acted as an appropriate metaphor for the everyday struggle for survival among the often poverty-stricken inhabitants of early twentieth-century New York.

CREATED

New York

MEDIUM

Lithograph

SERIES/PERIOD/MOVEMENT

Ashcan School

SIMILAR WORKS

Between Rounds by Thomas Eakins, 1899

George Wesley Bellows *Born* 1882 Columbus, Ohio

Died 1925

Rockwell, Norman

Are We Downhearted?, 1917

Courtesy of Private Collection/Bridgeman Art Library/© Estate of Norman Rockwell

In 1916, when Rockwell was still in his early twenties, he produced a cover that was accepted for the *Saturday Evening Post*, one of America's largest circulation magazines. From that point onwards, he produced hundreds of illustrations for popular journals and became one of the most widely known artists in the United States. His artistic objectives were clearly defined, and he described his work as 'this best-possible-world, Santa-down-the-chimney, lovely-kids-adoring-their-kindly-grandpa sort of thing'. Rockwell's work has frequently been critically dismissed as excessively sentimental, and it is certainly true that he mostly paints an idealized vision of American life, avoiding darker subjects, though he did later produce a powerful series of images exploring racism in the United States. *Are We Downhearted?* was created shortly after the United States entered the First World War. It is, nonetheless, a highly optimistic vision of American servicemen, whose buoyant spirits and happy expressions belie the dangers that they are imminently facing. Significantly, the work was reproduced in *Life* magazine on 28 November 1918, just two weeks after the end of the conflict.

CREATED

New York

MEDIUM

Illustration for *Life* magazine

SERIES/PERIOD/MOVEMENT

First World War

SIMILAR WORKS

Portrait of a German Officer by Marsden Hartley, 1914

Norman Rockwell *Born* 1894 New York

Died 1978

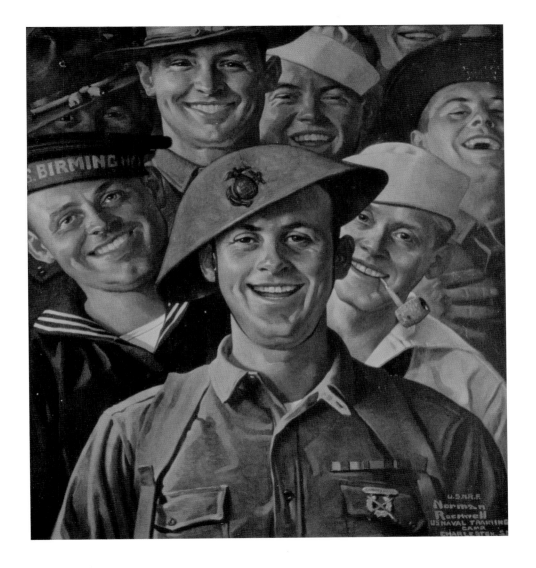

Bellows, George Wesley
The Ghost of Sergeant Kelly, 1918

The United States entry into the First World War in 1917 divided political opinion. Many on the left feared that the ordinary foot soldier would be used as little more than cannon fodder to prop up capitalism. Others, however, bitterly opposed German imperialism and strongly supported intervention. During the last year of the conflict, Bellows produced a number of works highlighting the atrocities of war. These were clearly based on Francisco de Goya's (1746–1828) *Disasters of War* etchings, produced in response to the Napoleonic Wars, and proffered an unflinching condemnation of the depravity and bestiality brought about by war. In *The Ghost of Sergeant Kelly*, Bellows depicts two soldiers wrestling each other in hand-to-hand combat. This close, physical struggle recalls Bellows' boxing pictures of a decade earlier, with their emphasis on the struggle for the survival of the fittest. The combatants fight in the midst of a pile of mutilated corpses, their pallid forms silhouetted against a leaden sky. Bellows' image also notably recalls the later war paintings and engravings by the German artist Otto Dix (1891–1969).

CREATED

New York

MEDIUM

Watercolour and crayon on paper

SERIES/PERIOD/MOVEMENT

First World War

SIMILAR WORKS

War Portfolio by Otto Dix, 1924

George Wesley Bellows *Born* 1882 Columbus, Ohio

Died 1925

Fuller, Meta Vaux Warrick

Ethiopia, 1921

Courtesy of Photo: Manu Sassoonian/Schomburg Center/The New York Public Library/© Estate of Meta Warrick Fuller

Meta Vaux Warrick Fuller's *Ethiopia* is, in many respects, an apt precursor to the Harlem Renaissance. Produced in 1921, a few years before Harlem was officially declared the 'Mecca of the New Negro', Fuller's allegorical sculpture is reminiscent of the work of Augustus Saint-Gaudens (1848–1907), under whom she had studied. She also studied under Auguste Rodin (1840–1917) in Paris. However, while many of her contemporaries looked to Ancient Greece as a source of inspiration, Fuller turned her attention to Ancient Egypt. *Ethiopia* refers explicitly to ancient funerary sculpture and represents an Egyptian noblewomen casting off the bandages of the dead. By associating this metaphorical rebirth with the legacy of Ancient Egypt, Fuller was reinforcing a link between modern African-Americans and the heritage of Ancient Egypt, the birthplace of civilization, and thus engaging with the Pan-Africanism widely espoused by the writer W. E. B. Du Bois. Fuller's specific reference to Ethiopia also carried important connotations in the wake of the nation's defeat of Italy in 1896. In this wider context, *Ethiopia* provided a message of hope for the rebirth of a new African-American culture, emerging from the shadow of slavery's dark past.

CREATED

Framingham, Massachusetts

MEDIUM

Plaster

SIMILAR WORKS

Forever Free by Sargent Johnson, 1935

Meta Vaux Warrick Fuller *Born* 1877 Philadelphia, Pennsylvania

Died in 1968

Benton, Thomas Hart
The Steel Mill, 1930

Courtesy of Christie's Images Ltd/© Estate of Thomas Hart Benton

In the early twentieth century, America's international reputation was largely founded upon its industrial expertise and output. In the years following the First World War, corporate capitalism reigned supreme and the production-line ethos, brought in by Henry Ford and F. W. Taylor, led to an explosion in manufacturing. The Wall Street Crash of 1929, however, brought much of this industry and prosperity to an end, and the subsequent Great Depression led to widespread industrial shutdowns, major strikes and mass unemployment. By 1932 steel production had dropped to a mere fraction of its pre-1929 volume. In this context, Thomas Hart Benton's depiction of a steel mill working at full tilt carried strong political resonances. Benton's work is neither a celebration nor a condemnation of American industry. While ignoring the reality of closing factories and the subsequent social destitution, Benton's work extols the sheer energy and force of industry. Yet his diminutive workers, silhouetted against the infernal smoke stacks of an energy as powerful as nature itself, appear as little more than anonymous minions, mere cogs in the wheels of powerful industry.

CREATED

New York

MEDIUM

Oil on canvas

SERIES/PERIOD/MOVEMENT

Depression Era

SIMILAR WORKS

Detroit Industry mural by Diego Rivera, 1933

Thomas Hart Benton *Born* 1889 Neosha, Missouri

Died 1975

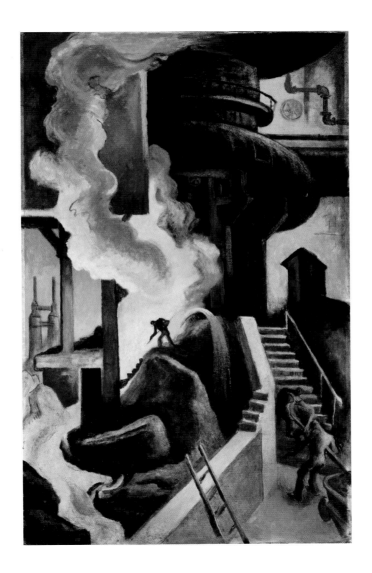

Curry, John Steuart
Medicine Man, 1931

John Steuart Curry was one of the least likely of the Regionalist painters. He was certainly born on a farm in the Midwest. He also spent the last decade of his short life working as artist-in-residence at an agricultural college in Wisconsin. However, from the late 1910s to the mid 1930s – his most active years as an artist – Curry moved between the sophisticated urban centres of Chicago, Paris and New York. Despite this, he never lost sight of his native roots and used them as a subject for his art throughout his career. In *Medicine Man*, he depicts a travelling salesman advertising his wares, an elixir called 'Aquavita', the water of life, to a small-town community. His extravagant performance, enhanced by dramatic lighting and the use of flares seems to captivate the audience. However, this excess of drama leads us to believe that his wares are of dubious value, and it is only the quaint naivety of the unsophisticated audience that will bring the salesman success. Curry thus positions us as a spectator down amongst this crowd, allowing us to participate within the notional innocence of the local audience, while simultaneously maintaining our urban, sophisticated and sceptical distance.

CREATED

New York

MEDIUM

Oil and charcoal on canvas

SERIES/PERIOD/MOVEMENT

Regionalist

SIMILAR WORKS

America Today mural by Thomas Hart Benton, 1930

John Steuart Curry *Born* 1897 near Dunavant, Kansas

Died 1946

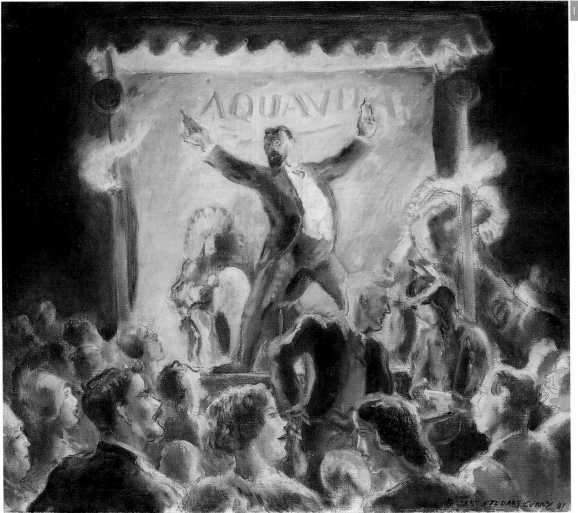

Shahn, Ben

Sacco and Vanzetti, 1931–32

The widespread collapse of the American economy brought about by the Wall Street Crash of 1929 had a devastating effect upon the art market, and a large number of artists were forced to join the ranks of the unemployed. In response to these desperate circumstances, many painters abandoned the avant-garde experimentalism of the early twentieth century in favour of a more realist-inspired art addressing the social concerns of the day. Ben Shahn was one of the most prominent of the left-wing Social Realist artists to emerge at this time. Shahn was obsessed with exposing injustice and, in the early 1930s, produced over two-dozen works representing two Italian-Americans by the name of Nicola Sacco and Bartolomeo Vanzetti. In 1920, Sacco and Vanzetti had been tried and found guilty of murder following a robbery at a Massachusetts shoe factory. They were condemned to death and executed in 1927. It was widely believed, however, that they were innocent and had been arrested because of their left-wing political beliefs. Shahn's works set out to promote their cause, presenting them as martyrs and victims of the political oppression of the American justice system.

CREATED

New York

MEDIUM

Oil on canvas

SERIES/PERIOD/MOVEMENT

Social Realist

SIMILAR WORKS

Employment Agency by Isaac Soyer, 1937

Ben Shahn *Born* 1898 Kavno, Lithuania

Died 1969

Jones, Lois Mailou

Les Fétiches, 1938

The publications of several influential African-American writers and activists, including W. E. B. Du Bois, Alain Locke and Marcus Garvey, brought the issue of race to the forefront of the American consciousness in the early twentieth century. In 1919, when the all African-American 369th Regiment, recently returned from duty in the First World War, paraded down New York's Fifth Avenue, many hoped for the dawning of a new era of equal opportunities. Harlem, the centre of New York's African-American community, now became a mecca for artists, writers and musicians. Lois Mailou Jones was amongst the artists who emerged during this cultural renaissance. Jones spent time in Paris and became aware of European artists' interest in African masks. The incorporation of these into works such as *Les Fétiches* reflected her awareness of this interest. More importantly, however, Jones' conflation of modern painting techniques with African masks engaged with the wider notion of dual identity, or double-consciousness – the sense of simultaneously being both African and American. This idea had earlier been explored by Du Bois in his 1903 publication *The Souls of Black Folks*.

CREATED

Paris, France

MEDIUM

Oil on canvas

SERIES/PERIOD/MOVEMENT

Harlem Renaissance

SIMILAR WORKS

Fetish and Flowers by Palmer Hayden, 1926

Lois Mailou Jones *Born* 1805 Boston, Massachusetts

Died 1998

Lawrence, Jacob

John Brown Formed an Organization Among the Colored People of Adirondack Woods, 1941

Jacob Lawrence was born in the south but travelled north during the Great Migration, the mass exodus of millions of African-American workers from the cotton-picking regions of the southern states to the urban centres of Chicago and New York. Growing up in Harlem, Lawrence studied at the Harlem Art Workshop and also attended lectures in African-American history in the home of the historian Charles Seifert. Many of Lawrence's works, including this depiction of the nineteenth-century Abolitionist John Brown, engaged directly with major events in African-American history. He also produced a series of works recounting the life of the slave rebel and founder of Haiti, Toussaint L'Ouverture. Lawrence's most famous work, however, was the series of 60 panels he produced charting the history of the Great Migration. Known as the *Migration Series*, these works were executed in Lawrence's unique pictorial language, which he referred to as 'dynamic cubism'. Like the work illustrated here, this style uses simple, angular forms executed in bright, flat colours reminiscent of modern European painting. This, however, also gives the works a stillness, a sense of order and harmony, simultaneously reminiscent of Ancient Egyptian frieze painting.

CREATED

New York

MEDIUM

Gouache on paper

SIMILAR WORKS

Going to Church by William H. Johnson, *c.* 1940–41

Jacob Lawrence *Born* 1917 Atlantic City, New Jersey

Died 2000

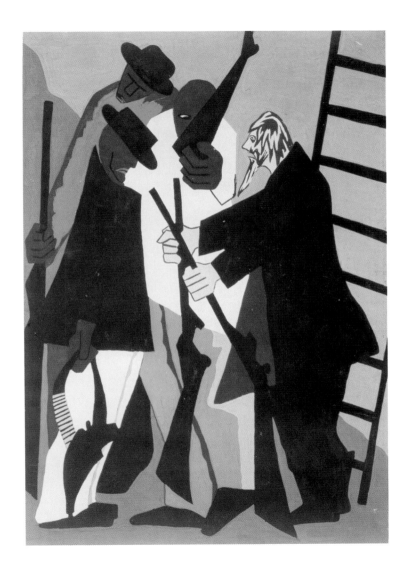

Shahn, Ben

This is Nazi Brutality, 1942

When the United States entered the Second World War in December 1941 the impact was felt throughout society. The Great Depression had resulted in many artists gaining state support through the WPA programme. As the economy recovered, with the increased demands for weapons, many artists lost the financial support of the state. Some, however, argued that artists were needed by the state more than ever in a time of war, particularly to produce anti-fascist propaganda material. Thus, in the autumn of 1942 the newly formed Office of War Information hired Ben Shahn to produce a series of posters supporting the war effort. Shahn produced many posters, but only two were accepted. One of these, entitled *This is Nazi Brutality*, is an explicit condemnation of Nazi atrocities in what was then Czechoslovakia, recounting the decimation of the village of Lidice. Shahn's forceful image shows an imprisoned victim, handcuffed, hooded and placed before an enormous wall, presumably in the moments before his execution. The huge, tightly clenched fists dominate the image and suggest both the power and the continual resistance of the masses in the face of such terror.

MEDIUM

Poster

SERIES/PERIOD/MOVEMENT

Second World War

SIMILAR WORKS

Exterminate (from the series *The Year of Peril*) by Thomas Hart Benton, 1942

Ben Shahn *Born* 1898 Kavno, Lithuania

Died 1969

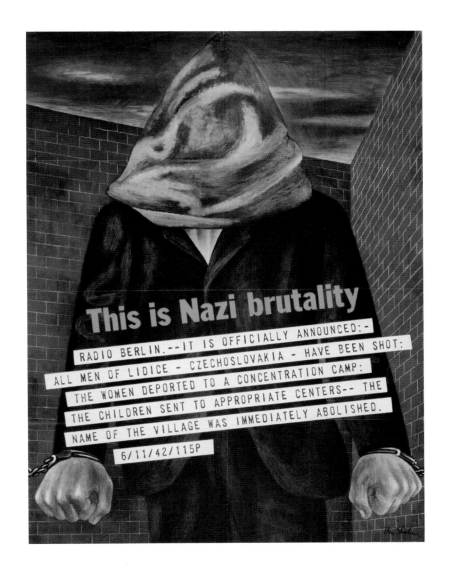

Pollock, Jackson

Lavender Mist, 1950

Abstract Expressionism first came to prominence in the years immediately following the Second World War. Its best-known practitioner was Jackson Pollock who, following the publication of an article in *Life* magazine in 1949, rapidly became a household name. Pollock's *Lavender Mist* is the culmination of his famous 'drip' technique. The work is made up of layers of poured and dripped paint, creating a network of webs of colour. It has no centre, no top or bottom, but runs to the very margins of the canvas, as if continuing into infinity. At the same time, the tiny detail and exquisitely produced skeins of colour draw the eye into the very heart of the painting so that it seems to suggest both the microcosmic and the macrocosmic. Pollock's *Lavender Mist* can be related to the social circumstances of early Cold War America. At a time when global conflict and widespread fears of imminent nuclear annihilation were uppermost in the minds of many American citizens, Pollock's tense, fragile surfaces, described by one critic as at the edge of their own destruction, can be read as metaphors for the profound tensions and anxieties of the age in which they were produced.

CREATED

Long Island, New York

MEDIUM

Oil on canvas

SERIES/PERIOD/MOVEMENT

Abstract Expressionism

SIMILAR WORKS

Spring by Hans Hofmann, 1940

Jackson Pollock *Born* 1912 Cody, Wyoming

Died 1956

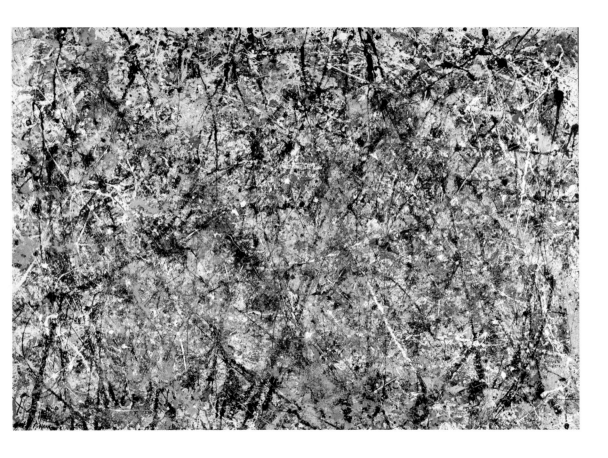

Noguchi, Isamu
Big Boy, 1952

Isamu Noguchi's sculptural work embraced both figuration and abstraction, and absorbed a wide range of influences from Europe, the United States and Japan. In the 1920s, he travelled to Paris and worked as an assistant to the Romanian sculptor Constantin Brancusi (1876–1957). Like Brancusi, Noguchi produced highly polished, abstract sculptures carved in stone or cast in metal. However, he also retained a strong figurative emphasis in his work, not least of all in a piece he produced in 1934 entitled *Death*. The work represents the contorted and still-suspended body of a lynched African-American. Noguchi's awareness of the racial injustices of the United States were further increased after the Japanese invasion of Pearl Harbor in 1941, when he was interned as an enemy alien. Noguchi's *Big Boy* also alludes to the theme of victimhood. Here, Noguchi represents a figure with all four limbs outstretched. The head has been displaced to the torso and the posture suggests torture, or even crucifixion. The large costume recalls a Japanese kimono, yet also gives the work a more abstract form, breaking up the contours of the body.

CREATED

New York

MEDIUM

Bronze

SERIES/PERIOD/MOVEMENT

Abstract Sculpture

SIMILAR WORKS

Storm Man by Germaine Richier, 1947–48

Isamu Noguchi *Born* 1904 Los Angeles, California

Died 1988

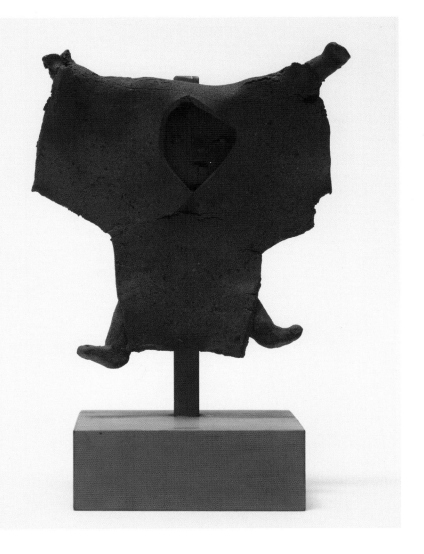

Rockwell, Norman

Waiting for the Vet, 1952

Courtesy of Private Collection, © Christie's Images/Bridgeman Art Library/© Estate of Norman Rockwell

By the early 1950s, Norman Rockwell's fans were legion and his cover illustrations for the *Saturday Evening Post* still constituted the most popular art in the United States. *Waiting for the Vet*, first published as the cover of the issue for 29 March 1952, represents a small boy and his equally ragamuffin dog seated in the waiting-room of a veterinarian surgery. Both boy and dog are isolated and seem highly self-conscious, surrounded by other dog owners with their pets. Here Rockwell has deployed the familiar trope to suggest that dogs physically resemble their owners, but with an added class antagonism. Indeed the other dogs, as well as their owners, seem to express considerable disapproval of the youngster and his charge, whose injury, we might assume, is the result of clumsiness (the boys shoelaces are notable untied) or ill-behaviour. Here, however, Rockwell's sympathies clearly lie with the youngster, whose determination to care for his injured companion resists this social pressure. It is also, perhaps, no coincidence that this representation of loyalty and comradeship in the face of opposition was produced in the midst of the Korean War, when such values were widely promoted as essential to American national identity.

CREATED

Arlington, Vermont

MEDIUM

Illustration from *The Saturday Evening Post*

RELATED WORK

Cape Cod Morning by Edward Hopper, 1950

Norman Rockwell *Born* 1894 New York

Died 1978

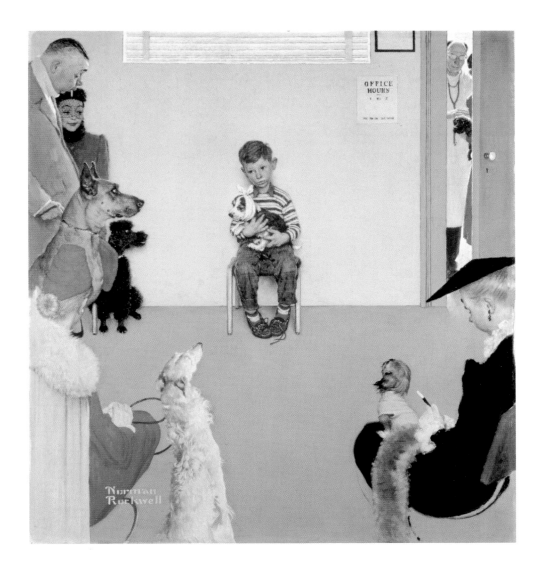

Rivers, Larry

Washington Crossing the Delaware, 1953

Emanuel Leutze's *Washington Crossing the Delaware* (1851) is one of the most famous and familiar paintings in the United States. In 1952, it was displayed in a special exhibition to celebrate the 175th anniversary of this historic moment. The event, held at the site of the famous crossing, was widely reported in the press. It was certainly no coincidence that this overt celebration of a military hero leading his nation to triumph should have taken place in the midst of the Korean War. Nor was it a coincidence that such a patriotic gesture should have been enacted at a time when Senator Joseph McCarthy was conducting his anti-communist witch-hunts, attempting to condemn his enemies as 'un-American'. All of this makes Larry Rivers' 1953 reworking of Leutze's original all the more striking and daring. Rivers' Washington, all but lost in a mist of painterly gestures and muddy pigments, is a parody of Leutze's original. Its critique, however, extends beyond excessive heroism. By reintroducing the figurative dimension into his work and by parodying popular symbols, Rivers paved the way for the emergence of Pop Art in the 1960s.

CREATED

New York

MEDIUM

Oil on canvas

SIMILAR WORKS

Washington Crossing the Delaware by Roy Lichtenstein, *c.* 1951

Larry Rivers *Born* 1923 New York.

Johns, Jasper

Target with Four Faces, 1955

America in the 1950s was, in many respects, a nation in the thrall of fear and paranoia. The tensions of the early Cold War, exacerbated by military conflict in Korea, spread into every aspect of daily life – from the televized pictures of Senator McCarthy's anti-communist witch-hunts, to science fiction movies metaphorically recounting alien invasion. Even the promotion of the somewhat optimistic defensive technique of 'duck and cover' served only to keep such fears at the very forefront of American citizens' minds. In this climate, Johns' series of works representing targets carried clear political resonances. In this work, Johns also included four plaster casts of heads, confined in box-like structures, their eyes covered in a manner reminiscent of the widespread images of witnesses to nuclear testing. However, Johns' target and confined figures might also signify another important social factor. Homophobia was particularly rapacious in 1950s America, making gay men a target of widespread social condemnation. Johns, himself a gay man who kept his sexuality private, may here be alluding to this circumstance.

CREATED

New York

MEDIUM

Encaustic and collage on canvas with plaster and wood

SERIES/PERIOD/MOVEMENT

Cold War Era

SIMILAR WORKS

Song by Kenneth Noland, 1958

Jasper Johns *Born* 1930 Augusta, Georgia

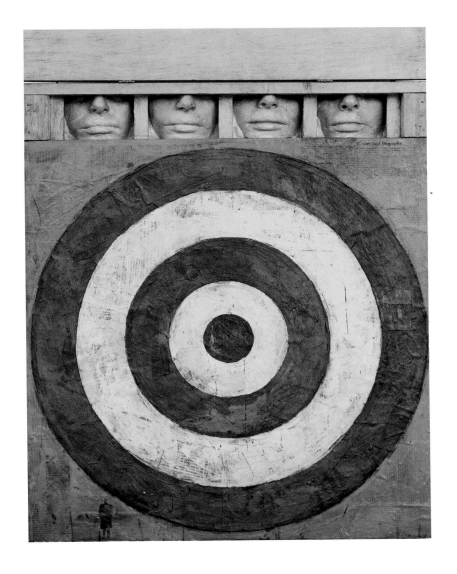

Rothko, Mark

Untitled, 1961

By the early 1960s, Abstract Expressionism was no longer at the cutting edge of artistic activity. Now, younger artists, including Rivers, Johns and Robert Rauschenberg (b. 1925), whose works self-consciously countered Abstract Expressionism, were in the vanguard. Despite this shift, Mark Rothko continued to produce atmospheric Colour Field paintings that strove to escape the realities of the contemporary political climate and to evoke a more spiritual sense of being. Institutionally, however, Abstract Expressionism had now come to serve important political ends for the US government. Since the late 1950s Abstract Expressionism had been widely promoted in the international arena, frequently with covert state support. It was seen as potentially symbolic of core American values such as individuality and freedom of expression, and could thus be presented as a stark contrast to the state control practised by the Soviet authorities. Although it was never the intention of Abstract Expressionist artists to have their works deployed as political weapons, this, it has been widely argued, was to be their fate during the increasing tensions of the developing cultural Cold War.

CREATED

New York

MEDIUM

Oil on canvas

SERIES/PERIOD/MOVEMENT

Abstract Expressionist

SIMILAR WORKS

Untitled by Clyfford Still, 1957

Mark Rothko *Born* 1903 Dvinsk, Lithuania

Died 1970

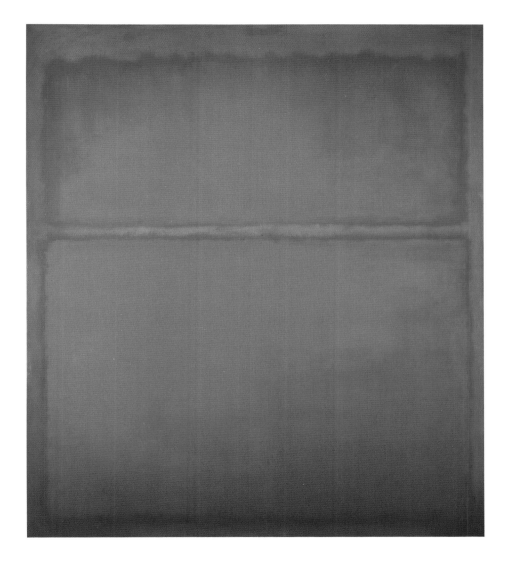

Oldenburg, Claes
Floor Burger, 1962

The artistic representation of food has long been part of the still-life tradition. In the post-Second World War era, many American artists also represented food in their works, though now much emphasis was placed on the culinary products of American mass culture – the hot dog, Coca Cola and the hamburger. In 1962, Claes Oldenburg produced one of the most dramatic of these works, exhibiting a giant hamburger, made from painted canvas stuffed with foam rubber and placed directly on the gallery floor. Oldenburg's inflated representation of American fast food was more than a simple joke. Like many of his Pop Art compatriots, Oldenburg engaged directly with the products of the post-war consumer boom, taking them as a serious subject for his work. His giant *Floor Burger* can thus be read as a parody of the expansion of fast-food outlets in the 1950s and early 1960s, the era of the first drive-in burger bars and the expansion of franchised companies like McDonald's, Burger King and Wendy's. In their competition for trade, ambitious advertising claims were made about who offered the biggest bun or the largest patty. In 1962 the answer was easy. It was Claes Oldenburg.

CREATED

New York

MEDIUM

Acrylic on canvas filled with foam rubber and cardboard boxes

SIMILAR WORKS

Five Hot Dogs by Wayne Thiebaud, 1961

Claes Oldenburg *Born* 1929 Stockholm, Sweden

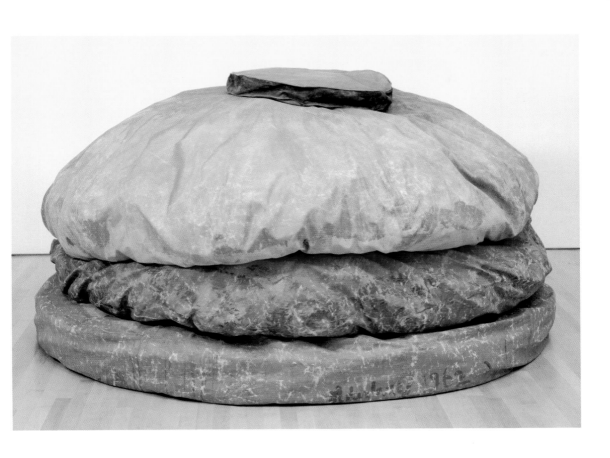

Rauschenberg, Robert

Untitled, 1964

The inauguration of John F. Kennedy as President of the United States in January 1961 launched a new era in American history. Kennedy has often been credited as recognizing the power of television. His assassination in November 1963 proved just how powerful the new medium had become. For four days all normal programming was suspended as the horrific event was played over and over on television screens throughout the nation. The American people also watched in horror as the chief suspect, Lee Harvey Oswald, was himself assassinated, live on air. Robert Rauschenberg's response to these events was to incorporate the image of the president into a series of collage-like works, combining oil paint, silkscreen printing and other media. In these works, Kennedy's image was duplicated, printed upside-down and juxtaposed with other photographs. In *Untitled*, the image in the lower left shows an astronaut's parachute, while a weather gauge can be seen centre-top. The deliberate graininess of these images replicates the experience of watching the assassination unfold on the television screen, and the stark juxtaposition of images alludes to the collage of ever-changing images typical of 1960s' news broadcasts, or of the visual experience of constantly changing television channels.

CREATED

New York

MEDIUM

Print

SIMILAR WORKS

Instant On by Ed Kienholz, 1964

Robert Rauschenberg *Born* 1925 Port Arthur, Texas

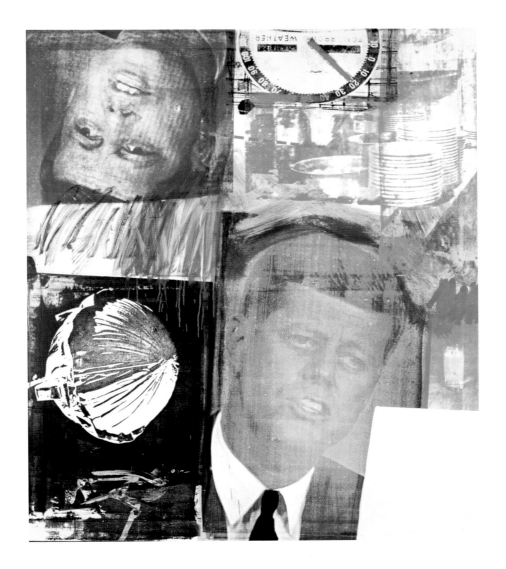

De Kooning, Elaine
Untitled, 1965

The history of Abstract Expressionism has often been written with a significant emphasis on the activities of male artists such as Jackson Pollock, Barnett Newman (1905–70) and Willem de Kooning (1904–97). However, many female Abstract Expressionists, including Helen Frankenthaler (b. 1928), Grace Hartigan (b. 1922), Lee Krasner (1908–84), Joan Mitchell (1926–92) and Elaine de Kooning, have been largely overlooked. Notions of aesthetic quality have frequently been invoked to justify this prioritizing of the male canon. However, others have convincingly argued that this relegation of women artists' achievements is more symptomatic of the conventional gender roles ascribed during the 1950s and 1960s. Elaine de Kooning, for example, was most commonly recorded as the wife of the painter Willem de Kooning rather than as a painter in her own right. This small sketch shows her capacity to produce powerful, evocative landscapes in the bold painterly style typical of Abstract Expressionism. A year later, de Kooning was a key participant in the famous Los Angeles *Peace Tower*, an unofficial project supported by over 400 artists to express their opposition to the war in Vietnam.

MEDIUM

Gouache on paper

SERIES/PERIOD/MOVEMENT

Abstract Expressionist

SIMILAR WORKS

Hemlock by Joan Mitchell, 1956

Elaine de Kooning *Born* 1919 Brooklyn, Pennsylvania

Died 1989

Warhol, Andy
Big Electric Chair, 1967

Death and destruction have long been important subjects explored by artists. In the mid 1960s, Andy Warhol approached this theme in his series of silkscreen prints derived from a simple photograph of a sparse, empty room, at the centre of which sits an unoccupied electric chair. The work highlights the absurdity of this chair, whose function has shifted from object of human comfort to tool of destruction, whilst simultaneously alluding to the perverted uses to which technology has now been deployed. Warhol was aware that most modern industrial nations had abolished the death penalty by the mid 1960s, and that no other nation used electrocution as a punishment. In the United States, however, over 900 such executions had taken place since the beginning of the 1950s. Here, the absence of a figure makes Warhol's work all the more disturbing, as the chair silently awaits its next victim. By offering the spectator this voyeuristic view into the torture chamber, Warhol also forces us to confront the dark side of the American dream, and the crude printing process echoes the mechanical nature of this modern, terrifying means of human destruction.

CREATED

New York

MEDIUM

Synthetic polymer and silkscreen inks on canvas

SIMILAR WORKS

Soft Toilet by Claes Oldenburg, 1966

Andy Warhol *Born* 1928 Pittsburgh, Pennsylvania

Died 1987

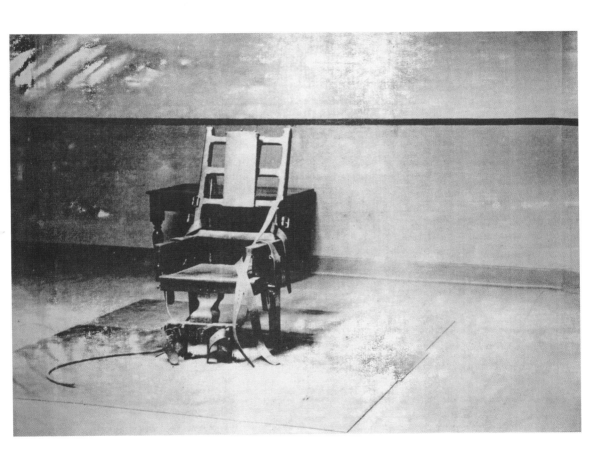

Kienholz, Edward
The Eleventh Hour Final, 1968

Ed Kienholz's idiosyncratic assemblage sculptures challenged both social and artistic conventions. His works incorporate real objects, the detritus of the consumer society of modern America, to create whole environments designed to raise key questions about major political issues. Among his best works are those attacking the war in Vietnam, such as *The Eleventh Hour Final*. The Vietnam War was the first conflict in which television images were beamed daily into the homes of those back home. Responding to this fact, Kienholz presents a television set as the centrepiece of a domestic living room, its wooden console notably transformed into a concrete slab reminiscent of a tombstone. Where the inscription would normally be, however, the screen transmits the message 'American Dead – 217, American Wounded – 563, Enemy Dead – 435, Enemy Wounded – 1291'. Such statistics were regularly issued in the last news bulletin of the day, broadcast at the eleventh hour, thus reducing the conflict to a gruesome game of numbers, in which America is always coming out on top. Kienholz's work thus deliberately parodies the television set as the innocent purveyor of news, highlighting how such news is controlled and manipulated by the political authorities.

CREATED

Los Angeles

MEDIUM

Mixed media

SIMILAR WORKS

Lipstick Ascending on Caterpillar Tracks by Claes Oldenburg, 1969

Edward Kienholz *Born* 1927 Fairfield, Washington

Died 1994

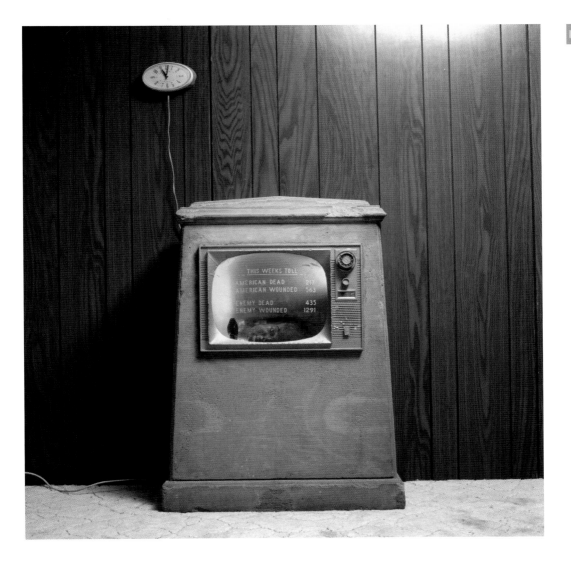

Rosenquist, James
Untitled, 1969

James Rosenquist's early experiences as a billboard painter provided the impetus for his later Pop Art works, many of which specifically addressed the changing visual landscape of 1950s and 1960s America. The post-war economic boom had facilitated the expansion of advertising in towns and cities throughout the nation, as well as contributing to the growing number of billboards erected alongside highways. These monumental images frequently adopted brash, eye-catching colours and slick finishes. Designed to be taken in at a glance, they provided little more than fragmentary glimpses of a clichéd world of consumerism. Rosenquist's *Untitled* draws extensively upon this aesthetic language. Here we see a colossal, but notably elegant, female hand, executed with the slick finish of a black-and-white photograph, holding what appears, at first glance, to be a cleaning brush. Or is it the decorative fringe of a piece of material, being gently and sensually caressed? This object is painted in hot, acid colours to match the lurid pink background, and to ensure immediate visual attention. Rosenquist's images, with their simultaneous visual intensity and narrative irrationality generate a sense of instability and disorientation – a mood widely regarded as characteristic of early post-war consumerist America.

CREATED

New York

MEDIUM

Acrylic on canvas

SERIES/PERIOD/MOVEMENT

Pop Art

SIMILAR WORKS

Still-Life #24 by Tom Wesselman, 1962

James Rosenquist *Born* 1933 Grand Falls, North Dakota

Art Workers' Coalition

Q: And Babies? A: And Babies, 1970

By the mid 1960s, opposition to the war in Vietnam was spreading throughout the United States. This was further exacerbated in 1968 when 583 women, children and elderly Vietnamese citizens were killed by US infantrymen in the notorious My Lai massacre. In the wake of this atrocity, the Poster Committee of the Art Workers' Coalition, a collective of art-activists, anonymously issued a poster entitled *Q: And Babies? A: And Babies*. The poster reproduced a famous photograph by the photojournalist Ronald Haeberle, which had previously been published in *Life* magazine, that showed, in graphic detail, the victims of the My Lai massacre. Over the image, inscribed in blood-red letters, are the words taken from an interview between an American journalist and a participant in the massacre. The Art Workers' Coalition intended the poster to be distributed by the Museum of Modern Art, but intervention from the Museum's President of the Board of Trustees prevented this from occurring. In protest at this decision, members of the Coalition distributed 50,000 copies of the poster worldwide. They also staged a widely publicized demonstration in front of the Museum of Modern Art's most famous anti-war icon, Pablo Picasso's *Guernica*.

CREATED

New York

MEDIUM

Offset lithograph

SERIES/PERIOD/MOVEMENT

War Protest

SIMILAR WORKS

Los Angeles Peace Tower, 1966

Hanson, Duane

Young Woman Shopper, 1973

In the late 1960s, Duane Hanson began work on a series of sculptures inspired by the Superrealist paintings of Chuck Close (b. 1940) and Richard Estes (b. 1936). Striving to replicate the styleless veracity of Superrealism, Hanson made casts of real bodies to produce life-size resin and polyvinyl models. He then added human hair, dressed the models in real clothes and staged them with real props. In these early works, Hanson focused upon the dark side of American society, creating tableaux representing the Vietnam conflict and race riots. After 1970, however, he turned to ordinary everyday figures; tourists, security guards or, as seen here, shoppers. Hanson's focus on mundanity and drudgery offered a commentary of the harsh realities of life in urban America. As he stated, 'The subject matter that I like best deals with the familiar lower and middle class American types of today. To me the resignation, emptiness and loneliness of their existence captures the true reality of life for these people'. Hanson's hyper-real sculptures, barely distinguishable from real people, can create a disturbing, destabilizing effect when encountered in their museum context.

CREATED

Miami, Florida

MEDIUM

Cast polyvinyl, polychromed in acrylic with hair and cloth

SERIES/PERIOD/MOVEMENT

Superrealist

SIMILAR WORKS

'61 Pontiac by Robert Bechtle, 1968–69

Duane Hanson *Born* 1925 Alexandria, Minnesota

Died 1996

Rosenquist, James

F1–11, 1974

In the mid 1950s James Rosenquist travelled to New York to study at the Art Students League, where he met many of the artists who later featured prominently in the Pop Art movement. It was also around this time that Rosenquist got a job painting enormous advertising billboards in New York's famous Times Square. In the mid 1960s Rosenquist brought these two experiences together to produce one of the icons of Pop Art, the 86-foot long mural entitled *F1-11*, a work first shown in the Castelli Gallery in New York in the spring of 1965. The piece comprises several large-scale panels, which include images of everyday consumer items, such as tinned spaghetti, a firestone tyre and angel cake, all executed in acid colours and finished in a slick, photographic style. These images are then juxtaposed with a scene representing atomic explosion whilst the sleek fuselage of an F1-11 US Military fighter jet hovers behind the whole scene. Rosenquist's work explicitly links consumerism with the military industry that both generated and sustained the post-war American economic boom. This later print is based on the original large-scale work.

CREATED

New York

MEDIUM

Lithograph

SERIES/PERIOD/MOVEMENT

Pop Art

SIMILAR WORKS

Them and Us by Neil Jenney, 1969

James Rosenquist *Born* 1933 Grand Falls, North Dakota

Wilke, Hannah

SOS Starification Object, 1974–82

Photo: Zindeman/Fremont/Courtesy Ronald Feldman Fine Arts, New York/© 2005 Marsie, Emanuelle, Damon and Andrew Scharlatt/Estate of Hannah Wilke

The protest movements of the late 1960s addressed a whole host of social issues, opposing then-prevalent discrimination on the grounds of race, sexuality and gender. The Feminist movement gained considerable strength during this period, campaigning extensively for equal rights for women at a time when women workers earned, on average, half that of men. Supporters of Women's Liberation also challenged conventional constructions of the female body as the passive object of the male gaze. A major objective of Feminist art, therefore, was to reclaim the female body and free it from these conventional, power-based associations. Hannah Wilke was a key figure in this reclamation of the female body. Throughout the 1970s and early 1980s, she produced a series of photographs depicting herself in postures parodying female stereotypes. To highlight further the problematic nature of conventional female identity Wilke covered her body with small 'sculptures' made from chewing gum. As she later stated, 'I choose gum because it's the perfect metaphor for the American woman – chew her up, get what you want out of her, throw her out and pop in a new piece'.

CREATED

New York

MEDIUM

Mixed media

SERIES/PERIOD/MOVEMENT

Feminist Art

SIMILAR WORKS

Interior Scroll (Performance) by Carolee Schneemann, 1975

Hannah Wilke *Born* 1940 New York

Died 1993

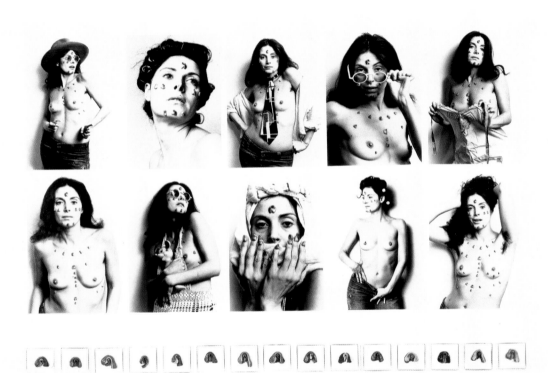

Lin, Maya
Vietnam Veterans' Memorial, 1980–82

In the aftermath of the war in Vietnam, the problematic question of how to commemorate those American soldiers who had died during the conflict generated much public debate. The traditional, heroic war memorial was widely regarded as inappropriate, given both America's defeat and the widespread public dissent that had contributed to the nation's final withdrawal. In 1980 a competition was launched to design a suitable monument. The winner, a 20-year-old student from Yale University by the name of Maya Lin, produced what has subsequently become the most visited monument in the American capital. Lin's memorial is breathtaking in its simplicity, yet profoundly moving. It consists of a simple V-shaped wall of black granite, reminiscent of Minimalist sculpture, that descends into the ground at one end and re-emerges at the other. The names of the 58,135 American soldiers who fell in the conflict are inscribed on the wall in the order of their death. The wall is highly polished, so that the image of the spectator is reflected back as the names are read, thus uniting the living with the dead and facilitating a sense of close association and profound contemplation.

CREATED

Washington D.C.

MEDIUM

Polished black granite

SIMILAR WORKS

Tilted Arc by Richard Serra, 1981–89

Maya Lin *Born* 1959 Athens, Ohio

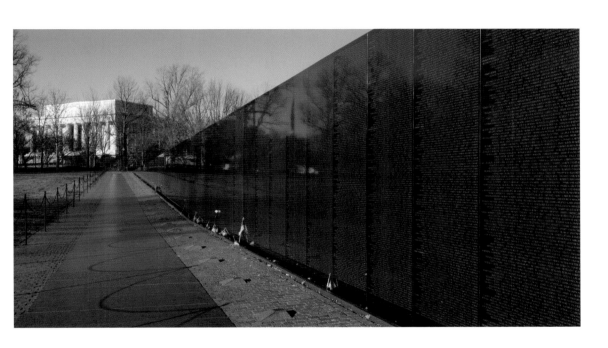

Golub, Leon

Interrogation III, 1981

Leon Golub cut his political teeth as an activist during the Vietnam War. Prior to this he had dabbled in Abstract painting but, much inspired by Picasso's *Guernica* – which he had seen in his native Chicago in 1939 – he soon turned to political subjects. Golub's works frequently expose power and its abuse, a major theme in his *Interrogation III*. Here Golub presents a naked prisoner being tortured by two figures dressed in military uniforms. The passivity of the prisoner is notably contrasted to the more dynamic and aggressive movements of the torturers. Golub's scene is set against a plain, neutral background of bare canvas and does not suggest a specific context for this torture. Rather it is torture in general that is being condemned. As if to further the sense of brutality and suffering, Golub's figures are built up with layer upon layer of dry, scumbled paint, each layer then scraped back to leave a scarred and pitted surface, adding to the rawness of the presentation. Moreover, Golub left his canvases unmounted, their edges untrimmed, so that they hang on the wall like tapestries or, as Golub himself claimed, like stretched hides.

CREATED

New York

MEDIUM

Acrylic on linen

SERIES/PERIOD/MOVEMENT

Abstract Art

SIMILAR WORKS

Sleepwalker by Eric Fischl, 1979

Leon Golub *Born* 1922 Chicago, Illinois

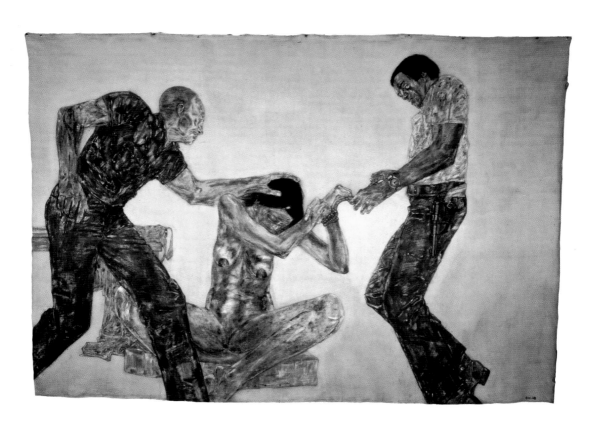

Sherman, Cindy
Untitled (Self-Portrait of Marilyn), 1982

Courtesy of © Museum of Fine Arts, Houston, Texas, USA/Bridgeman Art Library/© Cindy Sherman

Since the 1970s many artists have embraced the photographic medium as a means to explore and to critique the truths and falsehoods of our image-saturated era. Traditionally, photography has been widely regarded as a scientific medium, whose mechanical nature implies the veracity of the images it produces. However, for some artists the capacity either to manipulate the subject being photographed or to manipulate the photograph itself was increasingly a primary concern. Cindy Sherman's work explores this issue. In the late 1970s, Sherman began to produce a series of photographs that resembled stills from typical 1950s movies. These images explored the conventional modes for representing femininity and included representations of women as objects of desire or as homely housewives. Sherman herself posed for these carefully staged photographs, as can be seen here in her work *Untitled (Self-Portrait of Marilyn)*, a thinly veiled image of Sherman masquerading as Marilyn Monroe. In this way Sherman constructs herself as both the image, or model, and the producer, or artist. These works strove to expose the power relations of the male spectator gazing upon the female model, a problem central to gender politics that was widely discussed by Feminist critics in the 1970s.

CREATED

New York

MEDIUM

Ektachrome photograph

SERIES/PERIOD/MOVEMENT

Feminist Art

SIMILAR WORKS

Carving: A Traditional Sculpture by Eleanor Antin, 1982

Cindy Sherman *Born* 1954 Glenn Ridge, New Jersey

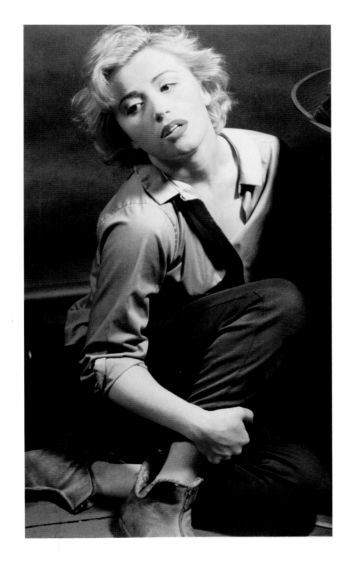

Koons, Jeff
Winter Bears, 1988

Few individuals, with the exception of Paul Gauguin (1848–1903), have become successful artists following a career in finance. Since the 1980s, however, Jeff Koons, previously a prosperous Wall Street commodities broker, has become one of the most famous – and notorious – artists in the United States. Koons is best known for taking the most extreme forms of commodity kitsch and turning it into gallery art. His work celebrates the gaudy, the glossy and the glitzy, frequently in the form of large polychrome statues based upon the kind of cheap plastic or ceramic models picked up for a few pennies in souvenir stores. *Winter Bears*, for example, is a four-foot tall sculpture of two cutesy teddies, holding hands and waving at the spectator, their rosy cheeks and love-heart bag epitomizing the excessive sentimentality so beloved by Koons. Drawing from the Pop Art tradition they embrace and celebrate banality and superficiality. Koons does not make his own works, but has them manufactured, often producing multiple copies. The presence of his works in art galleries, and the high prices they fetch at auction, serves deliberately to undermine the conventional distinctions made between so-called 'high' art and popular culture.

CREATED

New York

MEDIUM

Polychromed wood

SIMILAR WORKS

Basics #1/3 by Haim Steinbach, 1986

Jeff Koons *Born* 1955 York, Pennsylvania

Gober, Robert

Untitled (Newspaper), 1990

In 1989, Robert Gober stated, 'For me, death has temporarily taken over life in New York City. And most of the artists I know are fumbling for ways to express it'. Gober was referring directly to the AIDS crisis and its devastating impact on the gay community in New York. His work, inevitably, has been interpreted as a response to these circumstances and conforms to the wider expansion of art practices in the 1980s that self-consciously addressed the darker mood prevailing in the United States. Gober's works articulate a sense of disturbance and vulnerability, an unease in the midst of the contemporary world. *Untitled (Newspaper)* – one of a series of similar works, is an installation piece based upon ordinary, seemingly found, objects. However, Gober's work is notable for the fact that he does not use actual found objects. Rather he careful manufactures his artefacts, here even reprinting the newspaper text and image. Gober's emphasis on this bundle of newspapers comments on the transience of life, what is news today is discarded tomorrow. At the same time he raises ideological questions about the motives of the news media, its lurid fascination with, and exploitation of both personal, and global, disasters.

CREATED

New York

MEDIUM

Photolithography on archival paper

SERIES/PERIOD/MOVEMENT

Installation Art

SIMILAR WORKS

Untitled by David Wojnarowicz, 1992

Robert Gober *Born* 1954 Wallingford, Connecticut

Kruger, Barbara

Untitled (You Can't Drag Your Money into the Grave With You), 1990

Barbara Kruger's early career was spent as a commercial artist. In the mid 1970s, however, she began to produce works that combined image and text, and adopted the visual language of advertising to make more overt political statements. She soon developed what has become, in effect, a signature style, using black-and-white images combined with slogans printed white on red, seemingly pasted on to the surface of the image. Kruger's style is highly reminiscent of the political posters produced by the Russian Constructivists in the years immediately following the Bolshevik Revolution of 1917. Like their source of inspiration, Kruger's posters also address political issues, particularly by confronting the spectator directly by use of the personal pronoun 'you'. Kruger's main concern is to challenge conventional media representations of gender and sexuality. She has also used her work to critique the consumer world and the advertising media that support it. In *You Can't Drag Your Money into the Grave With You*, Kruger parodies the Western obsession with consumerism, presenting a huge image of a pair of male shoes, produced on a similar scale to the advertising billboards found in many cities.

CREATED

New York

MEDIUM

Screen print on vinyl

SIMILAR WORKS

Truisms by Jenny Holzer, 1982

Barbara Kruger *Born* 1945 Newark, New Jersey

Boltanski, Christian

Monument Odessa, 1991

Christian Boltanski began his artistic career as a painter and a filmmaker. His work addresses issues of memory and loss and he frequently incorporates photographs and pieces of clothing into his installations to suggest documents of a past life. Boltanski, however, is less concerned with the veracity of the 'pasts' he reconstructs and frequently mixes fact with fiction or creates a mythical past suggestive of flashbacks, or isolated fragmentary memories. In the late 1980s Boltanski began a series of installations entitled *Monument Odessa*. These works consist of an assemblage of old photographs, often of young girls, combined with biscuit tins, sometimes the repositories of such photographs, and electric lights. The objects are mounted on a wall in tiers and illuminated to give the appearance of an altar. The electric cables are left exposed, suspended in front of the photographs, thus resembling ropes or suggesting the possibility of torture. Boltanski's photographs represent unknown individuals from before the Second World War, individuals who may well have been the victims of Nazism, though Boltanski deliberately leaves this unresolved. The work is nonetheless a poignant reminder of the victims of the Holocaust.

MEDIUM

Gelatin silver prints, tin boxes and electric lights

SERIES/PERIOD/MOVEMENT

Installation Art

SIMILAR WORKS

The Red Wagon by Ilya Kabakov, 1989

Christian Boltanski *Born* 1944 Paris, France

American Art

Places

Shinn, Everett

The Tightrope Walker, 1904

Courtesy of Christie's Images Ltd/© Estate of Everett Shinn

Like many of the artists associated with the Ashcan School, Everett Shinn's works engaged directly with modern life in New York City. As a commercial illustrator for magazines including *Harper's Weekly* and *Collier's* he produced countless illustrations of all aspects of city life, from scenes of poverty and degradation to representations of urban entertainments, including the theatre and, as here, vaudeville acts. Shinn's inspiration was undoubtedly the work of the nineteenth-century French painter Edgar Degas (1834–1917). In *The Tightrope Walker*, Shinn depicts a scantily clad performer being watched by a shadowy audience in the upper tier. These figures all crane their necks, one woman clutching her hands together anxiously while a young man beside her leans over to gain a 'better' view. The garish lighting and exotic Japanese parasols used to assist the performer's balance suggest the slightly sordid nature of the entertainment, and Shinn notably positions us as spectators in the balcony above the upper tier – in the cheap seats. Shinn's work sets out to capture the excitement and magic of vaudeville, the affordable public entertainment that characterized New York life in the early twentieth century.

CREATED

New York

MEDIUM

Pastel on board

SERIES/PERIOD/MOVEMENT

Ashcan School

SIMILAR WORKS

Miss La La at the Cirque Fernando by Edgar Degas, 1879

Everett Shinn *Born* 1876 Woodstown, New Jersey

Died 1953

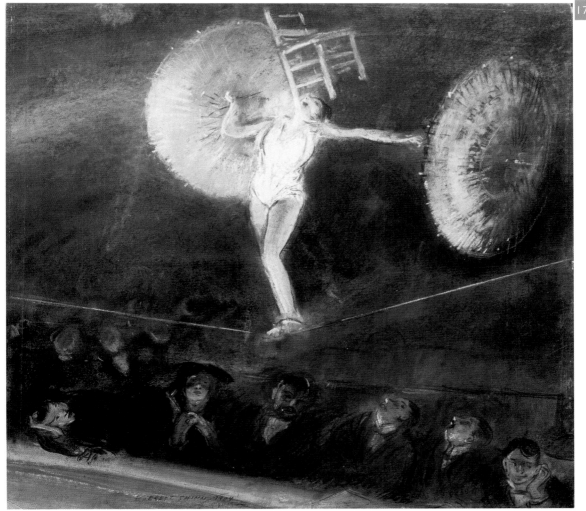

Luks, George
Hester Street, 1905

Few artists claimed the epithet 'man of the people' more audaciously than the Ashcan School artist George Luks. Raised in the small town of Shenandoah in Pennsylvania, Luks spent his youth amongst the local coal mining community. As a young man he performed in a comedy vaudeville act with his brother, before moving to Philadelphia to take up a post as an illustrator for the Philadelphia Press. By the early twentieth century he had moved to New York's Lower East Side, where he lived amongst the predominantly immigrant community of this poor quarter of the city. Here he painted *Hester Street*, an exuberant, colourful and positive image of his local neighbourhood. At the time Luks painted this view, documentary photographers such as Jacob Riis (1849–1914) and Lewis Hine (1874–1940) were recording the slum conditions of life in such regions. Luks, however, ignored the poverty and deprivation, focusing instead upon the exotic, picturesque aspects of New York's ever-changing communities. His work celebrates the energy and diversity of this 'melting-pot' atmosphere, with its hawkers, traders and casual onlookers all crowded into this one tiny corner of the city.

CREATED

New York

MEDIUM

Oil on canvas

SERIES/PERIOD/MOVEMENT

Ashcan School

SIMILAR WORKS

Hairdresser's Window by John Sloan, 1907

George Luks *Born* 1867 Williamsport, Pennsylvania

Died 1933

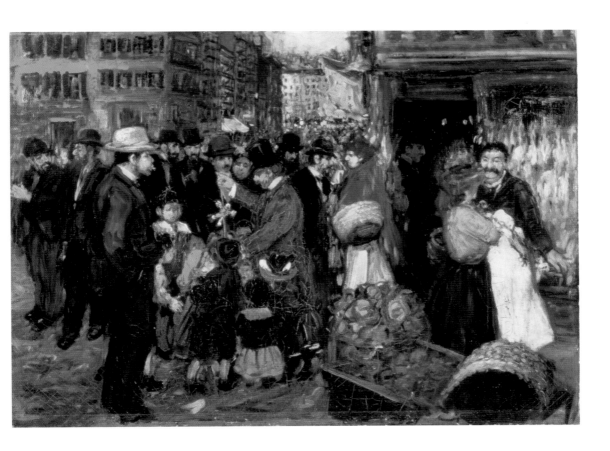

Bellows, George Wesley

Pennsylvania Station Excavation, 1907–09

When George Bellows first moved to New York in 1904, his arrival coincided with one of the major engineering projects of the early twentieth century. As the population of the city grew, along with the ever-rising wave of immigration from Europe, the city's transportation links with the rest of the country reached breaking point and plans were put in place to build a new, major railway terminal – the Pennsylvania station. The project demanded the clearance of over 400 shops and houses, and the excavation of colossal tunnels running underneath the city itself, as well as under the Hudson and East rivers. Bellows, like most Americans, was fascinated by this six-year project, widely reported in the press as one of the engineering marvels of the modern age. Indeed, he produced a whole series of drawings and paintings recording the various stages of the operation. Bellows' work, however, is far from a heroic celebration of technological achievement. Rather, he presents the excavation as a barren, desolate site reminiscent of a battleground, with dark louring forms and billowing steam dominating the diminutive workers, who appear only sporadically throughout the scene.

CREATED

New York

MEDIUM

Oil on canvas

SIMILAR WORKS

Roundhouse at High Bridge by George Luks, 1909–10

George Wesley Bellows *Born* 1882 Columbus, Ohio

Died 1925

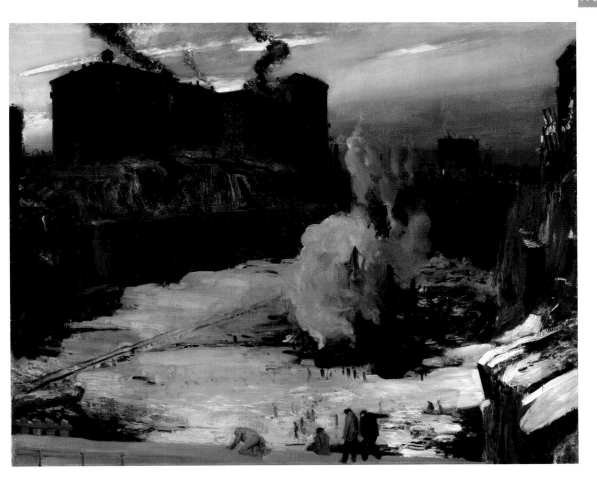

Kent, Rockwell

Rocky Inlet, Monhegan, 1909

Like many of the American Realist painters who emerged in the early twentieth century, Rockwell Kent studied in New York under the tutelage of Robert Henri (1865–1929). Kent, however, moved in the opposite direction of many of these painters, abandoning the urban metropolis for the remote landscapes of the American north. In 1905 Kent first travelled to Monhegan Island off the Maine coast, where he produced a series of landscapes. Kent's inspiration for these works may well have been the work of Winslow Homer (1836–1910), at that time living at nearby Prout's Neck. However, unlike Homer, Kent, a member of the Socialist Party since 1904, was keen not only to depict the life of the local fishing community, but also to live it, working as a carpenter and a fisherman and remaining at Monhegan until 1910. Later his travels took him to even more remote sites in Newfoundland, Alaska and Greenland. *Rocky Inlet, Monhegan* uses stark contrasts of light and shade to emphasize the ruggedness and severity of Monhegan Island, thus extolling the pioneering spirit of the local inhabitants, whose existence depends entirely upon this uncompromising landscape.

CREATED

Monhegan Island, Maine

MEDIUM

Oil on canvas

SERIES/PERIOD/MOVEMENT

Realist

SIMILAR WORKS

West Point, Prout's Neck by Winslow Homer, 1900

Rockwell Kent *Born* 1882 New York

Died 1971

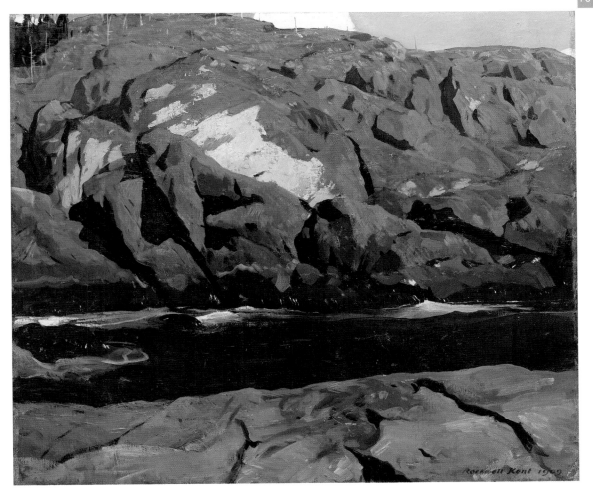

Rockwell Kent 1909

Sloan, John

McSorley's Bar, 1912

Much of the impetus for painting modern-life subjects in New York had come from the rapid expansion of newspapers and popular journals in the early twentieth century. In the period before technology allowed for the mass reproduction of photographs, many of these journals employed artists to illustrate their news stories. Among these, John Sloan originally forged a career as a cartoonist and later provided illustrations for the left-wing journal *The Masses*. Sloan first arrived in New York in 1904 and soon adopted the urban realism of the Ashcan School, producing his most famous work *McSorley's Bar* in 1912. Sloan regularly frequented this haunt of the Irish working-class, and here offers a notably sympathetic view of the establishment. In contrast to the more sensationalist representations of such spaces as hotbeds of debauchery and violence, Sloan offers a scene of order, calm and tranquillity, with low lighting giving the scene a domestic character. The distance between the spectator and the main characters also implies a sense of privacy, thus denying full access to the spectator and presenting McSorley's Bar as a haven for its regular customers.

CREATED

New York

MEDIUM

Oil on canvas

SERIES/PERIOD/MOVEMENT

Ashcan School

SIMILAR WORKS

Kids by George Bellows, 1906

John Sloan *Born* 1871 Lock Haven, Pennsylvania

Died 1951

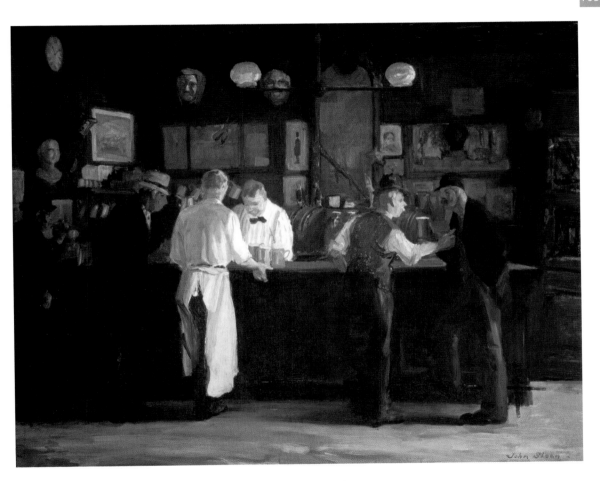

Stella, Joseph
The Bridge, 1920–22

For the Italian-born artist Joseph Stella, the vision of New York at night was nothing short of a religious experience. Between 1920 and 1922 Stella produced a series of five paintings entitled *The Voice of the City of New York Interpreted*, which set out to encapsulate his sense of awe when confronted with nocturnal New York, the city that never sleeps. One work from this series, *The Bridge*, aptly explores the sacred nature of Stella's vision. Here the artist represents the towers and cables of the Brooklyn Bridge, first completed in 1883. Much emphasis is placed upon the gothic arches of the bridge tower, through which are seen the skyscrapers of Wall Street framed against a dark night sky. Despite the overt modernity of the work, however, Stella's work notably recalls medieval stained-glass windows, whilst the view of the tunnels running beneath the bridge, seen at the bottom of the image, also recalls the predella panels of early Renaissance altar panels. Here both the past and the present, the sacred and the secular are conjoined to celebrate the sheer richness and diversity of New York City.

CREATED

New York

MEDIUM

Oil on canvas

SERIES/PERIOD/MOVEMENT

The Voice of the City of New York Interpreted Series

SIMILAR WORKS

The Radiator Building – Night, New York 1927 by Georgia O'Keeffe, 1927

Joseph Stella *Born* 1877 near Naples, Italy

Died 1946

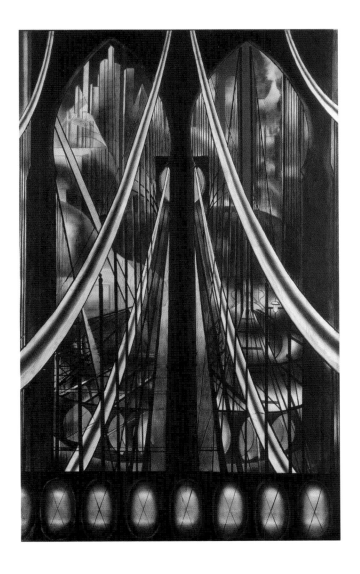

Demuth, Charles

I Saw the Figure 5 in Gold, 1928

© The Metropolitan Museum of Art, New York

Charles Demuth's *I Saw the Figure 5 in Gold* is one of America's most famous and familiar icons. Produced in the 1920s by one of the key figures in the Precisionist movement, the work is based on an Imagist poem by Demuth's close friend, William Carlos Williams. The poem, using terse, precise, staccato phrases (Among the rain/and lights/ I saw the figure 5/in gold), describes the experience of seeing, and indeed hearing, a fire truck screaming through the streets of New York. Demuth attempted to produce a visual analogue to Williams' poem, adopting a similarly terse, precise and staccato vocabulary. In place of the truck itself, Demuth presents fragmented views of the vehicle and focuses his attention on the gold-emblazoned number 5, seen three times as it recedes down a street, past glaring electric lights and neon signs, several of which (BILL, CARLO, and W.C.W.) refer explicitly to Williams. Demuth's use of fragmentation and multiple viewpoints was clearly influenced by Cubism, but is here deployed to express the energy, excitement and sheer cacophony of New York in the 1920s.

CREATED

Lancaster, Pennsylvania

MEDIUM

Oil on board

SERIES/PERIOD/MOVEMENT

Precisionist

SIMILAR WORKS

Church Street El by Charles Sheeler, 1920

Charles Demuth *Born* 1883 Lancaster, Pennsylvania

Died 1935

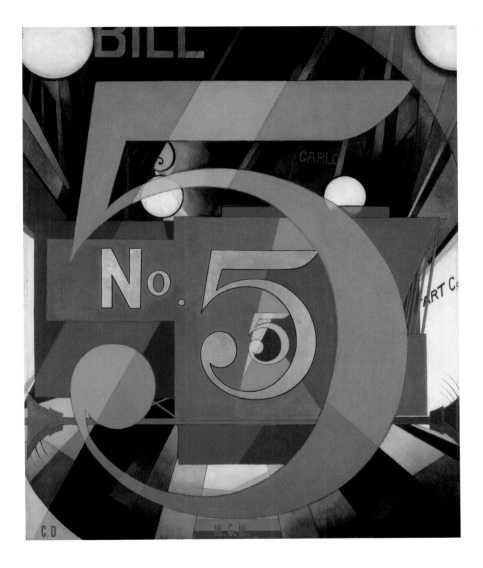

Hopper, Edward
Lighthouse at Two Lights, 1929

Courtesy of the Metropolitan Museum of Art, New York, USA/Bridgeman Art Library

Edward Hopper spent almost his entire career living and working in New York. From 1912 onwards, however, he regularly travelled north to summer in Gloucester, Cape Cod and Monhegan Island, off the coast of Maine. In 1927 he bought his first motorcar and, from that point on, explored some of the more remote regions of Maine, spending several summers in a coastal resort known as Two Lights. Here Hopper painted the local sites, including *Captain Upton's House* (1927) and the lighthouse positioned on a grass-covered promontory overlooking the ocean. Hopper's *Lighthouse at Two Lights* is painted from a low viewpoint, thus giving a sense of grandeur to what appears otherwise to be a rather squat structure. More importantly, he chose a very particular time of day – early morning, when the low sunlight cast long shadows across the landscape, modulating the forms of the lighthouse and silhouetting it against the sky. Hopper frequently depicted scenes at this quiet time of day, the stillness thus lending his images a sense of solitude and isolation.

CREATED

Cape Elizabeth, Maine

MEDIUM

Oil on canvas

SERIES/PERIOD/MOVEMENT

Realist

SIMILAR WORKS

Stone City, Iowa by Grant Wood, 1930

Edward Hopper *Born* 1882 Nyack, New York

Died 1967

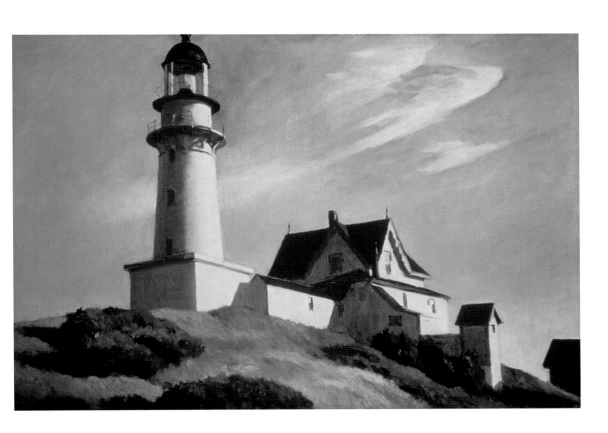

Wood, Grant

Stone City, Iowa, 1930

Grant Wood is widely regarded as the archetypal Regionalist painter. He was born in Iowa and remained there for the best part of his life, depicting local scenes and presenting the Midwest as an idealized region, imbued with values of traditionalism, continuity and spirituality. His works can be regarded as the very antithesis of American modern art, rejecting what was viewed by more conservative critics as the artificiality of European modernism. This is not to say that Woods did not draw on the wider European tradition. Indeed, paintings like *Stone City, Iowa*, with its meticulously depicted landscape, exquisitely perfect little buildings and harmoniously composed hills, trees and agricultural crops, recalls sixteenth-century Flemish painting, and particularly the work of Jan van Eyck (*c.* 1395–1441). Woods' vision, however, was notably a fantasy, a mythical world of escapism produced in the wake of the economic crash of 1929. Indeed, the 1930s was an era in which the rural Midwest experienced extreme economic hardship. In this context, Woods' images contrast strikingly with the WPA sponsored photographs of migrant workers produced in the mid 1930s by Dorothea Lange (1895–1965).

CREATED

Stone City, Iowa

MEDIUM

Oil on wood

SERIES/PERIOD/MOVEMENT

Regionalist

SIMILAR WORKS

Erosions No 2: Earth Mother Laid Bare by Alexandre Hogue, 1936

Grant Wood *Born* 1892 near Anamosa, Iowa

Died 1942

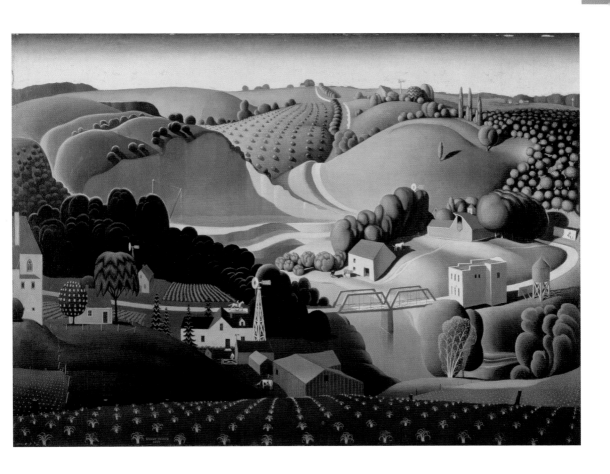

O'Keeffe, Georgia

Bell-Cross Ranchos Church, New Mexico, 1930

Whilst the Midwest remained the spiritual home of the Regionalists, some artists set up shop a little further south. In 1929 the former New York socialite Mabel Dodge invited the painter Georgia O'Keeffe to spend the summer at her ranch at Taos, New Mexico. O'Keeffe was not the first artist to travel to the Southwest. Marsden Hartley (1877–1943) and John Marin (1870–1953) had been earlier guests at Dodge's ranch. What inspired these artists was the luminosity of the New Mexico desert, the striking forms of the indigenous adobe architecture, the local culture of the native Pueblo community and a sense of being in touch with a mythic, spiritual existence untouched by modernity. In Taos, O'Keeffe, further developed the modernist style with which she had built her reputation in New York, painting a whole series of New Mexico motifs, including adobe buildings, bleached-out animal skulls found in the desert, and the local churches of the Christian missionaries. Many of these works, like *Bell-Cross Ranchos Church*, are characterized by their use of bold forms and sharp contrasts of colour, typical of both the landscape itself and the indigenous Pueblo arts and crafts.

CREATED

Taos, New Mexico

MEDIUM

Oil on canvas

SERIES/PERIOD/MOVEMENT

Regionalist

SIMILAR WORKS

New Mexican Village (Taos Houses) by Andrew Dasburg, 1926

Georgia O'Keeffe *Born* 1887 near Sun Prairie, Wisconsin

Died 1986

Bishop, Isabel

Dante and Virgil in Union Square, 1932

Courtesy of © Delaware Art Museum, Wilmington, USA/Bridgeman Art Library/© Estate of Isabel Bishop

In 1934, Isabel Bishop leased a studio in Union Square, Lower Manhattan, in a district that had previously been rich and fashionable but had more recently fallen on hard times. In the years immediately prior to the First World War, Union Square had become particularly associated with political dissent and, by the 1920s, a site for mass demonstrations and protests. During the 1930s, both the Socialist Party and the Communist Party established their headquarters here. This left-wing milieu suited Bishop, whose works often depicted the urban poor and, in particular, working women. *Dante and Virgil in Union Square* presents a frieze-like pageant, reminiscent of the paintings of Paulo Veronese (1528–88) and Peter Paul Rubens (1577–1640). This 'pageant', however, is made up of massed, ordinary workers, mostly women, crowded into the square. The somewhat incongruous appearance of Dante and Virgil in the foreground alludes to the literary descent into hell by the two characters in Dante's *Divine Comedy*. However, Bishop's characterization of this working-class district as 'infernal' is complex. By representing the massed ranks of workers forming an impenetrable barrier across the square, Bishop alludes to the potential strength and social threat of the masses when united.

CREATED

New York

MEDIUM

Oil on canvas

SIMILAR WORKS

Fourteenth Street by Reginald Marsh, 1932

Isabel Bishop *Born* 1902 Cincinnati, Ohio

Died 1988

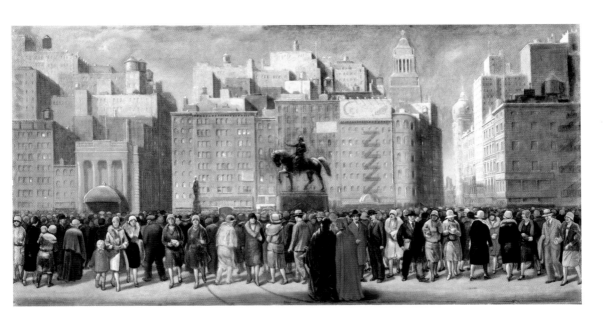

Grandma Moses

Help, c. 1932–50

In 1887, Anna Mary Robertson married a farmer by the name of Thomas Moses and left her native home to spend the next 20 years in Virginia. After this the Moses family returned to Washington County, New York and lived a quiet rural life. Anna Mary had a talent for embroidery and regularly won prizes at the local fairs. At the age of 70, however, arthritis prevented her from continuing to work with a needle, so she took up painting. Over the next 30 years, right up to her 100th birthday, she established a reputation as one of the most famous, best-loved and widely collected painters in the United States under the name 'Grandma' Moses. Moses' paintings were all executed in and around her home and present simple, idealized visions of the rural community of New York State. She regularly produced winter scenes, such as *Help*, showing snowy landscapes with tiny figures working together or playing in the open air. These paintings were frequently reproduced and sold as Christmas cards. Moses's paintings combined the Regionalist theme, so prominent in the 1930s, with the idealized sentimentality characteristic of rural embroidery practices.

CREATED

Washington County, New York

MEDIUM

Oil on masonite

SIMILAR WORKS

Saturday Night Bath by Horace Pippin, 1945

Grandma Moses (Anna Mary Robertson) *Born* 1860 Washington County, New York

Died 1961

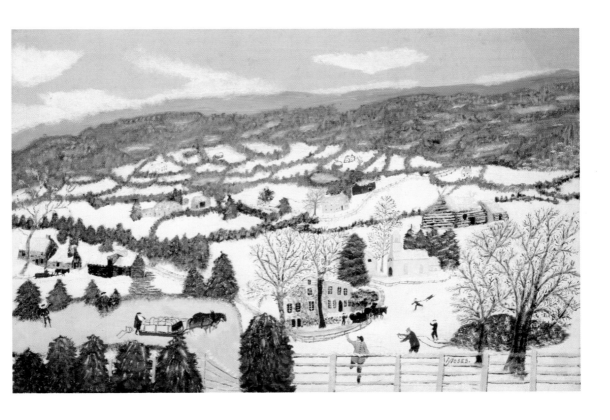

Rivera, Diego

Detroit Industry (detail from north wall), 1933

In April 1932 the Mexican muralist Diego Rivera arrived in Detroit, where he had been commissioned to produce a mural for the garden court of the Detroit Institute of Arts. Rivera spent the next month visiting Henry Ford's River Rouge factory, the recently completed hub of the city's automobile industry. Ford's factory played a major part in the 27-panel work Rivera completed 10 months later. However, the main subject of the mural was the interaction between nature, humankind and technology – a theme that dominated many of Rivera's mural projects. Rivera was an avowed Socialist and valued technological advancement and industrialization as beneficial to society as a whole. However, he was also aware of the potentially negative deployments of technology, and his works frequently included condemnations of the capitalist exploitation of labour and the production of weapons of mass destruction. This image is one of two panels on the north wall of the garden court, which play off the bad use of technology against the good. It shows workers in a chemical factory producing gas bombs. The contrasting image in the opposite corner notably depicts a child in a medical laboratory being vaccinated against disease.

CREATED

Detroit, Michigan

MEDIUM

Fresco

SIMILAR WORKS

Classic Landscape by Charles Sheeler, 1931

Diego Rivera *Born* 1886 Guanajuato, Mexico

Died 1957

Hogue, Alexandre

Drought-Stricken Area, 1934

Courtesy of Dallas Museum of Art, Texas, USA/Bridgeman Art Library/© Estate of Alexandre Hogue

While some of the Regionalist painters of the 1930s celebrated the heartland of the American Midwest as an idealized region, others dwelt more explicitly on the darker side of the more remote American landscape. One such artist was Alexandre Hogue. The devastating effects of mass unemployment in the cities, brought about by the Depression, had doubtless contributed to the Regionalist vision of the Midwest as an untouched rural Eden. However, the Depression also wrought havoc in the countryside and regular droughts, along with falling grain prices, brought collapse to many farming communities, forcing many Midwesterners to embark upon the long trek west to seek employment. Hogue's image of a dilapidated Texas farmstead, with its broken wind tower, starving cattle and arid soil, encapsulates this experience of the dustbowl. On the horizon, yellow dust clouds gather beneath a relentless blue sky, about to bring further devastation to this desolate region, whose only beneficiaries are the vultures perched in the foreground and hovering in the distant sky. Hogue's work also recalls the dustbowl novels of John Steinbeck and the WPA photographs of Dorothea Lange.

CREATED

Texas

MEDIUM

Oil on canvas

SERIES/PERIOD/MOVEMENT

Regionalist

SIMILAR WORKS

Migrant Mother (photograph) by Dorothea Lange, 1936

Alexandre Hogue *Born* 1898 Memphis, Missouri

Died 1994

Sheeler, Charles

City Interior, 1935

In the mid 1930s the city of Detroit was at the very heart of American industry. In 1914 Henry Ford had started his production-line method of car production here and by 1927 a new factory, called the River Rouge, was built at Dearborn, just outside the city. It was the largest and most up-to-date factory in the entire world, and employed over 75,000 workers. Shortly after it opened, Ford invited the Precisionist painter Charles Sheeler to visit the factory. Over the next six weeks Sheeler took hundreds of photographs, some of which appeared in popular journals such as *Vanity Fair*. He also used these photographs as source material for a series of paintings of the factory, including *American Landscape* (1930), *Classic Landscape* (1931) and *City Interior*. Produced in Sheeler's typical highly meticulous style, these works extol the virtues of Ford's achievements with respect and reverence. As Sheeler himself stated, 'Our factories are our substitute for religious expression'. For all their awe and wonder, however, Sheeler's works noticeably exclude the presence of the workers themselves, the individuals whose labour had built not only Ford's factories and cars, but also his fortune.

CREATED

Detroit, Michigan

MEDIUM

Oil on board

SERIES/PERIOD/MOVEMENT

Precisionist

SIMILAR WORKS

Detroit Industry mural by Diego Rivera, 1933

Charles Sheeler *Born* 1883 Philadelphia, Pennsylvania

Died 1965

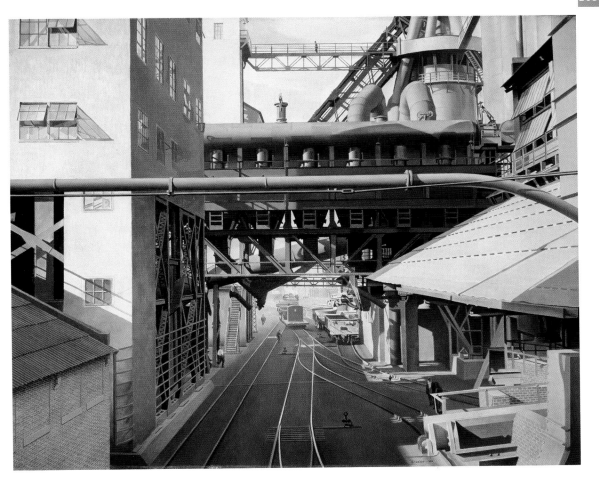

Gorky, Arshile
The City, c. 1935

Vosdanig Adoian's childhood was characterized by tragedy and displacement. During the First World War he was separated from his father and lost his mother to starvation during the Turkish genocide of Armenians. Thankfully, however, he and his sister escaped to the United States, where he adopted the name Arshile Gorky. After a brief spell living and working in Massachusetts, Gorky moved to New York where he encountered the works of the major European modernists on display at the Museum of Modern Art. Stylistically, Gorky's *The City* is clearly inspired by the biomorphic forms of the Dada artist Jean (Hans) Arp (1887–1966), and the automatic drawing techniques of the Surrealist, André Masson (1896–1987). However, Gorky adopts this approach specifically to highlight a sense of threat and alienation within the modern urban environment. Here, a strange metamorphic creature is framed against a tall form on the left side of the painting, thus confronting the spectator and blocking his or her further passage into the picture space. By placing this nightmarish monster within a claustrophobic urban setting, Gorky highlights the city as a place of darkness and mystery, where threat and danger is always imminent.

MEDIUM

Oil on canvas

SIMILAR WORKS

Gradiva by André Masson, 1939

Arshile Gorky (Vosdanig Manoog Adoian) *Born* 1904 Khorkum, Armenia
Died 1948

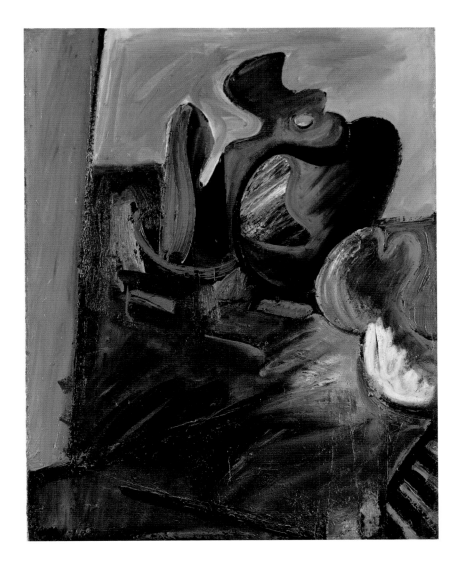

Motley, Archibald

Saturday Night, 1935

Courtesy of The Howard University of Art, Washington DC/© Estate of Archibald Motley

Archibald Motley is renowned for his paintings representing the vibrant nightlife of African-American communities in Paris, New York and Chicago. Motley began his career as a portraitist, working within the academic tradition. Like many of the artists associated with the Harlem Renaissance, however, he undertook a trip to Europe in the late 1920s and, on his return, adopted a more modernist-inspired approach to painting. He was also very much aware of the call for artists to forge a new culture based specifically upon African-American identity and experience. With this in mind, Motley's works, such as *Saturday Night*, celebrated the energy and passion of jazz, that uniquely African-American musical form that was born and raised in Motley's native New Orleans. *Saturday Night* makes no reference to a specific geographical location. However, the vivid colours and the sense of movement, as well as the *bonhommie* so evident among this establishment's staff and patrons, all evoke the mood of New Orleans' French Quarter.

MEDIUM

Oil on canvas

SERIES/PERIOD/MOVEMENT

Harlem Renaissance

SIMILAR WORKS

Midsummer Night in Harlem by Palmer Hayden, 1938

Archibald J. Motley Jr *Born* 1891 New Orleans, Louisiana

Died 1981

Crawford, Ralston

Industrial Landscape, Buffalo, 1937

Ralston Crawford was closely associated with the group of painters known as the Precisionists, and like many of these artists, he was fascinated with the architectural forms of the American industrial landscape. Crawford spent much of his youth in Buffalo, New York and, although he later travelled extensively throughout the world, many of his works recall the coal and grain elevators, the bridges and the water tanks that he had first seen in Buffalo. Yet Crawford's works seem to offer little comment upon the social significance of American industry, rather embracing these industrial forms predominantly for their visual impact. In *Industrial Landscape, Buffalo*, Crawford represents three grain elevators silhouetted against a dark blue sky. All detail is removed from the scene, so as to emphasize the basic geometrical forms executed in a precise, hard-edged, linear manner more reminiscent of technical drawings than of oil paintings. Here Crawford is clearly drawing upon his knowledge of Cubist still-lifes and landscapes, some of which he had seen in the Barnes Foundation in Pennsylvania, and others whilst studying in Paris in 1932.

CREATED

New York

MEDIUM

Oil on canvas

SERIES/PERIOD/MOVEMENT

Precisionist

SIMILAR WORKS

My Egypt by Charles Demuth, 1928

Ralston Crawford *Born* 1906 Ontario, Canada

Died 1978

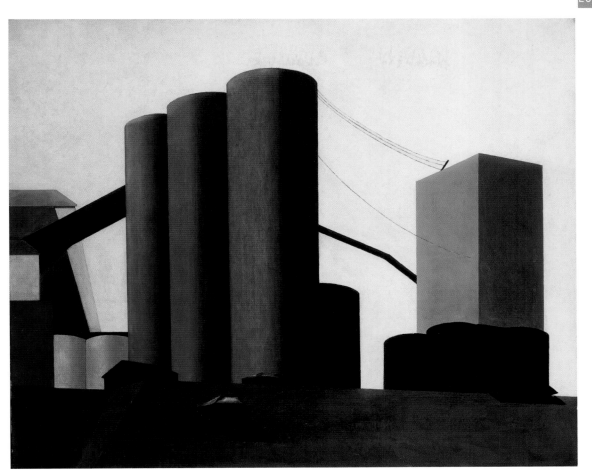

Feininger, Lyonel
Manhattan, Night, 1940

Lyonel Feininger spent the first 16 years of his life in New York, the city adopted by his immigrant German family. In 1887, however, he left for Germany, where he remained for the next half century. Feininger's early work was influenced by both Cubism and Expressionism. He is probably best known for his affiliation with the Bauhaus, the design school established by Walter Gropius (1883–1969) in 1919, and which proved to be a major influence on the development of modern art and design in Europe. Indeed, Feininger's best-known work is a woodcut featuring the jagged, spiky, forms of a Gothic Church silhouetted against a star-strewn night sky, produced for the cover of the first Bauhaus manifesto. By 1937, with the Bauhaus closed and Hitler's National Socialist Party condemning all forms of modern art, Feininger abandoned Germany, returning to his native New York, where he continued to work in the style he had developed at the Bauhaus. Now, however, Feininger replaced the Gothic church with the new temple of modernity, the skyscraper, whose geometrical forms and jagged outlines stand out against another star-strewn sky, situated on the other side of the Atlantic.

CREATED

New York

MEDIUM

Oil on canvas

SERIES/PERIOD/MOVEMENT

Bauhaus

SIMILAR WORKS

New York by Louis Lozowick, *c.* 1925

Lyonel Feininger *Born* 1871 New York

Died 1956

Johnson, William H.

Moon Over Harlem, 1944

In 1938, William H. Johnson returned to the United States after a lengthy sojourn in Europe. He moved to Harlem, where he had earlier built a reputation as an abstract painter at the outset of the Harlem Renaissance, and soon re-established roots, producing murals sponsored by the WPA and contributing works to exhibitions organized by the Harlem Artists Guild. It was also at this time that Johnson launched a new project, to recount the history of African-American experience in both the rural south and the urban north. *Moon Over Harlem* was part of this project. The work was executed in his so-called 'primitive' style, typical of 'naïve' artists such as Grandma Moses (1860–1961) and Horace Pippin (1888–1946), though as an Academically trained artist, Johnson was no 'naïve'. Here he uses bright colours and rhythmic forms to produce a decorative surface. This, however, belies the fundamental violence of the image, in which Johnson exposes the darker side of Harlem life, depicting public drunkenness and brawling. The undignified restraining tactics and excessively heavy police presence further highlights social injustice and the brutality of life for many in Harlem at this time.

CREATED

Harlem, New York

MEDIUM

Oil on canvas

SERIES/PERIOD/MOVEMENT

Harlem Renaissance

SIMILAR WORKS

The Migration Series by Jacob Lawrence, 1940–41

William H. Johnson *Born* 1901 Florence, South Carolina

Died 1970

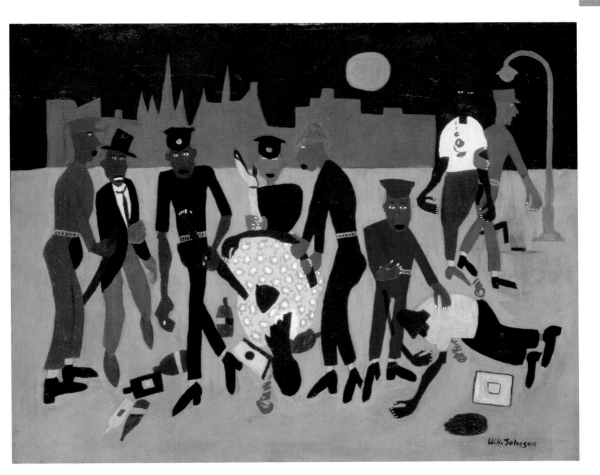

Wyeth, Andrew
Christina's World, 1948

Andrew Wyeth's *Christina's World* has established a reputation as one of the best-known and widely reproduced of all American paintings. Wyeth's work comes out of the Regionalist tradition of the 1930s. Indeed, the artist's whole career has been spent depicting his native Chadds Ford, Pennsylvania or Port Clyde, Maine, where he spends his summers. The painting depicts Wyeth's friend Christina Olson, a woman crippled with polio, who is here shown dragging herself along the ground with her arms, moving towards the house on the distant horizon. The high skyline reflects the low viewpoint of Olson herself, and thus suggests empathy rather than sympathy. Indeed, what is most striking about this figure is her endurance and independence, forging her own way through this vast and isolated landscape. As one critic wrote, *Christina's World* 'seems to express both the tragedy and the joy of life with such vivid poignancy that the painting becomes a universal symbol of the human condition'. The work is notably set in a field on Olson's farm in Maine, thus conflating her sense of Puritan stoicism and unquestioned determination with the locality, and associating the region metaphorically with these traditional American values.

CREATED

Port Clyde, Maine

MEDIUM

Tempera on gessoed panel

SERIES/PERIOD/MOVEMENT

Regionalist

SIMILAR WORKS

Cape Cod Morning by Edward Hopper, 1950

Andrew Wyeth *Born* 1917 Chadds Ford, Pennsylvania

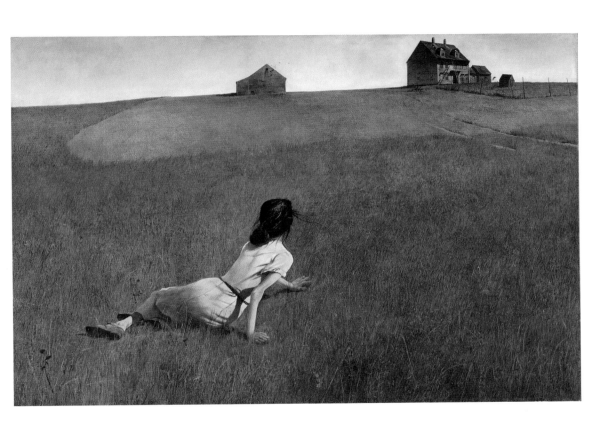

Tooker, George

Government Office, c. 1950s

George Tooker's speciality was painting anonymous, often faceless, individuals seemingly overwhelmed by the eerie, threatening spaces they inhabit. In *Government Office*, for example, Tooker represents an assortment of isolated individuals in an administrative space full of glassed-off partitions. It is unclear what purpose this space serves, only that it contributes to the sense of isolation and helplessness of the individual in the face of such bureaucracy. The low angle of view serves further to reinforce our sense of powerlessness, whilst the uniform lighting and regular layout of the space seems as intimidating as a prison. Tooker's spaces are Kafkaesque in their sense of oppression, and their emphasis on the isolation of the individual recalls the *film-noir* aesthetic then being developed in cinema. Tooker's use of the traditional egg tempera technique, giving his works a flat, even surface, contributes to this mood. His disconcerting, alienating spaces recall the works of Hopper. However, they also allude specifically to the unique post-war mood of anxiety in the face of Cold War fears about the rise of Communism and potential nuclear annihilation.

CREATED

New York

MEDIUM

Egg Tempera on canvas/panel

SERIES/PERIOD/MOVEMENT

Cold War Era

SIMILAR WORKS

Office at Night by Edward Hopper, 1940

George Tooker *Born* 1920 Brooklyn, New York

Diebenkorn, Richard

Ocean Park No. 27, 1970

No other painter has so successfully created a body of work that is fundamentally abstract, yet simultaneously captures a sense of locale, as Richard Diebenkorn. Diebenkorn spent his entire life and career on the west coast of the United States. Whilst a student at the California School of Fine Arts he worked alongside the Abstract Expressionists Mark Rothko (1903–70) and Clyfford Still (1904–80), and his early works followed this Colour Field trend. In the late 1950s, however, he also produced a number of figurative works influenced by both Hopper and Henri Matisse (1869–1954). It was not until 1967 that he began to produce the *Ocean Park* series for which he is best known. In these works, Diebenkorn presents large, flat areas of colour that recall the hard-edged abstraction of Ellsworth Kelly (b. 1923). However, Diebenkorn softens this effect by using sun-bleached cobalt blues, greens and yellows, each colour gently modulated by his transparent brushwork. In this way, his works radiate warmth and invoke the Santa Monica coastline, with the sun setting over the Pacific.

CREATED

Santa Monica, California

MEDIUM

Oil on canvas

SERIES/PERIOD/MOVEMENT

Abstract Art

SIMILAR WORKS

Memory of Oceania by Henri Matisse, 1952–53

Richard Diebenkorn *Born* 1922 Portland, Oregon

Died 1993

Holt, Nancy

Sun Tunnels, 1973–76

Site was a primary concern for the Earthworks artists of the 1970s, many of whom situated their works in remote and distant spots in Utah, New Mexico and Nevada. In 1973, the Earthworks artist Nancy Holt began work on a major project entitled *Sun Tunnels*, transporting four sections of a large concrete pipe to a remote spot in the Great Basin Desert in Utah. Here she placed the sections in a cruciform pattern lying on the desert floor. Holt's *Sun Tunnels* are notably oriented to line up with the rising and setting of the sun during the summer and winter solstices, and thus makes an explicit reference to prehistoric sites such as Stonehenge. Each tunnel is also perforated with holes drilled to echo the constellations of Draco, Perseus, Columbo and Capricorn so that, in the bright light of the Utah desert, they cast patterns of light on the inside of the tunnels. The appearance of these monumental concrete tunnels, situated miles from civilization, also suggests the presence of humanity in the midst of the vast and barren landscape, not least as, during the day, they provide the sole refuge from the heat of the sun.

CREATED

Great Basin Desert, Utah

MEDIUM

Concrete

SERIES/PERIOD/MOVEMENT

Earthworks

SIMILAR WORKS

Spiral Jetty by Robert Smithson, 1970

Nancy Holt *Born* 1938 Worcester, Massachusetts

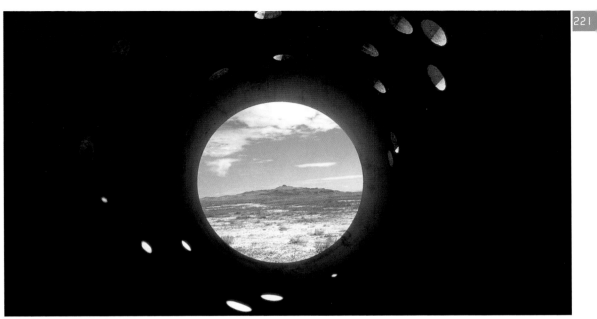

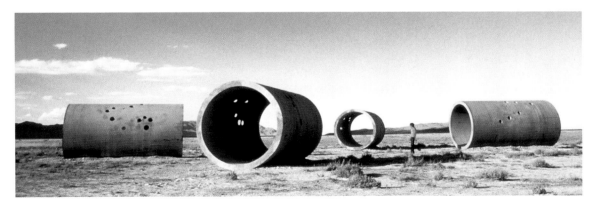

Christo

Running Fence, 1976

The Bulgarian born artist Christo has established a significant reputation for his many projects that have involved wrapping objects in materials such as canvas and plastic. The son of a textile manufacturer, Christo spent his early career working in Paris before he moved to New York in 1964. It was here that he first encountered the Earthworks movement, and particularly the works of Robert Smithson (1938–73). Christo's first large-scale project involved wrapping one million square feet of the Australian coastline in cloth. Following this, he completed two projects in the United States, *Valley Curtain* in Colorado (1972), and the work illustrated here. *Running Fence* has been described as a textile equivalent of the Great Wall of China, and ran for 39 km (24 miles) through the Sonoma and Marin counties of northern California. Notably, *Running Fence* remained in place for only 14 days before being dismantled. This, however, was entirely in accord with Christo's intentions to make an ephemeral art that, in its brief existence, transformed the landscape it inhabited, generating the possibility of seeing familiar scenes in an entirely different context.

CREATED

California

MEDIUM

Nylon, steel cable and steel poles

SERIES/PERIOD/MOVEMENT

Earthworks

SIMILAR WORKS

Lightning Field by Walter de Maria, 1977

Christo (Christo Vladimirov Javacheff) *Born* 1935 Gabrovno, Bulgaria

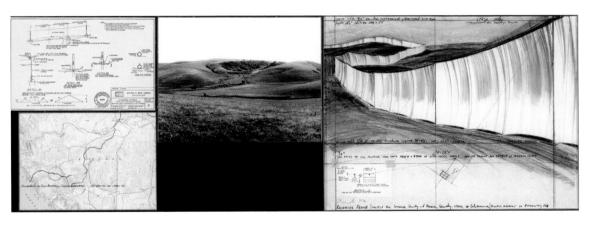

De Maria, Walter

Lightning Field, 1977

Courtesy of Photo © John Cliett © Dia Art Foundation/© Walter de Maria

In 1977, Walter de Maria created one of the largest ever examples of Earthworks in a remote valley in Catron County, New Mexico. The work, entitled *Lightning Field*, consists of 400 stainless-steel poles erected in a grid formation across a landscape one mile long by one kilometre wide. Each pole is arranged to stand at exactly the same height so that together they create the equivalent of a giant rectangle formed by the needle-like points of the poles themselves. As a consequence of this, the scale of the work is so vast that it cannot properly be perceived from a single viewpoint and demands that the viewer enter into its space. As the title implies, in stormy weather the poles act as lightning conductors creating dramatic visual effects, though this is a relatively rare occurrence. Like other Earthworks, the isolation of the site is an integral aspect of the final work. Indeed, visitors to *Lightning Field* must book in advance, are limited in number and are required to stay overnight, thus experiencing the work at different times of the day. Such huge demands on the spectator mean that few but the most committed ever experience these works first-hand.

CREATED

Quemado, New Mexico

MEDIUM

Stainless steel

SERIES/PERIOD/MOVEMENT

Earthworks

SIMILAR WORKS

Double Negative by Michael Heizer, 1969

Walter de Maria *Born* 1935 Albany, California

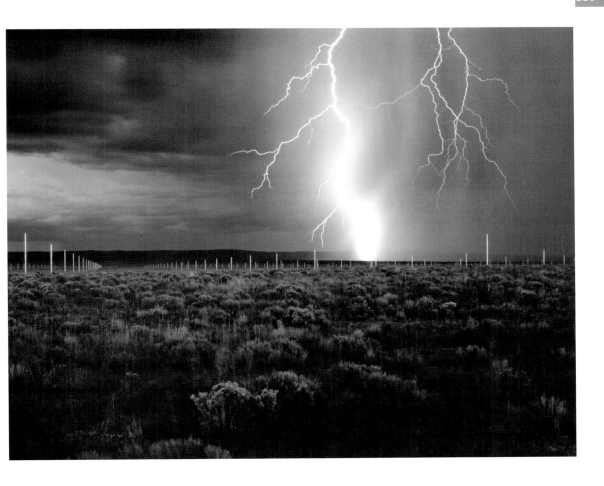

Turrell, James
Roden Crater, 1979–present

James Turrell's works of art are, in many respects, not works of art at all. At least they are not material works in the sense that we usually use that term. Turrell's fascination is with the effect of light upon human perception. Since the late 1970s Turrell has been working on a vast project to transform an extinct volcano in the Arizona desert into a series of viewing spaces – tunnels, chambers, pools – designed to capture the ever-changing effects of light. Turrell spent seven months flying over the Arizona desert in a plane before he came upon the Roden Crater. He subsequently purchased the site and has spent much of the last quarter century altering and modifying its geological contours to create the light effects he is seeking. The project is still not complete. The *Roden Crater* project, through its extreme geographical isolation and its emphasis upon nature itself as art, directly addresses the increased concerns with ecological issues that characterize twenty-first century culture. At the same time, its celebration of the sheer grandeur of the American landscape recalls the nineteenth-century encounter with this vast wilderness during the expansion westwards.

CREATED

Arizona

SERIES/PERIOD/MOVEMENT

Earthworks

SIMILAR WORKS

Spiral Jetty by Robert Smithson, 1970

James Turrell *Born* 1943 Los Angeles, California

American Art

Influences

Cassatt, Mary
The Letter, 1890–91

In 1890, Mary Cassatt visited an exhibition of Japanese prints held at the Ecole des beaux-arts in Paris. Like much of Paris at the time, Cassatt was wildly enthusiastic about the works displayed, admiring their stylistic simplicity, bold linearity and colour harmonies. She was also fascinated by the many images of women depicted in ordinary, everyday circumstances, particularly those produced by the eighteenth-century artist Kitagawa Utamaro (1754–1806). Cassatt's response to the exhibition was to produce a series of her own prints, adopting both the subject and style of Utamaro's works, but updating them and transplanting them into the modern, western world. For example, in *The Letter*, she presents a simple scene, representing a woman in an interior seated at a writing desk and sealing an envelope. Here, Cassatt deploys the simple outlines and patterned surfaces typical of Japanese *ukiyo-e* prints to represent a modern woman in a domestic setting, quoting directly from an Utamaro print showing a Japanese courtesan raising a handkerchief to her lips. Cassatt's prints were widely collected in the United States.

CREATED

Paris, France

MEDIUM

Drypoint and aquatint on paper

SIMILAR WORKS

La Coiffure by Berthe Morisot, 1894

Mary Cassatt *Born* 1845 Allegheny City, Pennsylvania

Died 1926

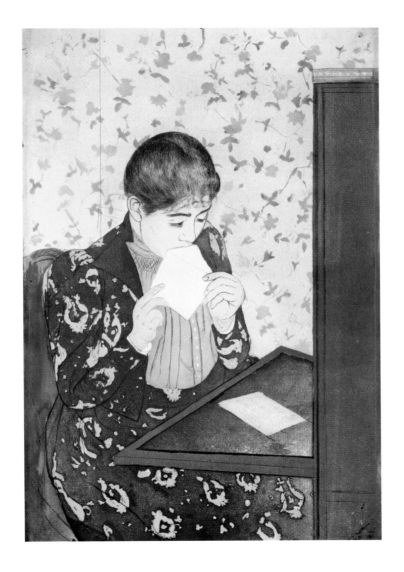

Weber, Max

The Pleasures of Summer, c. 1905

Few American artists absorbed the lessons of the early twentieth-century Parisian avant-garde as successfully – or deployed them as widely – as Max Weber. When Weber first arrived in Paris in 1905, he studied at the prestigious Academie Julian. In 1908, however he met Henri Matisse (1869–1954) and studied directly under the Fauvist painter. Earlier, in 1906, the death of Paul Cézanne (1839–1906) had generated widespread interest in the artist, whose works now featured prominently at the annual 'Salon d'Automne' exhibitions. As a consequence of this many artists, including Georges Braque (1882–1963) and Pablo Picasso (1881–1973), began to adopt Cézanne's style. Weber's *The Pleasures of Summer* is based on Cézanne's late bather paintings and adopts the typically awkward body forms characteristic of these works. The use of diagonal brushstrokes to construct the surface of the canvas compresses the sense of space in a manner typical of the French master, whilst the occasional breaking up of the picture surface with red highlights, here to indicate the roofs of houses, is highly Cézannesque. After his return to New York in 1909, Weber also produced paintings heavily based upon the Cubism of Picasso and in the style of the Italian Futurists.

CREATED

Paris, France

MEDIUM

Oil on canvas

SIMILAR WORKS

The Large Bathers by Paul Cézanne, c. 1900–05

Max Weber *Born* 1881 Bialystok, Poland (then Belostok, Russian Empire)

Died 1961

Bellows, George Wesley

42 Kids, 1907

When George Bellows exhibited his painting *42 Kids* at the Pennsylvania Academy in 1908 it was denied a prize on the grounds that it was too offensive. This criticism was no doubt levelled at the working-class nature of the street urchins Bellows depicted leaping into the East River from a broken-down pier, known colloquially as Splinter Beach. In one sense Bellows' work offered a snapshot of real life, as numerous documentary photographs showing such scenes attest. However, this painting is much more than simple reportage. Rather, it engages with, and simultaneously modifies, the tradition of Arcadian painting, particularly works representing nymphs and satyrs by the sea. On a more direct level, the work could also be read as a parody of Thomas Eakins' (1844–1916) earlier, and more heroic, scene of boys bathing, entitled *Swimming (The Swimming Hole)* (1885). In this way, Bellows combined the influences of past art with a new approach to modern-life subjects. Indeed it may well have been this perceived disrespect to the classical tradition that caused as much offence as the introduction of low life into the halls of the Pennsylvania Academy.

CREATED

New York

MEDIUM

Oil on canvas

SIMILAR WORKS

Hester Street by George Luks, 1905

George Wesley Bellows *Born* 1882 Columbus, Ohio

Died 1925

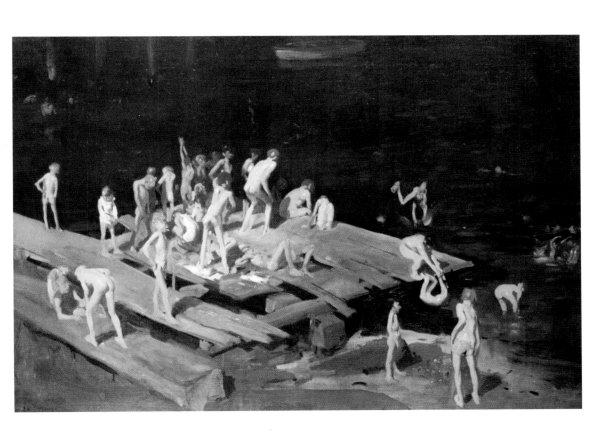

Prendergast, Maurice

By the Sea, c. 1907–14

Since 1908, when he exhibited alongside Robert Henri (1865–1929) and his urban realist colleagues, Maurice Prendergast has been associated with the Ashcan School. However, his painterly, decorative canvases stand apart from those of his contemporaries. Prendergast was much influenced by the works he saw in Paris during his three-year stay in the city during the early 1890s. In particular, his many beach scenes recall similar works produced by French Impressionists such as Claude Monet (1840–1926) and Edgar Degas (1834–1917). However, it was the later works of the Fauve painters, and in particular Matisse, that left the biggest mark on Prendergast's style. *By the Sea* represents a group of bourgeois women spending a day on a beach. Their fashionable urban costumes suggest that they are tourists on vacation, enjoying the sea and fresh air, much as Prendergast himself would have. The work adopts a high viewpoint overlooking the bay and is executed in bright colours with a loose, sketchy finish. In both subject and style it is highly reminiscent of Matisse's views of the Mediterranean coast, produced in 1904–05 – works that famously launched the Fauvist movement.

MEDIUM

Oil on canvas

SERIES/PERIOD/MOVEMENT

Ashcan School

SIMILAR WORKS

By the Sea by Henri Matisse, 1904

Maurice Prendergast *Born* 1858 Newfoundland, Canada

Died 1924

Homer, Winslow
Driftwood, 1909

Winslow Homer was a self-taught painter born in Boston, whose early career was launched after he was sent to cover the Civil War as a picture journalist for *Harper's Weekly*. He is perhaps best known for his dramatic views of the rugged coastline of New England, as depicted here in *Driftwood*. Homer first visited the coast of Maine in 1875. Eight years later he moved to a remote coastal spot called Prout's Neck, where he lived for the remainder of his life. At this time the New England coast was widely associated with the dangers of the fishing and whaling industries, the latter encapsulated in Herman Melville's novel *Moby Dick*. In *Driftwood*, the sea itself is the main subject, and Homer successfully conveys the sheer force of nature with its potentially devastating impact upon frail humanity. However, Homer's stormy seascapes were also heavily influenced by the work of earlier artists including, most notably, J. M. W. Turner's (1775–1851) paintings of storms at sea. His works can also be compared with the dark and sketchy, stormy seascapes of Homer's American contemporary Albert Pinkham Ryder (1847–1917).

CREATED

Maine

MEDIUM

Oil on canvas

SIMILAR WORKS

Maine Coast by Rockwell Kent, 1907

Winslow Homer *Born* 1836 Boston, Massachusetts

Died 1910

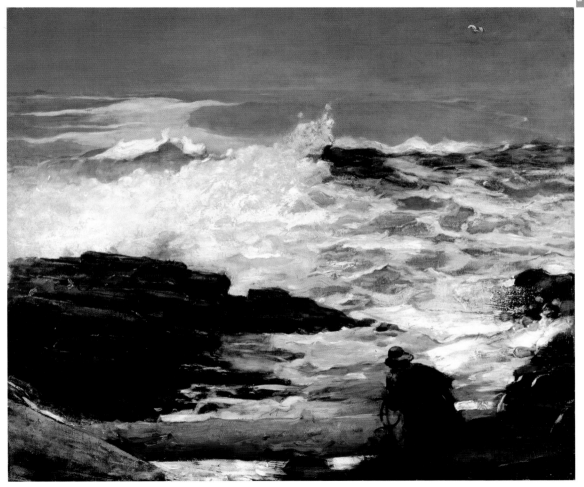

Marin, John

Brooklyn Bridge, New York, 1910

Like many early twentieth-century American artists, John Marin spent some of his formative years in Europe, first visiting Paris in 1905, the same year that Matisse and André Derain (1880–1954) caused a storm exhibiting their Fauvist works. Marin certainly admired the rough, sketchy finish and the immediacy of Fauve canvases, and incorporated this technique into his work. However, he preferred to use watercolour to achieve this effect. In Paris, and also back in New York at Alfred Stieglitz's 291 Gallery, Marin had discovered the watercolours of Cézanne. In *Brooklyn Bridge*, he notably uses the diagonal brushstrokes typical of Cézanne's work to break up the form of the bridge, also allowing the white of the paper to shine through the blue, further disintegrating the form. Notably, Marin's technique also owed a debt to the Chinese landscape paintings that he had seen in the Metropolitan Museum in New York, a factor identified by fellow artist Marsden Hartley (1877–1943). Despite this range of influences, however, Marin, like the earlier Ashcan School artists, turned his attention to modern life, painting the steady stream of traffic crossing the Brooklyn Bridge on their way to and from the modern, urban metropolis.

CREATED

New York

MEDIUM

Watercolour on paper

SIMILAR WORKS

The Bridge by Joseph Stella, 1922

John Marin *Born* 1870 Rutherford, New Jersey

Died 1953

Hassam, Childe

Flags on 57th Street, 1918

Childe Hassam painted this view of New York's 57th Street in the winter of 1918, shortly after the Allied victory over Germany in the First World War. Here Hassam has presented a high viewpoint over the city, looking down from a balcony at the street below, and placing much emphasis on the colourful flags hanging from the buildings, probably in the aftermath of a victory parade. Hassam produced dozens of works representing flags, commencing in 1917 when the United States first entered the conflict. These colourful emblems, brightening up the winter scene below, clearly carry strong nationalistic and celebratory significance. However, the works were much more than a simple patriotic gesture. Hassam was highly influenced by the art of the French Impressionists, whose paintings he had seen on trips to Paris in the 1880s. In particular he adopted the light tonality and broken brushstrokes of Monet, to produce what was frequently referred to as Hassam's 'glare-style'. Notably Monet, as well as Edouard Manet (1832–83) and Camille Pissarro (1830–1903), had earlier painted scenes of the streets of Paris decked out with flags, a factor that clearly inspired this work.

CREATED

New York

MEDIUM

Oil on canvas

SIMILAR WORKS

Cliff Dwellers by George Bellows, 1913

Childe Hassam *Born* 1859 Boston, Massachusetts

Died 1935

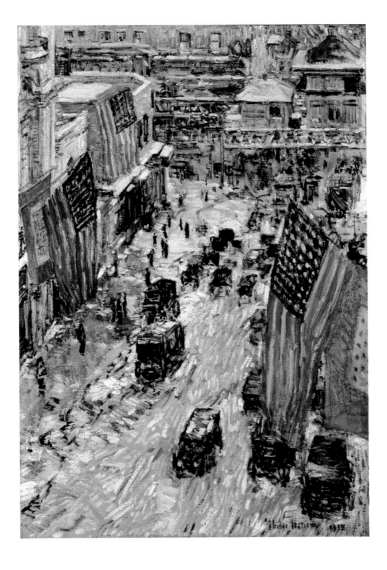

Tanner, Henry Ossawa

Flight into Egypt, 1921

Courtesy of © The Detroit Institute of Arts, USA, Founders Society Purchase; African Art Gallery Committee Fund/Bridgeman Art Library/© Estate of Henry Ossawa Tanner

Henry Ossawa Tanner acquired a huge reputation as a painter both in the United States and in his adopted home in Paris. To this day, he remains one of the best-known African-American artists, whose success was to open the doors for many artists to follow. Tanner's early studies in his native Pennsylvania brought him into contact with the painter Thomas Eakins, whose influence left an indelible mark on the younger painter. Following a successful solo exhibition in Cincinnati in 1890, Tanner visited Paris for the first time. A few years later he returned to the French capital, which became his home for the rest of his life. Here, Tanner's genre scenes and religious paintings were regularly shown at the Paris Salon, the most important annual art exhibition in the French capital. His late paintings, such as *Flight into Egypt*, show the influence of his staunchly religious upbringing as the son of a bishop in the African Methodist Church. Tanner's travels to the Holy Land also informed his work, as did his familiarity with late nineteenth-century French Symbolist painting. In 1927 Tanner became the first African-American artist to be elected a full academician at America's prestigious National Academy of Design.

CREATED

Paris, France

MEDIUM

Oil on panel

SIMILAR WORKS

Jesus and the Three Marys by William H. Johnson, 1935

Henry Ossawa Tanner *Born* 1859 Pittsburgh, Pennsylvania

Died 1937

Davis, Stuart

Odol, 1924

Courtesy of © 2005, Digital Image, The Museum of Modern Art, New York/Scala, Florence/© Estate of Stuart Davis/VAGA, New York/DACS, London 2005

In 1913, Stuart Davis was one of the youngest exhibitors at the famous 'Armory Show' in New York, where he was exposed, for the first time, to European modern art. Davis much admired Cubism, in particular the work of Picasso, Braque and Léger, and, in 1924, produced *Odol*, a clear paean to the Parisian avant-garde. With its tilted angles, textured surfaces and use of lettering, *Odol* recalls early Cubist still-lifes. However, Davis fragments his forms significantly less, and his introduction of words and packaging generates an entirely different mood. Whereas the Parisian works tended to emphasize newspapers and bottle labels, thus evoking the café culture of the French capital, Davis focuses on something much more mundane: mouthwash. Davis's audacious presentation of mouthwash as art has all the hallmarks of the iconoclastic works of Marcel Duchamp (1887–1968), widely known in New York at this time as one of the instigators of the 'Armory Show' and a key figure in the Dada movement. Duchamp's anarchic presentation of a signed urinal, entitled *Fountain*, to an exhibition in New York in 1917, also notably identified the bathroom as a site for artistic inspiration.

CREATED

New York

MEDIUM

Oil on cardboard

SIMILAR WORKS

Cocktail by Gerald Murphy, 1927

Stuart Davis *Born* 1894 Philadelphia, Pennsylvania

Died 1964

Murphy, Gerald
Watch, 1925

Courtesy of akg-images/© Estate of Gerald Murphy

Gerald Murphy was a latecomer to painting, taking it up only after he moved to Paris in 1921. Here, and at his villa in fashionable Antibes, he socialized with the American expatriate community, including F. Scott Fitzgerald, Ernest Hemingway and Cole Porter. Murphy first studied with the Russian painter Natalya Goncharova (1881–1962), but his work was more influenced by the paintings of his close friend Fernand Léger (1881–1955), by the Cubism of Picasso and Braque, and by the Purist canvases of Amedée Ozenfant (1886–1966) and Charles-Édouard Jeanneret (1887–1965), better known as Le Corbusier. Despite this French stylistic influence, however, Murphy's work often focused on the consumer products of his native country. One of his best-known works, *Watch*, presents the inner workings, the cogs and wheels, of a watch. The forms are sharply defined and composed within a rigid geometry. This precise, cool rendering of the products of industry links Murphy's work to Precisionism in the United States and heralded the later obsession with consumerism in Pop Art.

CREATED

Paris, France

MEDIUM

Oil on canvas

SERIES/PERIOD/MOVEMENT

Precisionist

SIMILAR WORKS

Lucky Strike by Stuart Davis, 1921

Gerald Murphy *Born* 1888 Boston, Massachusetts

Died 1964

Kuhn, Walt

Dressing Room, 1926

Courtesy of © Brooklyn Museum of Art, New York, USA, Gift of Friends of the Museum/Bridgeman Art Library/© Estate of Walt Kuhn

Walt Kuhn is perhaps better remembered for his success as an exhibition organizer than as a painter. However, his activities in this field make him, in many respects, a highly influential figure in the history of twentieth-century American art. Kuhn, along with fellow artist Arthur B. Davies (1862–1928) was the driving force behind the 1913 'Armory Show', historically recorded as the milestone exhibition that introduced modern European art to American audiences. Kuhn's credentials for this task were based upon his skills as a promoter and his wide knowledge of European modern art, having studied in Europe between 1901 and 1903. This broad knowledge inevitably left its mark on his own work. Kuhn's main passion was for the work of Matisse. He was an ardent admirer of Fauvism and, in *Dressing Room*, he has striven to incorporate the simple drawing and bold use of colour typical of Matisse's early work. More importantly, Kuhn strove to use flattened-out and patterned surfaces to achieve an overall decorative sense. During the 1920s Kuhn produced several similar works based upon the single, female circus performer, often seen backstage or in the privacy of a dressing room.

CREATED

New York

MEDIUM

Oil on canvas

SIMILAR WORKS

Acrobats by Charles Demuth, 1919

Walt (William) Kuhn *Born* 1880 New York

Died 1949

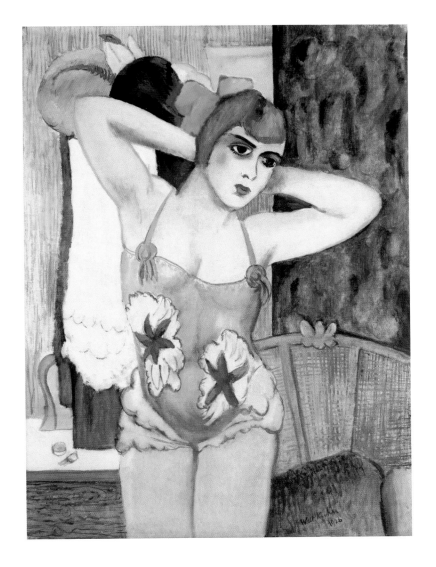

Hopper, Edward

Chop Suey, 1929

Courtesy of Collection of Mr. and Mrs. Barney A. Ebsworth/Bridgeman Art Library

Edward Hopper, perhaps more than any other artist, has captured the sense of loneliness and isolation that can only be experienced in the midst of a crowd in the modern city. His paintings, carefully constructed and composed to give the impression of a momentary glance – a voyeuristic gaze into the private space and emotions of an anonymous stranger – constitute a unique record of the changing sociology of modern America. *Chop Suey* focuses upon two women seated at a restaurant table. Despite this company, however, each woman seems alone, lost in her own thoughts in a world of silence, while the couple in the background seem similarly uncommunicative. The high angle of view and the cropping of both the 'Chop Suey' sign, seen through the window, and the female customer on the left, all add a sense of strangeness and alienation to the scene. Yet, for all its specifically American detail, Hopper's work was highly influenced by nineteenth-century French painting. Here, Hopper explicitly refers to the café scenes of both Degas and Manet, while simultaneously updating and relocating them in modern America.

CREATED

New York

MEDIUM

Oil on canvas

SIMILAR WORKS

Why Not Use the 'L'? by Reginald Marsh, 1930

Edward Hopper *Born* 1882 Nyack, New York

Died 1967

O'Keeffe, Georgia

Abstraction, 1930

Many of the works produced by Georgia O'Keeffe during the 1920s and 1930s hover enticingly on the margins between figuration and abstraction. The notion that art could be entirely non-representational, or abstract, was widely explored in the decade from 1910, particularly in the work of the Russian painter Vasily Kandinsky (1866–1944) and the Dutchman Piet Mondrian (1872–1944). Although O'Keeffe did not visit Europe during this period, she would have been made aware of these trends in European modern art through her contact with avant-garde circles in New York. Her attention would also have been drawn to the Synchromist works of Stanton MacDonald-Wright (1890–1973), an early American supporter of abstraction. From early in her career, O'Keeffe experimented with abstract forms, most notably in the work *Blue and Green Music* (1919). However, the key strength of O'Keeffe's work often resided in its derivation from natural, organic forms, producing shapes and colours that evoke plant forms, flowers and shells. O'Keeffe's near abstract, natural forms were highly influential on later painters, including Helen Frankenthaler (b. 1928) and Arshile Gorky (1904–48).

MEDIUM

Oil on board

SERIES/PERIOD/MOVEMENT

Abstract Art

SIMILAR WORKS

Fog Horns by Arthur G. Dove, 1929

Georgia O'Keeffe *Born* 1887 near Sun Prairie, Wisconsin

Died 1986

Johnson, Sargent

Mask, 1930–35

Sargent Johnson's early interests in sculpture were probably inspired by the work of his aunt, the African-American sculptor May Howard Jackson (1877–1931). He was also familiar with the work of many of the sculptors associated with the Harlem Renaissance, including Meta Warrick Fuller (1877–1968), Augusta Savage (1892–1962) and Richmond Barthé (1901–89), as well as the paintings of Aaron Douglas (1898–1979) and Archibald J. Motley (1891–1981). Johnson won a Harmon Foundation Award but, unlike many of the Harlem Renaissance recipients of this award, he showed no desire to travel to Europe. As he stated in 1935, 'Too many Negro artists go to Europe and come back imitators of Cézanne, Matisse, or Picasso'. Johnson's *Mask* is more concerned with celebrating African-American identity, emphasizing what he described as 'the natural beauty and dignity in that characteristic lip, and that characteristic hair, bearing and manner'. Johnson's reduction of form shows some influence from African masks as well as revealing a stylistic affinity with contemporary Art Deco. However, his chief concern was to promote a dignified image of African-American identity.

CREATED

San Francisco, California

MEDIUM

Bronze mounted on wooden base

SERIES/PERIOD/MOVEMENT

Harlem Renaissance

SIMILAR WORKS

Gamin by Augusta Savage, 1930

Sargent Claude Johnson *Born* 1887 Boston, Massachusetts

Died 1967

Pollock, Jackson

Going West, 1934–35

Jackson Pollock is best known for his abstract 'drip-painting' technique developed in the late 1940s. Earlier in his career, however, Pollock's work adopted a more narrative style and subject matter derived heavily from late nineteenth-century painters such as Pinkham Ryder. Like many American artists during the 1930s, Pollock was largely dependent upon the financial assistance of the Federal Arts Project (FAP) of President Roosevelt's 'New Deal'. He became widely aware of Regionalism and of the works of the Mexican muralists, for a while attending the experimental workshop of the painter David Alfaro Siqueiros (1896–1974). Pollock's Going West also reveals the strong influence of another muralist, Thomas Hart Benton (1889–1975), under whom Pollock had studied at the New York Art Students League. Here, Pollock's adoption of a heroic, frontier subject executed with broad, gestural brushstrokes pays homage to Benton's Regionalism. However, where Benton by now largely rejected modern European art and, in particular, abstraction, Pollock increasingly incorporated such factors into his own work as a means to express the changing experiences of life in modern America.

CREATED

New York

MEDIUM

Oil on canvas

SERIES/PERIOD/MOVEMENT

Abstract Art

SIMILAR WORKS

Over the Mountains (American Historical Epic) by Thomas Hart Benton, 1924–26

Jackson Pollock Born 1912 Cody, Wyoming

Died 1956

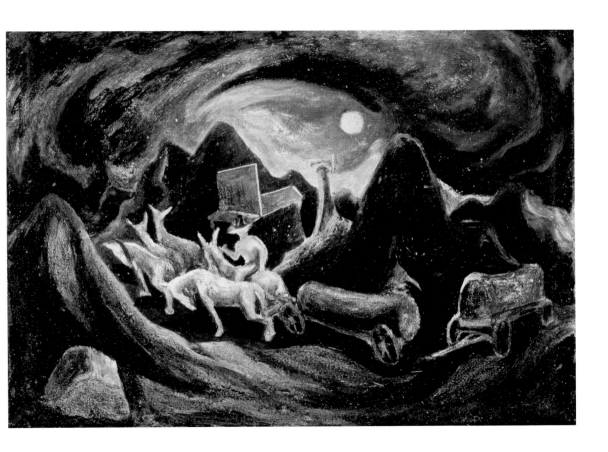

Davis, Stuart

Marine Landscape, 1937

Courtesy of Christie's Images Ltd/© Estate of Stuart Davis/VAGA, New York/DACS, London 2005

'I paint what I see in America, in other words I paint the American scene.' Stuart Davis's straightforward description of his approach to painting reveals the importance of national identity to the painter, not least of all at a time when many American artists were looking to Europe for inspiration. Davis's 'American scene' painting, however, was in stark contrast to the Regionalism espoused by Benton, Grant Wood (1892–1942) and John Steuart Curry (1897–1946). For where these artists rejected avant-garde developments, Davis embraced them, incorporating them into a style that made him the quintessential inter-war American artist. Davis's use of sharply defined, bright colours and flat patterned surfaces reminiscent of cartoons and posters, brought a rhythm and a vitality to works such as *Marine Landscape*, probably painted at the seaport of Gloucester, Massachusetts, where Davis regularly spent his summers. They also carry much of the energy, dynamism and improvisational flare of the jazz music he so passionately loved. As Davis later stated, 'For a number of years jazz had a tremendous influence on my thoughts about art and life ... I think all my paintings, at least in part, come from this influence.'

CREATED

Gloucester, Massachusetts

MEDIUM

Gouache on paperboard

SIMILAR WORKS

Organization by Arshile Gorky, 1933–36

Stuart Davis *Born* 1894 Philadelphia, Pennsylvania

Died 1964

Wood, Grant

Parson Weems' Fable, 1939

Grant Wood's idealized vision of the American Midwest attracted considerable attention throughout the 1930s. His works promoted traditional values of honesty, hard work and religious sentiment, and served as the visual articulation of American Isolationism. By the later 1930s, however, Regionalism was increasingly criticized for its naivety and its chauvinism. Despite these attacks, Wood continued to produce paintings extolling such values. In 1939, he turned his attention to one of the defining myths of American history, popularly known as Parson Weems' Fable. It recounts an episode in George Washington's childhood. Having been given a hatchet at the age of six, the young Washington chopped into the trunk of an expensive cherry tree. When his father sought the culprit, Washington confessed to his crime, whereupon he was embraced for telling the truth, rather than scolded. The story is apocryphal, having been made up by one Parson Mason Locke Weems in his biography of Washington. The tale was to act as a parable extolling the virtues of honesty and fortitude. For Wood, this myth served as a perfect vehicle for celebrating his own particular vision of traditional American values.

CREATED

Iowa

MEDIUM

Charcoal and chalk

SERIES/PERIOD/MOVEMENT

Regionalist

SIMILAR WORKS

Freedom from Want by Norman Rockwell, 1943

Grant Wood *Born* 1892 near Anamosa, Iowa

Died 1942

Pollock, Jackson
Moon Woman, 1942

During the 1930s, Jackson Pollock studied under the Regionalist painter Thomas Hart Benton and the Mexican muralist David Alfaro Siqueiros, both of whom influenced his later work. However, in the early 1940s he was also hugely fascinated by developments in Europe, including Surrealist Automatism and the recent paintings of Picasso. Pollock's *Moon Woman* clearly shows the influence of both. Here the artist depicts a strange metamorphic creature, crudely painted in bright, garish colours. On the left, he includes mysterious hieroglyphic signs, making the work highly reminiscent of the paintings of André Masson (1896–1987). By 1942, when Pollock produced *Moon Woman*, Masson was living in New York. However, Pollock notably combined this evocation of Automatism with stylistic devices culled directly from Picasso's recent work, including his many representations of his mistress Marie-Thérèse Walter. This is most evident in Pollock's depiction of the curvaceous left arm and the split eyeball. Although Picasso himself remained in Europe, much of his work, including his famous painting *Guernica*, could be seen in the Museum of Modern Art in New York at this time.

CREATED

New York

MEDIUM

Oil on canvas

SERIES/PERIOD/MOVEMENT

Abstract Art

SIMILAR WORKS

Girl Before a Mirror by Pablo Picasso, 1932

Jackson Pollock *Born* 1912 Cody, Wyoming

Died 1956

Diller, Burgoyne

Third Theme, 1945

As founding director of New York's Museum of Modern Art, Alfred H. Barr was probably one of the most influential supporters of European modernism in the United States. In 1936 he staged the groundbreaking exhibition 'Cubism and Abstract Art', an event that brought abstraction to the forefront of the American artistic consciousness and proved a major catalyst for the development of artists such as Burgoyne Diller. Diller was a member of the American Abstract Artists (AAA) group, an organization that looked to Europe, and particularly the work of the Dutch painter Piet Mondrian who, in 1940, had arrived in New York to escape the Second World War raging in Europe. Manhattan, with its tall skyscrapers, rigid grid structured streets and lively nightlife appealed hugely to Mondrian, who responded by modifying his geometrical abstraction to create colourful, exuberant works such as *Broadway Boogie-Woogie*. Diller's *Third Theme* draws heavily from Mondrian's work, adopting his simple grid structure and use of primary colours. Diller stuck rigidly to this style after Mondrian's death in 1944 and built a reputation as one of the most consistent and unflinching of the American abstractionists.

CREATED

New York

MEDIUM

Coloured pencils on vellum

SERIES/PERIOD/MOVEMENT

Abstract Art

SIMILAR WORKS

Broadway Boogie-Woogie by Piet Mondrian, 1942–43

Burgoyne Diller *Born* 1906 in New York

Died 1965

Gorky, Arshile
Year After Year, 1947

Like many young artists, Arshile Gorky took a while to find his own personal style and many of his early works reveal an agglomeration of diverse influences. After moving to the United States in 1920, Gorky initially produced works strongly influenced by European modernists including Cézanne, Braque and Picasso. During the late 1930s and early 1940s, however, Gorky increasingly adopted a looser, more abstract style of painting, revealing his increasing familiarization with Surrealism and particularly the works of Arp and Masson. From 1941 onwards, Gorky spent much of his time in the countryside in both Connecticut and Virginia where he produced a series of works, such as *Year After Year*, based loosely on the local landscape. Though seemingly abstract at first glance, these works incorporate rounded, organic shapes reminiscent of natural motifs such as rocks and plants and thus retain a clear reference to landscape painting. At the same time, these visceral forms seem to shimmer and float, recalling microscopic organisms drifting through a primordial soup. Gorky's near-abstract landscapes thus teem with life. His forms fill the entire surface of the canvas and, though never devoid of representation, were highly influential in the development of Abstract Expressionism.

MEDIUM

Oil on panel

SIMILAR WORKS

Untitled by Mark Rothko, 1946–47

Arshile Gorky (Vosdanig Manoog Adoian) *Born* 1904 Khorkum, Armenia

Died 1948

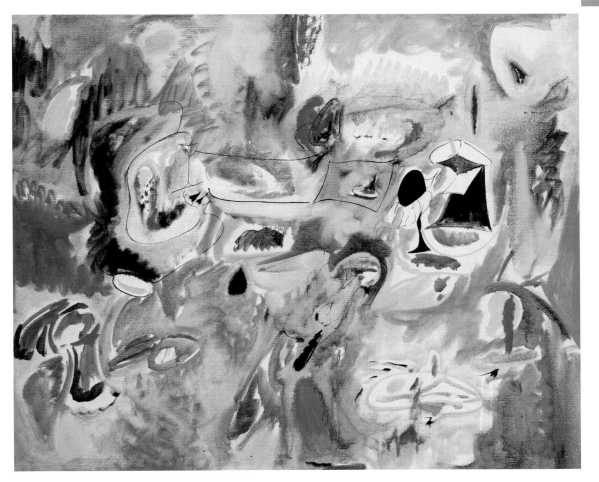

Lawrence, Jacob

The Wedding, 1948

Courtesy of Christie's Images Ltd/© ARS, NY, and DACS, London 2005

Like many Harlem Renaissance artists, Jacob Lawrence sought to combine the representation of specifically African-American experiences with the development of a unique style that combined African traditional forms with modern artistic trends. Lawrence's studies at the Harlem Art Workshop brought him into close contact with the painter Aaron Douglas, whose simplified forms and heightened colour palette left their mark on Lawrence's work. It was also during the 1930s that traditional American folk art began to be widely appreciated. Although a highly trained painter, Lawrence began to adopt a simplified drawing style reminiscent of the so-called 'naïve' painters. These qualities are very much evident in *The Wedding*. Here, Lawrence constructs the spectator as a participant in a wedding service, standing immediately behind the bride and groom. The figures are executed in a simple, stylized manner and silhouetted against a wall of flowers, painted as an explosion of chromatic colour. This decorative backdrop seems subtly to allude to the all-over style of Abstract Expressionism at a time when the movement was first drawing wider public attention.

CREATED

New York

MEDIUM

Tempera on gessoed board

SERIES/PERIOD/MOVEMENT

Harlem Renaissance

SIMILAR WORKS

Going to Church by William H. Johnson, *c.* 1940–41

Jacob Lawrence *Born* 1917 Atlantic City, New Jersey

Died 2000

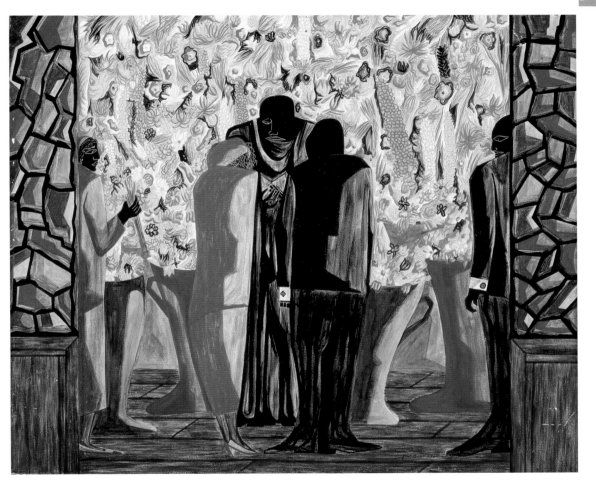

Baziotes, William

Eclipse, 1950

'It is the mysterious that I love in painting. It is the stillness and the silence. I want my pictures to take effect very slowly, to obsess and to haunt.' Many of the paintings produced by William Baziotes in the late 1940s and 1950s, such as *Eclipse*, certainly fulfil the artist's desire to create evocative, haunting images suggestive of strange creatures inhabiting mythical, ethereal landscapes. Here an undulating grey form, with a suggestion of both limbs and a head with open mouth, emerges from the bottom of the canvas, silhouetted against a blue-green background divided by a sharp horizon line. Two yellowish forms suggest celestial bodies, suns or moons, one in full glare, the other shrouded in shadow, as if during an eclipse. Baziotes was clearly inspired by the automatist works of the European Surrealists André Masson, Max Ernst (1891–1976) and Joan Miró (1893–1983), which became more widely known in the United States during the 1930s. His works adopt similarly abstract forms and colours, yet always evoke a poetic mood suggestive of the unconscious mind. Baziotes frequently exhibited alongside the Abstract Expressionists, but his works retain a stronger link to the European Surrealist tradition.

CREATED

New York

MEDIUM

Oil on canvas

SIMILAR WORKS

Painting by Joan Miró, 1950

William Baziotes *Born* 1912 Pittsburgh, Pennsylvania

Died 1963

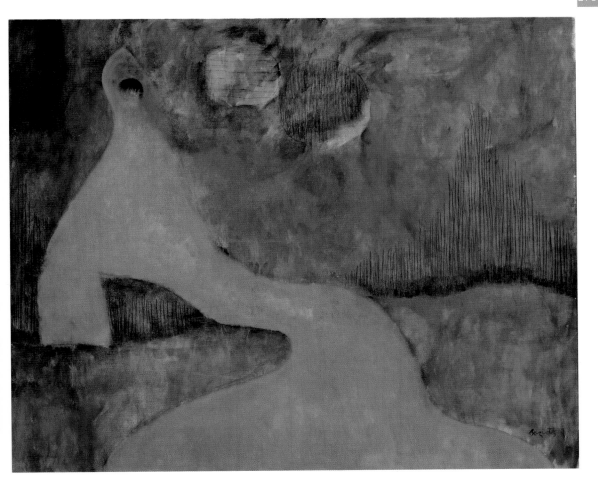

Smith, David

Family Totem, 1951

In 1925, David Smith spent a summer working at the Studebaker Motor Plant in his native Indiana, gaining experience working with metal that was later to shape his career as a sculptor. Smith initially introduced metal into his works after being shown illustrations of the welded iron works of the Spanish sculptor Julio González (1876–1942). In the mid 1930s, he travelled extensively throughout Europe, and the works he produced on his return reveal a number of key influences. For example, Smith began to incorporate pieces of scrap, clearly recalling the Dadaists' incorporation of detritus into their works. He also produced sculptures constructed from shapes of metal welded together, originally practiced by the Russian Constructivists and developed at the Bauhaus in Germany. However, Smith's strange, constructed assemblages, such as his *Family Totem*, also allude to human forms and recall Alberto Giacometti's (1901–66) early Surrealist sculptures. This emphasis on totems also carried resonances for the Native American tradition. Shortly after Smith's premature death in a road accident, the artist Robert Motherwell summed up his sophisticated treatment of such a brutal material as metal, when he stated of Smith, 'you were as delicate as Vivaldi and as strong as a Mack truck'.

CREATED

Bolton Landing, New York

MEDIUM

Painted steel

SIMILAR WORKS

Woman with a Mirror by Julio González, 1936–37

David Smith *Born* 1906 in Decatur, Indiana

Died 1965

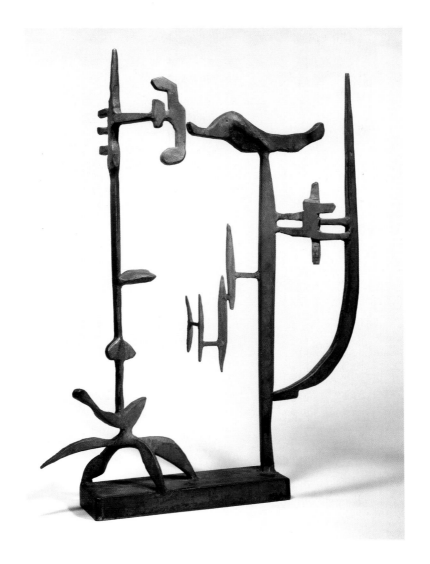

Francis, Sam
Round the World, 1958–59

Sam Francis was a key figure amongst the second generation of Abstract Expressionist painters who emerged in the mid to late 1950s. His emphasis on abstract forms and dripped paint was clearly influenced by Jackson Pollock, but unlike Pollock, Francis made extensive use of the white unprimed canvas and placed his canvases vertically while painting, thus allowing the paint drips to run in one direction. He also drew upon a range of other sources and, in 1950, travelled to Paris where he studied under Fernand Léger. Although Léger never fully abandoned figuration, his use of bold areas of floating colour overlapping the black outlines of his drawing clearly left their mark on Francis's work. Francis was also familiar with the distinctive type of abstract art practiced in Europe, usually referred to as Art Informel, and particularly the work of the Canadian-born painter Jean-Paul Riopelle (b. 1923). Francis's use of thin, fluid paints, seen in works such as *Round the World*, a title derived from his broad travels in 1957–68, have also been associated with Japanese calligraphy, an interpretation reinforced by his many visits to Japan and familiarity with Japanese cultural traditions.

CREATED

Paris, France

MEDIUM

Oil on canvas

SERIES/PERIOD/MOVEMENT

Abstract Expressionist

SIMILAR WORKS

Blue Night by Jean-Paul Riopelle, 1953

Sam Francis *Born* 1923 San Mateo, California

Died 1994

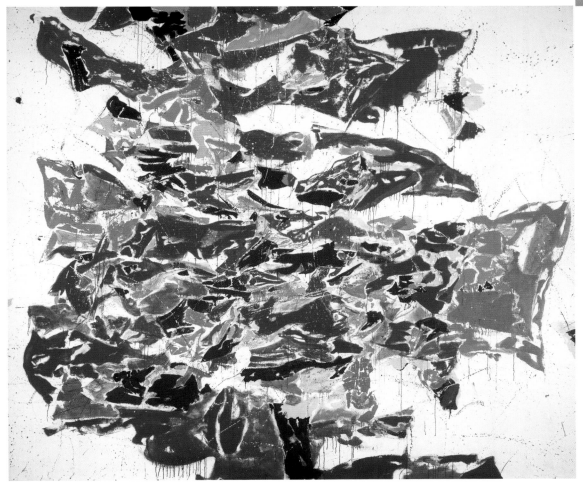

Ruscha, Edward

Art, c. 1960s

Ed Ruscha was a key participant in the Los Angeles-based Pop Art movement. He is best known for his cool, deadpan paintings based predominantly upon single words or phrases, frequently culled from the culture of advertising. Like Warhol, whose works celebrated consumer products such as Coca Cola and Campbell's soup, Ruscha introduced logos from major American corporations into his work. These have included Standard petrol stations, 20th Century Fox and even Spam. His works are often produced on the same scale as advertising billboards and thus emphasize the incursion of corporate signs into the American landscape. In *Art*, Ruscha offers a deliberately ironic comment on his own work. Where, after all, is the art in *Art*? And what distinguishes it from the countless painted billboards that littered the towns and highways of America? Ruscha's use of text worked within the tradition of earlier avant-garde art, including the Cubist collages of Picasso and Braque, René Magritte's (1898–1967) infamous painting of a pipe accompanied by the slogan 'Ceci n'est pas une pipe' ('This is Not a Pipe') and, closer to home, the collaged works of Robert Rauschenberg (b. 1925) and Jasper Johns (b. 1930).

CREATED

Los Angeles

MEDIUM

Acrylic on canvas

SERIES/PERIOD/MOVEMENT

Pop Art

SIMILAR WORKS

Eat, Die by Robert Indiana, 1962

Edward Ruscha *Born* 1937 Omaha, Nebraska

Kline, Franz
Black Sienna, 1960

Franz Kline is best known for his signature-style, monumental black-and-white abstract canvases. He was born in Pennsylvania, home to so many of the urban realists of the early twentieth century and, unsurprisingly, his early works displayed the gritty realism of his predecessors. After moving to New York, however, he increasingly came into contact with the emerging Abstract Expressionist artists and his works took a decidedly gestural turn. It has been claimed that Kline's turning point came after he saw one of his small sketches enlarged by a projector. From this point on, he worked on a monumental scale, producing canvases such as *Black Sienna* by painting bold, expressive marks, often using wide house painter's brushes, upon bare white canvas. This gestural style clearly owed a debt to both Willem de Kooning (1904–97) and Jackson Pollock. However, it has also been associated with oriental calligraphy, with its ideographs produced with the rapid movement of a thick, heavily loaded brush. Despite this seeming emphasis on gesture and speed, however, Kline frequently produced small sketches, which he then projected on to the large canvas before completing the work.

CREATED

New York

MEDIUM

Oil on canvas

SERIES/PERIOD/MOVEMENT

Abstract Expressionist

SIMILAR WORKS

At Five in the Afternoon by Robert Motherwell, 1950

Franz Kline *Born* 1910 Wilkes-Barre, Pennsylvania

Died 1962

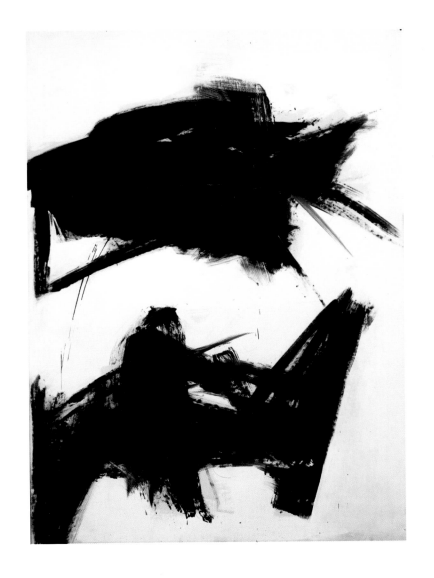

Frankenthaler, Helen

The Bay, 1963

Helen Frankenthaler's reputation was established in the early 1950s when she produced a painting entitled *Mountains and Sea* (1952). The work was characterized by its use of thin paint poured directly on to an unprimed canvas so that it seeped into the material, creating thin veils of floating colour. While the technique of pouring paint on to a flat canvas clearly derived from Pollock's recently developed drip technique, these floating veils of colour are more reminiscent of the early abstract watercolours and oils of Kandinsky, or the near-abstract, close-up views of plants and flowers by O'Keeffe. Frankenthaler's exquisite use of colour was also, without doubt, influenced by the subtle, richly saturated, colourist paintings produced by the Mexican artist Rufino Tamayo (1899–1991), under whom she studied. In paintings such as *The Bay*, Frankenthaler frequently alluded to the sublime qualities associated with the vastness of the American landscape, a factor that simultaneously recalls the nineteenth-century landscape paintings of Albert Bierstadt (1839–1902) and Thomas Moran (1837–1926). This allusion to the sublime, spiritually inspired landscape also links her works with those of the Colour Field painters, Barnett Newman (1905–70) and Mark Rothko (1903–70).

CREATED

New York

MEDIUM

Acrylic on canvas

SIMILAR WORKS

Months and Moons by Grace Hartigan, 1950

Helen Frankenthaler *Born* 1928 New York

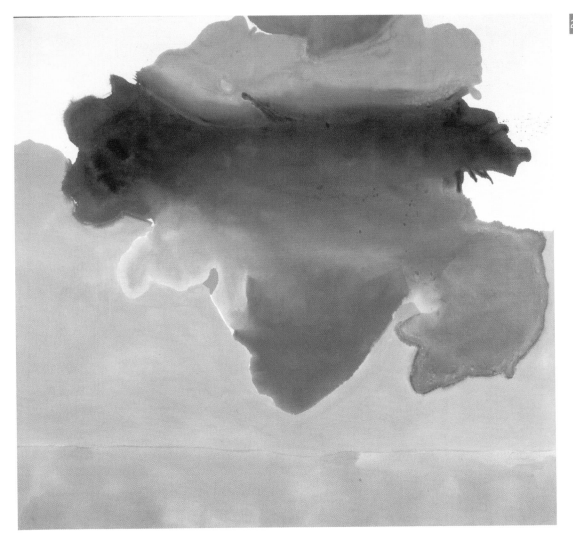

Wesselman, Tom

Great American Nude No. 44, 1963

The female nude has long played an important role in Western art. Thus when the Pop Art painter Tom Wesselman began a series of works under the title *Great American Nude*, he was self-consciously working within a long tradition of such representations. However, Wesselman's particular engagement with this theme both worked within and against established conventions. For example, in *Great American Nude No. 44*, Wesselman has combined a modern painting style, reminiscent of Matisse's sensuously painted nudes of the 1930s, with an assemblage technique recalling the recent work of Rauschenberg. Here a real radiator, telephone and door contrast with the painted interior and nude figure to highlight the artificiality of the later. Wesselman's work depersonalises and objectifies the female figure, whose body has been reduced to a flat plane of colour accentuated only by the blonde hair, lips and nipples. The stiff, provocative pose also draws upon the kind of pornographic images published in Hugh Hefner's recently launched *Playboy* magazine. Wesselman produced a series of these works, usually placing the female nude in domestic interiors typical of middle-class America. They remain, in many ways, problematic images, as they critique, yet simultaneously celebrate, this eroticised objectification.

CREATED

New York

MEDIUM

Acrylic and paper collage on board with radiator, telephone, coat and door

SERIES/PERIOD/MOVEMENT

Great American Nude series

SIMILAR WORKS

American Madonna #1 by Allan D'Arcangelo, 1962

Tom Wesselman *Born* 1931 Cincinnati, Ohio

Andre, Carl

Alstadt Rectangle, 1967

The Minimalist sculptor Carl Andre is best known for his use of standard components to create works that can simply be put together for an exhibition and then dismantled when the exhibition closes. Andre's chief inspiration here was the work of the early Soviet avant-garde and particularly Alexander Rodchenko (1891–1956). Following the Bolshevik Revolution of 1917, many Soviet artists set out to redefine art as a practice, striving to link it to industry and engineering in order to serve the masses. However, the leap from art to industry could not take place in one step and Rodchenko thus experimented with what he called laboratory work, using standardized units of wood and metal. In *Alstadt Rectangle*, Andre placed 100 standardized, flat steel plates on the floor of the gallery. As the components were not attached to each other or to the floor, they could simply be picked up and removed and thus, no longer constitute a work of art. Their existence was temporal and entirely dependent upon the museum context. Andre's floor pieces shifted the orientation of sculpture from the vertical to the horizontal and frequently encouraged spectators to 'enter' his floor pieces by walking upon them.

MEDIUM

100 hot rolled steel units

SERIES/PERIOD/MOVEMENT

Installation Art

SIMILAR WORKS

Untitled by Donald Judd, 1965

Carl Andre *Born* 1935 Quincy, Massachusetts

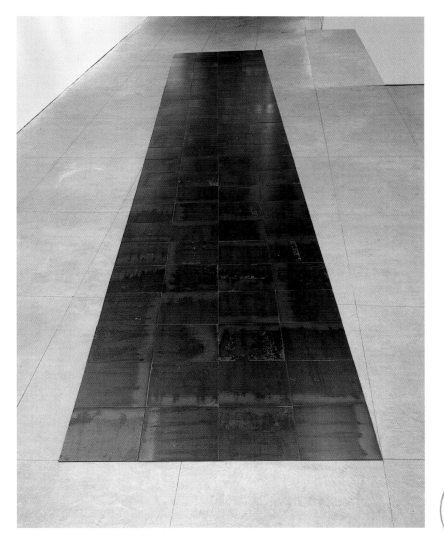

Pearlstein, Philip

Female Nude, 1973

Courtesy of Private Collection/Bridgeman Art Library/© Philip Pearlstein

Philip Pearlstein's paintings of the female nude, like those of Tom Wesselman, depersonalize and objectify the model, not least of all through the sharp cropping, often, as here, excluding the head altogether. In every other sense, however, his works are the very antithesis of Wesselman's quasi-pornographic representations. For Pearlstein, the nude, male or female, is not a sexualized body but, as he himself claimed, 'a constellation of still-life forms'. Pearlstein's works don't so much gaze at the body as analyze it – clinically, scientifically, matter-of-factly. They reveal it from odd angles and in the harsh glare of flat electric lighting, accentuating its every detail, its every flaw. Here Pearlstein was reacting against the individualistic, expressionist qualities of post-war American abstraction, returning instead to the realism of the French nineteenth-century painter Gustave Courbet (1819–77). He was also drawing on the Realist tradition as expounded in the United States by painters like Eakins and the Ashcan School. However, Pearlstein's works took this realism even further. Here every detail, from the model's torso, to the skirting board, is sharply focused and treated with equal emphasis. It is not just the model who is here de-individualized – so too is the artist as producer.

CREATED

New York

MEDIUM

Acrylic on canvas

SERIES/PERIOD/MOVEMENT

Realist

SIMILAR WORKS

John Perrault by Alice Neel, 1972

Philip Pearlstein *Born* 1924 Pittsburgh, Pennsylvania

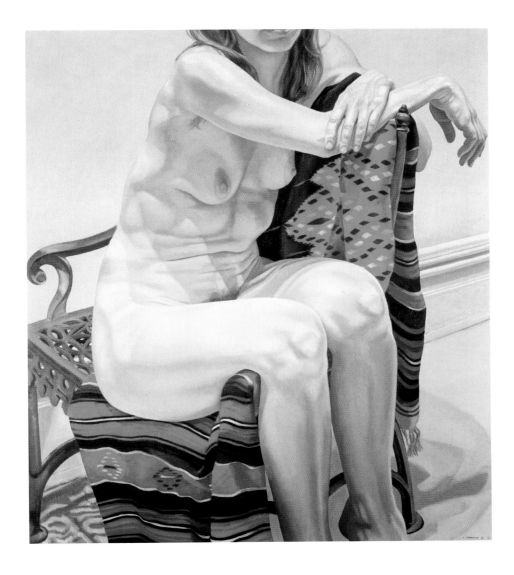

Nevelson, Louise

Dawn's Landscape, 1975

Courtesy of Christie's Images Ltd/© ARS, NY, and DACS, London 2005

Louise Nevelson is best known for her low relief sculptures made from scraps of wood. She first began to produce these works in the 1950s, placing old wooden fragments in boxes stacked against the wall. The resulting assemblages were then painted a single colour – initially black but later white – to create screen-like forms. Nevelson's work can be related to the Neo-Dada experiments of Rauschenberg and Johns, as well as the assemblage sculptures of Ed Kienholz (1927–94). However, her works retain an enigmatic, personal quality more reminiscent of Joseph Cornell's elusively Surrealistic boxes of the 1940s and 1950s. Some of Nevelson's early works in this style, such as *Sky Cathedral* (1958) were monumental in size, sometimes filling whole gallery walls. However, she also worked on a more intimate scale, as can be seen in *Dawn's Landscape*. Here Nevelson has constructed a relief using fragments of material including electrical components from domestic lighting circuits. Painted a uniform white and mounted on a flat, white background, these appear as decorative elements in an abstract composition, notably recalling Kasimir Malevich's (1878–1935) famous *Suprematist Composition: White on White* (c. 1918) from the Museum of Modern Art in New York.

CREATED

New York

MEDIUM

Wood, painted white

SIMILAR WORKS

Space Object Box ('Little Bear, etc' motif) by Joseph Cornell, 1950s–1960s

Louise Nevelson *Born* 1899 Kiev, Russian Empire

Died 1988

Kelly, Ellsworth
Nine Squares, 1976–77

Courtesy of Christie's Images Ltd/© Ellsworth Kelly

Ellsworth Kelly's Minimalist paintings, like those of Frank Stella (b. 1936), were a specific reaction against the dominance of Abstract Expressionism in post-war America. His hard-edged abstraction strove to undermine the heightened emotionality of Pollock's gestural painting and the Colour Field works of Newman and Rothko by emphasizing the impersonal, by diminishing any sense of individuality within his works. Like the Post-Painterly Abstract painters Morris Louis (1912–62) and Kenneth Noland (b. 1924), Kelly's works consist of simple geometrical forms and pure, flatly applied colours. In *Nine Squares*, for example, Kelly simply presents nine coloured squares in a mathematically precise, evenly spaced composition. Each square is a different colour, but evenly rendered, resembling an automatically produced print test, rather than an individual work of art. Though superficially resembling Mondrian's abstract compositions of the 1920s and 1930s, Kelly's cool, formulaic approach is clinical, and resists the spiritualist readings inspired by Mondrian's Theosophical beliefs. His subtle sense of colour does, however, recall the late works of Matisse, in particular his series of cut-outs. Kelly's work can also be associated with the Op Art movement of the 1960s.

CREATED

New York

MEDIUM

Screenprint and offset lithograph on Rives BFK, 101.6 × 101.6 cm/ 40 × 40 inches, A. 164

SERIES/PERIOD/MOVEMENT

Minimalist

SIMILAR WORKS

Untitled No. 8 by Agnes Martin, 1975

Ellsworth Kelly *Born* 1923 Newburgh, New York

Guston, Philip
Legend, 1977

Philip Guston began his artistic career as a figurative painter in the 1930s. Guston was a keen admirer of the Mexican muralists and, after meeting José Clemente Orozsco (1883–1949) in Los Angeles in 1934, travelled to Mexico to work as his assistant. After moving to New York in 1935, Guston participated as a mural painter for a number of projects commissioned by the government as part of the WPA. With the emergence of Abstract Expressionism in the 1940s, Guston abandoned figuration entirely. However, by the mid to late 1960s he had begun to reintroduce figurative content into his work. This was, to a certain extent, influenced by Pop Art's embracing of popular culture and, at this point Guston began to include cartoon-like details into his own works. In *Legend*, for example, Guston introduced a series of objects, including boots, open tin cans, bottles and other anomalous detritus, all executed in a red tonality and floating, like a series of indecipherable hieroglyphs in space. Yet Guston's revived figuration contrasted starkly with the Pop mentality. Rather than celebrating mass culture, Guston's works seem obscure, more motivated by a personal symbolism reminiscent of 1930s Surrealism.

CREATED

New York

MEDIUM

Oil on canvas

SERIES/PERIOD/MOVEMENT

Pop Art

SIMILAR WORKS

Red Banner by Susan Rothenberg, 1979

Philip Guston *Born* 1913 Montreal, Canada

Died 1980

Bearden, Romare

Jazz II, 1980

Romare Bearden's artistic career was slow in starting. He first began to make a name for himself in the mid 1940s as an abstract painter, but this success was not sustained. In the early 1960s, however, in the midst of the Civil Rights movement, Bearden joined a group of African-American musicians, writers, poets and painters called Spiral. Shortly after this he created his first large-scale collage. Bearden's collages were certainly influenced by the photomontages of the German Dadaists John Heartfield (1891–1968) and Hannah Höch (1889–1978); indeed, he had studied with the German Dadaist George Grosz (1893–1959) in New York in the mid 1930s. Bearden, however, frequently enlarged his collages to a monumental scale and included large, flat areas of coloured paper, recalling the late paper cut-outs of Matisse. More importantly for Bearden, his works represented experiences from African-American life. These included Harlem street scenes, rural scenes from his native North Carolina and, as seen here, scenes of African-American jazz musicians. Jazz, however, provided more than just a subject for Bearden. Like Stuart Davis, he sought to create a visual equivalent to jazz, celebrating the raucous energy, dissonant harmonies and passionate improvisations of America's greatest cultural invention.

CREATED

New York

MEDIUM

Lithograph with hand colouring

SIMILAR WORKS

Horn Players by Jean-Michel Basquiat, 1983

Romare Bearden *Born* 1914 Charlotte, North Carolina

Died 1988

Indiana, Robert

The Figure Five (Five Star), 1980

In 1963, Robert Indiana began a series of works entitled *The Demuth American Dream*. These consisted of several canvases placed in a cruciform shape, each representing a circle emblazoned with a red star and the figure 5 in gold at the centre. Around the edge of the circle, Indiana stencilled various three-letter words such as 'die', 'eat', 'hug' and, as in this later print, 'err'. The work pays homage to the American Precisionist painter Charles Demuth (1883–1935) and his most famous work *I Saw the Figure 5 in Gold* (1928). Demuth's original work introduced bright urban signs and neon advertising to celebrate the vibrancy and excitement of the city. By the 1960s, however, this idealism seemed outdated and Indiana's reworked signs seem more reminiscent of bland road markers or banal company logos. Here the commands, to 'die' or to 'err' introduce a sense of uncertainty, alluding to the use of stencilled letters on military vehicles and conflating the star-spangled banner with the red star of the Soviet Union. His reworking of Demuth's original work charts a shift from the utopianism of the American Dream in the 1920s, to the anxieties and uncertainties that underwrote this same concept in the 1960s.

MEDIUM

Colour screenprint on wove paper

SIMILAR WORKS

Art by Ed Ruscha, *c.* 1960s

Robert Indiana (Robert Clark) *Born* 1928 New Castle, Indiana

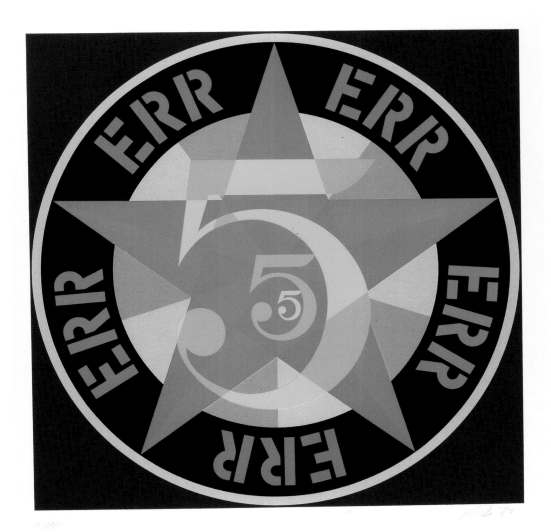

Nutt, Jim
Loop, 1988

The painter Jim Nutt has built a significant reputation as a figurative artist, most notably for his idiosyncratic, cartoon-like portraits of women. Nutt first emerged in the mid 1960s as a member of the oddball group of Chicago-based painters known as The Hairy Who. He has also been closely associated with the Chicago Imagists. Nutt's technique is highly meticulous and derived from the early northern renaissance tradition. Using modern acrylic paints he builds up his canvas with thin layers of transparent and translucent colour to create a luminous, highly detailed surface. Indeed, some of his paintings can take up to a year to complete. Nutt's portraits are shocking in their distortions and seem to challenge conventional notions of feminine beauty. At the same time, however, their clumsy draughtsmanship and shallow space alludes to the early portraits produced by the first settlers in America back in the seventeenth century, thus linking modern America to its colonial roots. Another major influence that should not be overlooked, however, is Picasso. In particular Nutt draws heavily on the Neoclassical paintings and drawings of the late 1910s and early 1920s, as well as Picasso's later portraits of his mistress Marie-Thérèse Walter.

CREATED

Chicago

MEDIUM

Acylic on canvas

SIMILAR WORKS

Anastasia by Alex Katz, 1984

Jim Nutt *Born* 1938 Pittsfield, Massachusetts

American Art

Styles & Techniques

Glackens, William James

Boys Sliding, 1897

William Glackens was one of the founder members of the group of realist painters who were later dubbed the Ashcan School. As *Boys Sliding* reveals, however, Glackens' interest in everyday subject matter developed early. Like many of the Ashcan School artists, Glackens first worked as a newspaper illustrator before taking up painting in 1891. In this work, Glackens has focused on a scene that might be witnessed any day, but rarely appeared as a subject for painters; a group of young boys playing together by sliding down a rocky outcrop. Glackens has notably added a sense of drama to the scene by his use of dark, contrasting light. The figures at the apex of the outcrop are silhouetted against a bright sky with one dominant yet isolated figure overseeing events. The presence of a single tree with broken branches on the right serves to draw the spectator's attention to the central activity yet, with its fractured branches, also alludes to the sense of physical risk that inspires the boys' game. Here, rough play is presented as a preparation for the dangers that these children may well face in later life.

CREATED

New York

MEDIUM

Oil on canvas

SERIES/PERIOD/MOVEMENT

Ashcan School

SIMILAR WORKS

42 Kids by George Bellows, 1907

William Glackens *Born* 1870 Philadelphia, Pennsylvania

Died 1938

Sargent, John Singer

Mrs Fiske Warren, 1903

By the beginning of the twentieth century, John Singer Sargent had established a reputation as one of the most sought-after society portraitists of his era. In 1903 he was commissioned to produce a portrait of Mrs Fiske Warren, a highly talented Bostonian who had studied music with Gabriel Fauré in Paris, together with her daughter Rachel. Painted in the splendid Gothic room of the influential art collector Isabella Stewart Gardner, Sargent has here placed his sitter in a throne-like Renaissance chair, looking directly towards the viewer. Mrs Warren's daughter rests her face affectionately on her mother's shoulder in a gesture echoed by the inclusion of a polychrome Madonna and child statuette placed on the mantelpiece in the background. Yet despite this overt reference to close family bonds, the pose seems highly staged, each figure unaware of each other's presence despite their physical proximity. Here Sargent has captured the mood of his sitters with great psychological intensity – who appear as mere adornments within this highly decorated interior. Perhaps not surprisingly, Mrs Warren was less than delighted with her portrayal, considering it far too superficial.

CREATED

Boston, Massachusetts

MEDIUM

Oil on canvas, 152.4 x 102.55 cm/60 x 40 3/8 inches

SIMILAR WORKS

Miss Amelia Van Buren by Thomas Eakins, c. 1891

John Singer Sargent *Born* 1856 Florence, Italy

Died 1925

Burchfield, Charles E.

Lighted Window, 1917

Charles Burchfield made his name as a watercolourist painting landscapes in which the grandeur of nature dominated. His early works, produced shortly after he completed his studies in Cleveland, are often dark and pessimistic, presenting the landscape as threatening and unforgiving. *Lighted Window* conforms to this style, depicting a small, rickety house overshadowed by the bare branches of a tree. Snow lies thick on the roof of the house and ground, and the whole scene is executed in a dull monochrome. This winter mood is momentarily broken, however, by the orange glow from a ground-floor window. Inside, the faint outline of a figure can be seen, looking out at the bleak wintry landscape. As if to echo this one bright light emanating from the shadowy house, Burchfield has also included a single white star shining in the night sky. These two points of light glow from out of the dense gloom of night, like beacons of hope. Burchfield notably painted this image on 31 December 1917, while war raged in Europe. Here, the passage of the old year to the new offered a tiny glimpse of optimism for the future in the midst of despair.

CREATED

Cleveland, Ohio

MEDIUM

Watercolour and gouache on paper laid down on board

SERIES/PERIOD/MOVEMENT

First World War Era

SIMILAR WORKS

Bleecker and Carmine Streets by George Luks, *c.* 1915

Charles Ephraim Burchfield *Born* 1893 Ashtabula Harbor, Ohio

Died 1967

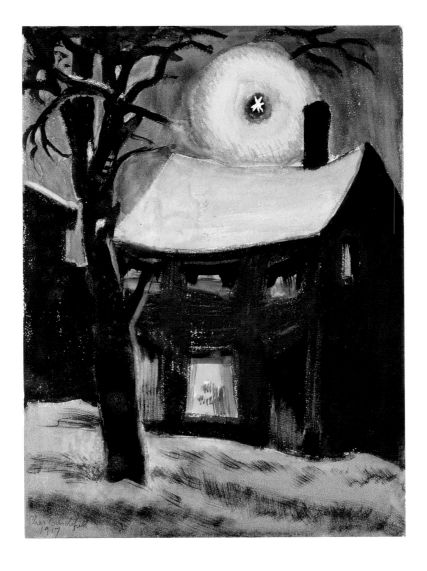

Stella, Joseph
The Virgin, 1922

Joseph Stella's fascination for the excitement and modernity of 1920s New York was amply expressed in his famous five-panel series entitled *The Voice of New York Interpreted* (1920–22) with its famous representation of Brooklyn Bridge. However, he never forgot the artistic tradition of his Italian homeland. In 1922 Stella made a return trip to his native Naples and here executed a number of paintings based upon Renaissance precedents. These included both mythological subjects, such as *Leda and the Swan* and *The Birth of Venus*, and religious works including *The Virgin*. This latter work pays homage to the early Renaissance paintings of Giotto (*c.* 1267–1337) and Piero della Francesca (*c.* 1415–92), particularly through the simplification of forms and use of bright colour. Here Stella has presented the virgin dressed in a highly decorated costume adorned with flowers. She is surrounded by exotic fruits and birds of paradise while in the background, a heavenly light glows behind her head to form a halo. Boats sail peacefully in the Bay of Naples, identifiable by the presence of Mount Vesuvius on the right, and the low lying buildings lining the coast, so much in contrast to the stark verticality of New York.

CREATED

Naples, Italy

MEDIUM

Oil on canvas

SIMILAR WORKS

Virgin and Child (Mary) by Henry Ossawa Tanner, *c.* 1922

Joseph Stella *Born* 1877 near Naples, Italy

Died 1946

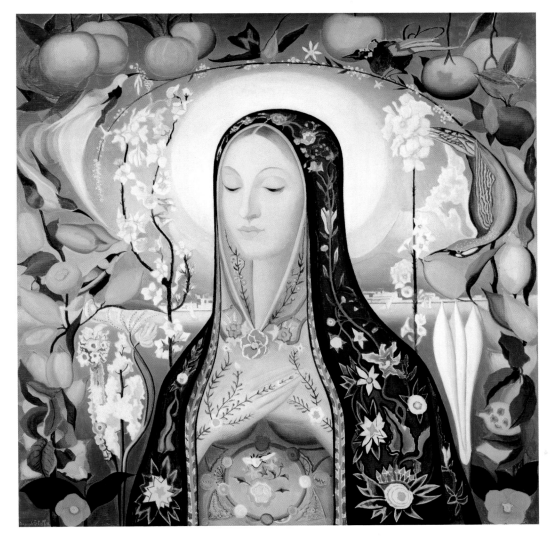

O'Keeffe, Georgia

The Red Maple at Lake George, 1926

Georgia O'Keeffe was a key player in the emergence of a uniquely American form of modern art. After early studies in both Chicago and New York during the first decade of the twentieth century, O'Keeffe took up teaching posts in South Carolina and Texas before returning to New York in 1918. Here, her career was supported by Alfred Stieglitz, the influential owner of a gallery called 291, whom she married in 1924. In the mid 1920s O'Keeffe was initially influenced by the Precisionists, and produced a series of hard-edged works representing New York skyscrapers, such as *New York with Moon* (1925). It was also around this time that she started to produce near-abstract paintings based upon natural forms including plants, flowers and shells. *The Red Maple at Lake George* provides a key example of this approach. Here the entire canvas is filled with soft, undulating, forms, executed in luminous reds and blacks. The use of carefully modulated tonalities reminiscent of watercolour paintings, gives the impression of light, ephemeral forms floating in an undefined space. At the same time, however, these shapes evoke, though never fully describe, natural forms, suggestive of leaves seen in extreme close-up.

CREATED

New York

MEDIUM

Oil on canvas

SIMILAR WORKS

Two Callas (photograph) by Imogen Cunningham, *c.* 1929

Georgia O'Keeffe *Born* 1887 near Sun Prairie, Wisconsin

Died 1986

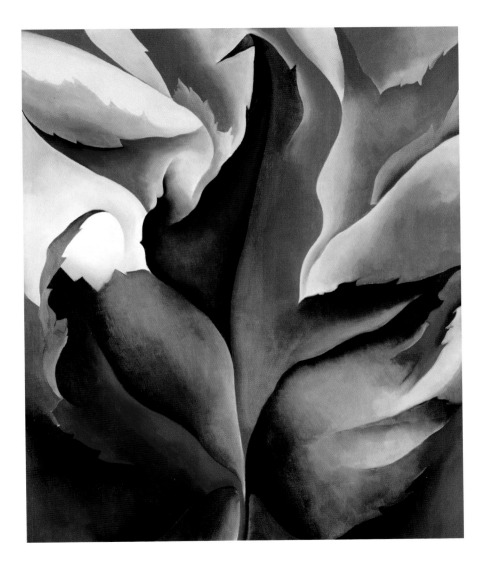

Calder, Alexander

Reclining Nude: Sculpture of Josephine Baker, c. 1930

Alexander Calder's career as a sculptor might seem to have been pre-ordained: both his father and grandfather had been successful sculptors, and his mother forged a career as a painter. Despite this noble lineage, however, Calder first studied mechanical engineering before working as a ship's fireman and a logger. In 1926 he travelled to Paris, where he set up a studio. Earlier, Calder had established a reputation for his skill in making rapid sketches of people in the street from a single, unbroken line. In Paris he extended this technique to sculpture, making caricatural portraits of his friends and acquaintances from thin wire, referring to this technique as 'drawing in space'. Here he represents the famous African-American singer and dancer Josephine Baker, who left the United States to forge a successful career in Paris. Calder's forms were, in large part, derived from the automatist drawings and biomorphic forms of Jean (Hans) Arp (1887–1966), and André Masson (1896–1987). Later, however, he developed his technique by introducing movement into his works. He is best known as the inventor of the 'mobile', a paean to his youthful experiences in mechanical engineering.

CREATED

Paris, France

MEDIUM

Wire

SERIES/PERIOD/MOVEMENT

Drawing in Space

SIMILAR WORKS

Wire Construction (Maquette for a Monument to Guillaume Apollinaire) by Pablo Picasso, 1928

Alexander Calder *Born* 1898 Lawnton, Pennsylvania

Died 1976

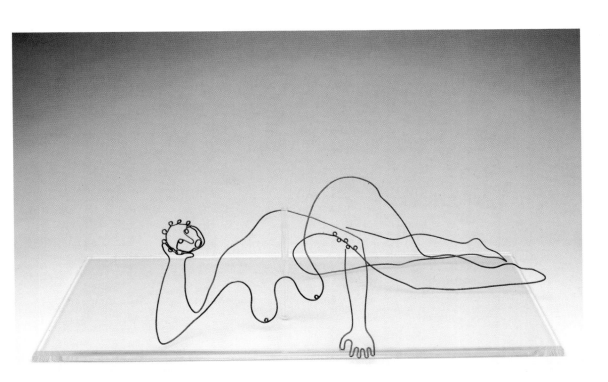

Dove, Arthur

Ice and Clouds, 1931

Arthur Dove is often recorded as the first abstract painter in the United States, a claim based upon a series of works produced in 1910 and 1911. These paintings, however, were not widely exhibited at the time and certainly incorporate both colours and motifs drawn directly from nature, reflecting Dove's lifelong passion for the great outdoors. Dove had a wide knowledge of modern European painting having spent much time in Paris between 1907 and 1909, but his main inspiration was always nature itself. As he later declared, 'I can claim no background except perhaps the woods, running streams, hunting, fishing, camping, the sky'. Dove's *Ice and Clouds* reflects this passion for nature in the raw. Here he presents a scene high in the mountains, with a glacial form moving slowly through a valley. Two cloud forms echo the shape of the mountains themselves as they hover in the sky, yet appear as solid as the rocks themselves. Dove described his technique as starting from nature, but gradually abstracting the forms and colours into shapes and planes of pure colour. With its bold shapes, strong colours and compressed space, *Ice and Clouds* encapsulates this process of abstracting from nature.

CREATED

New York

MEDIUM

Oil on board

SERIES/PERIOD/MOVEMENT

Abstract Art

SIMILAR WORKS

Untitled (Bear Lake) by Georgia O'Keeffe, 1931

Arthur Dove *Born* 1880 Canandaigua, New York

Died 1946

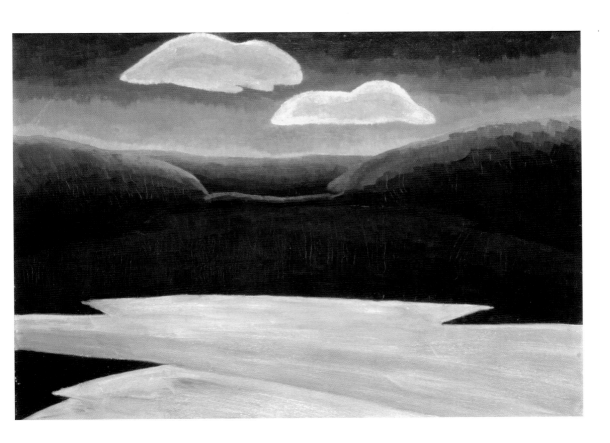

Demuth, Charles

Buildings Abstraction – Lancaster, 1931

Like many of the works produced by the Precisionists, Charles Demuth's *Buildings Abstraction – Lancaster*, focuses upon modern industrial forms. Its means of execution, however, also addresses notions of technology and industrialization. Demuth's painting is highly linear in its structure and uses a limited palette of red, blue and white with yellow highlights. The lines defining the structures represented are sharp and straight as if drawn with a ruler rather than freehand with a brush. Both curves and spatial recession are reduced to a minimum and every surface is given an equal solidity. Even the rays of light flooding diagonally over the factory, and the smoke emerging from the chimney, emphasize geometrical forms and are bordered by sharply defined, clean-edged lines. Notably, Demuth has left areas of the sky and the lower-left corner of the work devoid of colour, though structural lines can be seen, as if the work is as yet unfinished. However, this contrast of colour and monochrome only serves to highlight the artificiality of Demuth's image, constructed more like a technical drawing based upon measurements and ratios than on the subjective impression of the individual artist.

CREATED

Lancaster, Pennsylvania

MEDIUM

Oil on board

SERIES/PERIOD/MOVEMENT

Precisionist

SIMILAR WORKS

Pittsburgh by Elsie Driggs, 1927

Charles Demuth *Born* 1883 Lancaster, Pennsylvania

Died 1935

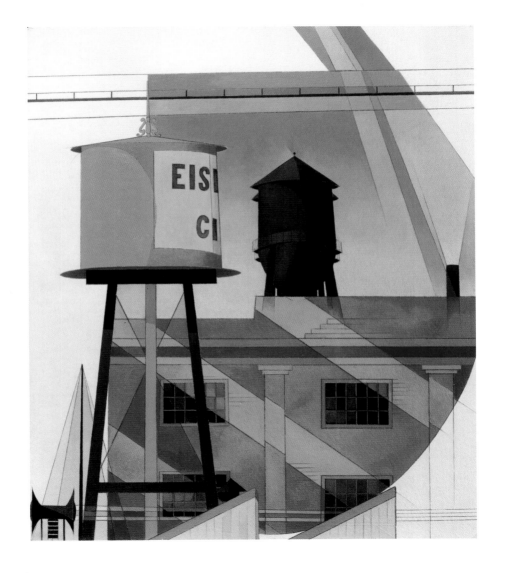

Hopper, Edward
Summer in the City, 1932

One of Edward Hopper's greatest strengths was his capacity to articulate a sense of loneliness and isolation, even in scenes representing urban life. *Summer in the City*, for example, presents two figures, a woman seated on the edge of a bed next to a naked man lying face down. Both inhabit a stark empty room devoid of any other furniture. No pictures adorn the plain walls and even the windows are positioned to allow the spectator no more than a partial view of rooftops and sky. Here only the contrast of light and shade generated by the sharply defined shadows falling across the room offers any relief to the monotonously plain interior. Yet it is Hopper's careful attentiveness to this monotony, to this visual inactivity, that reinforces the sense of isolation and alienation in the work. Who, we are bound to ask, are these two figures? Husband and wife? Lovers conducting an affair in a cheap, anonymous hotel room? And why do they sit in such physical proximity, yet convey such psychic distance from each other? Hopper offers us a tantalizing, voyeuristic glance at this mysterious, indefinable scene, but denies us any narrative closure.

CREATED

New York

MEDIUM

Oil on canvas

SIMILAR WORKS

The Street Balthus by Balthasar Klossowski, 1933

Edward Hopper *Born* 1882 Nyack, New York

Died 1967

Ray, Man
Self-Portrait, 1933

Man Ray was born Emmanuel Radinski, but from the age of 15 he was known as Man Ray. He was a major figure in the New York Dada movement that emerged during the First World War and a close colleague of both Marcel Duchamp (1887–1968) and Francis Picabia (1879–1953). Although he began as a painter, Man Ray is probably best known for his photographic works and, in particular, for his development of innovative techniques such as solarization (in which the photographic print is briefly exposed to light, thus causing a partial reversal of tones) and for the cameraless Rayograph (the placement of objects directly on to photographic paper, which is then exposed and printed). Ray moved to Paris in 1921, where he became heavily involved with the Surrealists. His photographic *Self-Portrait* also shows the influence of the German Dadaist Raoul Hausmann (1886–1971), especially his sculpture entitled *Mechanical Head* (1919–20). Here Ray has included a plaster bust of his own head alongside an assortment of strangely juxtaposed objects, casts of hands, a glass orb and a wooden ornament. This unlikely combination of objects is designed to evoke incongruity, the sense of the uncanny generated in the unconscious mind during dreams.

CREATED

Paris, France

MEDIUM

Silver gelatin print

SIMILAR WORKS

Mechanical Head by Raoul Hausmann, 1919–20

Man Ray (Emmanuel Radinski) *Born* 1890 Philadelphia, Pennsylvania

Died 1977

Davis, Stuart

Underpass No. 2

The interwar years witnessed something of a tension in American art. As European modern painting became more widely known, especially after the foundation of the Museum of Modern Art in New York in 1929, so many American artists embraced European styles and techniques such as Fauvism, Cubism and Surrealism. However, in the increasingly Isolationist political climate, other artists and critics condemned this dependence on Europe, rejecting modern art in favour of developing a more realist-inspired art based exclusively upon American life and values. Few artists managed to bring together these two seemingly conflicting concerns as successfully as Stuart Davis. Davis was a strong admirer of European modernism, which he had encountered at the 'Armory Show' in 1913 and again on a trip to Paris in the late 1920s. However, Davis also valued the American environment and developed a unique style that combined Cubist influences with the bright lights and colours of American cities and the syncopated rhythms and dissonant harmonies of jazz music. In works such as *Underpass No. 2*, Davis adopts abstract patterns and strong, vibrant colours to allude to, rather than represent, the energy and exuberance of an American urban setting.

CREATED

New York

MEDIUM

Gouache on paper

SIMILAR WORKS

Untitled by Willem de Kooning, *c.* 1937

Stuart Davis *Born* 1894 in Philadelphia, Pennsylvania

Died 1964

Wood, Grant

Hired Man, c. 1934–42

During the 1930s, in the midst of the Depression and widespread unemployment, Grant Wood's idealized vision of the American Midwest proved highly popular. His works avoided dwelling on poverty, providing instead a nostalgic, escapist world inhabited by contented individuals. In this way his work contrasts sharply with the contemporary Social Realist painters like Reginald Marsh (1898–1954), Ben Shahn (1898–1969) and Isabel Bishop (1902–88). Wood's *Hired Man* encapsulates this approach. Here he has depicted an anonymous worker during his lunch break. The posture of the figure is almost dance-like and his jaunty hat and remarkably clean dungarees betray no sign of previous heavy labour. Rather, Wood reinforces the sense of the worker's natural roots, his direct contact with nature, here sat on a cut tree trunk, as if he has naturally grown out of the soil itself. Moreover, he has placed this figure against a flat, bright orange background, further isolating him from the context of a working landscape. Sat on his plinth-like tree trunk, the figure resembles little more than a porcelain ornament, a jolly worker painted in bright colours to cheer up the domestic interior.

CREATED

Iowa

MEDIUM

Charcoal and chalk on paper

SERIES/PERIOD/MOVEMENT

Depression Era

SIMILAR WORKS

The Lord is My Shepherd by Thomas Hart Benton, 1926

Grant Wood *Born* 1892 near Anamosa, Iowa

Died 1942

Hopper, Edward
Study for *Nighthawks*, 1942

Nighthawks is perhaps Edward Hopper's most famous work. Produced in 1942, whilst the nation was at war, it depicts four figures, three customers and an employee, in a diner at night. In a typically Hopper manner, the narrative is obscure, the spectator remaining uncertain as to the relationship between the figures within, and indeed why he or she is situated on the empty street looking in. Hopper planned his paintings very carefully, as can be deduced by this preparatory study. Here Hopper, even at this early stage, has captured the effect of the artificial light flooding out from the diner and illuminating this nocturnal scene. He has also carefully plotted the position of each figure and the spaces between them so as to emphasize further the sense of isolation. From other preparatory drawings, it is evident that Hopper gradually shifted the viewpoint, from showing the diner straight on, as if from the opposite side of the street, to a more oblique angle. This shifted perspective, exaggerated still further in the final work, makes the spectator's gaze more surreptitious, less confrontational, and thus adds greatly to the overall sense of mystery and alienation.

CREATED

New York

MEDIUM

Charcoal on paper

SERIES/PERIOD/MOVEMENT

Second World War Era

SIMILAR WORKS

The Subway by George Tooker, 1950

Edward Hopper *Born* 1882 Nyack, New York

Died 1967

Cornell, Joseph

Box with Objects

Joseph Cornell lived a reclusive life with his mother and disabled brother in Flushing, New York. His passion was for collecting and throughout his life he visited junk shops and flea markets in search of odd knick-knacks and bric-a-brac. In the 1930s Cornell began visiting the Julian Levy Gallery in New York, at that time the centre of the Surrealist movement in America. Soon after, he made his first collages in the style of Max Ernst (1891–1976) and Kurt Schwitters (1887–1948), as well as assembling glassed boxes, resembling old museum cases, into which he would place a wide variety of objects and illustrations, many culled from the old books and journals he collected. The irrational juxtaposition of objects he displayed created a strangely evocative mood of nostalgia. In *Box with Objects*, for example, Cornell includes marbles, a small ball, a metal component and rubber hoops, all displayed against an illustration of what appears to be an astronomical chart. Cornell's boxes are like archaeological discoveries whose mysteries are still retained. They frequently invoke a sense of voyage, yet the mood is always one of fantasy, a voyage of the imagination rather than a modern journey.

CREATED

New York

MEDIUM

Mixed media

SIMILAR WORKS

Sky Cathedral by Louise Nevelson, 1958

Joseph Cornell *Born* 1903 Nyack, New York

Died 1972

Reinhardt, Ad

Abstract Painting, 1948

Unlike other abstract painters, Ad Reinhardt never adopted a figurative style. His early work, from the 1930s, was hard-edged and geometrical, based largely on the abstract paintings of Piet Mondrian (1872–1944) and his American followers such as Burgoyne Diller (1906–65). In the 1940s, however, Reinhardt's abstraction became more gestural. *Abstract Painting* is a product of this period. Here the busy, multicoloured surface positively scintillates with energy as the brushstrokes create a tight network of interwoven forms containing an array of bright colours: reds, blues, greens, yellows and pinks. Reinhardt's works of this period have been compared to Pollock's 'drip paintings'. However, some key differences can be detected. For example, where Pollock's work frequently spills over the edge of the canvas, Reinhardt's canvas is much more contained, framed by a border of pink paint. Indeed *Abstract Painting* resembles more the calligraphic marks deployed in the work of Mark Tobey (1890–1976). Reinhardt's gestural period was short-lived and he soon abandoned the technique altogether believing that, 'the busier the work of art, the worse it is'.

CREATED

New York

MEDIUM

Oil on canvas

SERIES/PERIOD/MOVEMENT

Abstract Art

SIMILAR WORKS

Universal Field by Mark Tobey, 1949

Ad Reinhardt *Born* 1913 Buffalo, New York

Died 1967

333

Newman, Barnett

Onement I, 1948

Barnett Newman's career as an Abstract Expressionist painter effectively began in 1948 when he produced the work entitled *Onement I*. This consists of a single, vertical stripe, or 'zip' as Newman preferred to call it, bisecting a monochrome red canvas and was to form the basis for Newman's work throughout the rest of his life. From the outset, Newman's works divided critical opinion, some regarding his 'zip' paintings as profound philosophical engagements with the modern world and, in particular, the concept of the sublime, others seeing them as hyped-up, over-inflated and vacuous works. Despite these disparate views Newman stuck with his signature style to the end, producing works with titles as disparate as *Covenant* (1949), *Vir Heroicus Sublimis* (1950–51) and *Who's Afraid of Red, Yellow and Blue* (1966). Although Newman's evocative titles are suggestive of narratives, the works are all variations on the simple 'zip' formula that Newman established with *Onement I*. Newman's simple, consistent formula forges an intriguing link between the abstract paintings of Mondrian and the emergence of Minimalism and hard-edged abstraction in the 1970s.

CREATED

New York

MEDIUM

Oil on canvas

SERIES/PERIOD/MOVEMENT

Abstract Expressionist

SIMILAR WORKS

Untitled by Clyfford Still, 1945

Barnett Newman *Born* 1905 New York

Died 1970

Sheeler, Charles

Convergence II, 1952

Throughout his career Charles Sheeler worked as both a photographer and a painter, and regularly used his photographs as source material for his Precisionist canvases. These frequently resembled highly detailed, enlarged and coloured versions of his black and white photographs. By the early 1950s, however, Precisionism had been largely consigned to the past. Originally inspired by great faith in industry and technology, such utopian aspirations for the machine age now seemed redundant in the wake of the Second World War, the gas chambers and the atomic bomb. In the 1950s, however, Sheeler's work reverted to a similar style to that he had adopted in the 1920s with pieces like *Upper Deck* (1929). However, he now introduced a new dimension by combining two overlaid images. In *Convergence II*, for example, Sheeler presents two simultaneous views of the Manhattan skyline, one seen from a distance overlooking the horizon, the other looking up steeply from ground level. This overlay effect was doubtless influenced by his recent use of colour film and the effect generated by placing one transparency over another. This technique also reintroduced Sheeler's early fascination with European avant-garde painting and, not least of all, the multiple viewpoints of Parisian Cubism.

CREATED

New York

MEDIUM

Tempera on board

SIMILAR WORKS

Wall with Green Door by Georgia O'Keeffe, 1952

Charles Sheeler *Born* 1883 Philadelphia, Pennsylvania

Died 1965

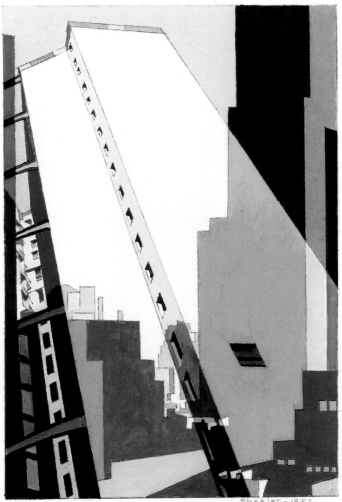

De Kooning, Willem
Palisade, 1957

Few painters, even amongst the Abstract Expressionists, could match the sheer energy, dynamism and aggression that characterized Willem de Kooning's paintings. His wild, gestural works, such as *Palisade*, are nothing less than frenzied in their execution, the bold swathes of paint, sometimes thick and unmixed, sometimes thin and diluted, seeming to burst screaming from the surface of the canvas as if some violent action has just been perpetrated. This emphasis upon the physical gesture in the painting process clearly owes a debt to Pollock. However, where Pollock's web of delicate colour skeins suggests fragility and tension, de Kooning's explosion of pigments suggests violent destruction, even annihilation. Here the rich blue background, the only suggestion of optimism in the entire canvas, is obscured by gooey layers of brown and ochre, all mixed together to produce a non-descript earthy tonality with a thick, scratched and pitted surface. De Kooning's emphasis on material disintegration can, in many senses, be read as the visual articulation of the sense of disorientation, destabilization and profound anxiety that characterized the early Cold War years in America.

CREATED

New York

MEDIUM

Oil on canvas

SERIES/PERIOD/MOVEMENT

Abstract Expressionist

SIMILAR WORKS

New York by Franz Kline, 1953

Willem de Kooning *Born* 1903 Rotterdam, Holland

Died 1997

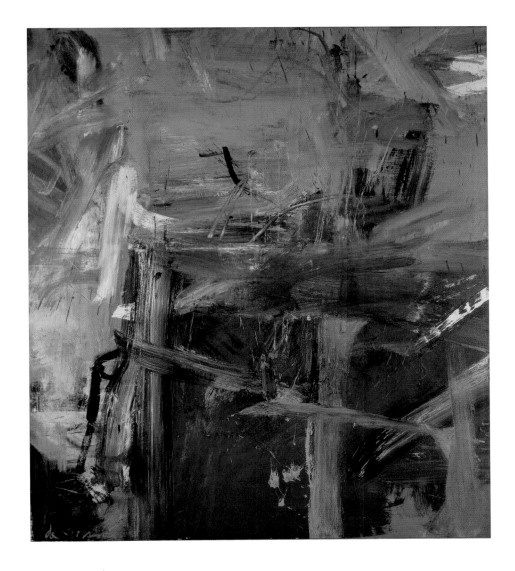

Rothko, Mark

Light Red Over Black, 1957

Mark Rothko is regarded as one of the most intense and spiritually motivated of all the Abstract Expressionist painters. His mature works, such as *Light Red Over Black*, consist of simple blocks of semi-translucent paint floating against a solid background colour. Rothko's works are highly contemplative, inviting the spectator to gaze into their ethereal surfaces. He achieved this effect by applying thin washes of paint in many layers so that light appears to emanate from their centre. This created a tension between a sense of overall flatness – he used no pictorial devises to suggest perspective – and of infinite depth. Rothko's simple, rectangular forms are also blurred at the edges to reinforce this sense of weightlessness. To increase the overall impact of his work, Rothko preferred to work in series and to have his works hung together in their own space, thus creating controlled environments, such as the non-denominational chapel he designed in Houston, Texas (1967–69). Indeed, when Rothko donated a series of his late maroon and black paintings to London's Tate Gallery in 1968–69 he specifically stipulated that they be hung together in their own room.

CREATED

New York

MEDIUM

Oil on canvas

SERIES/PERIOD/MOVEMENT

Abstract Expressionist

SIMILAR WORKS

Homage to the Square by Josef Albers, 1958

Mark Rothko *Born* 1903 Dvinsk, Lithuania

Died 1970

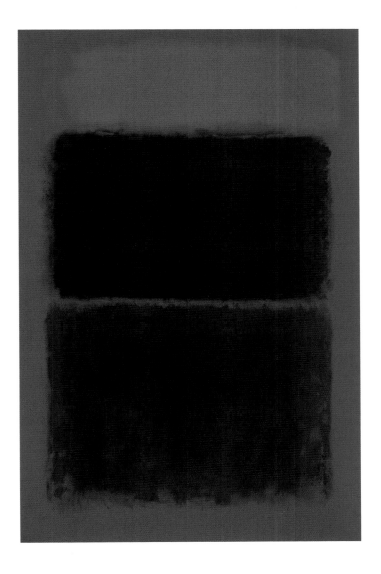

Johns, Jasper
Three Flags, 1958

'One night I dreamt I painted a large American flag, and the next morning I went out and bought the materials to begin it.' Jasper Johns made this claim about the series of paintings representing the flag of the United States that he began in 1954. Johns' engagement with this ultimate symbol of nationhood came at a time of heightened international tensions in the wake of the Korean War and in the same year that McCarthy's anti-communist witch-hunt was reaching a peak. Thus, to represent the flag was a highly political statement. Here, the techniques adopted by Johns were therefore significant. Johns used a variety of materials in his flag series, including collaged newspaper, wax encaustic and oil paint. He also presented the flag singly, in multiple overlays, as seen here, and against different, brightly coloured backgrounds. Johns' objective was to provoke a re-evaluation of the flag as a symbol. By giving his works a textured, painterly surface, particularly evident in *Three Flags*, he was also critiquing the gestural, individualized brushstrokes of Abstract Expressionism. Johns' use of familiar signs from everyday life marked a significant contribution to the emergence of Pop Art.

CREATED

New York

MEDIUM

Encaustic on canvas

SERIES/PERIOD/MOVEMENT

American Flag series

SIMILAR WORKS

The Old Dump Flag by Claes Oldenburg, 1960

Jasper Johns *Born* 1930 Augusta, Georgia

Krasner, Lee
Double Helix, 1961

Lee Krasner's reputation has suffered the same fate as many female artists. She is still widely remembered as the woman who married Jackson Pollock and supported him until shortly before his tragic death in 1956, sacrificing much of her own career as an artist. Krasner, however, was a successful and innovative painter in her own right and a key figure in the Abstract Expressionist movement. During the 1930s she trained under the European Abstract painter Hans Hofmann (1880–1966) and exhibited with the American Abstract Artists (AAA) association. She also participated in the Federal Arts Project of the WPA and, in 1951, was given a solo exhibition in New York. *Double Helix* shows the powerful, gestural style adopted by Krasner. The abstract composition focuses upon a vortex-like centre of energy spinning outwards with centrifugal force beyond the edges of the canvas. The work is predominantly monotone, based upon a series of black, swirling lines that determine the energy of the canvas. In the interstices between these lines, Krasner has brushed and spattered maroon-red and white forms, which appear like flashes of light caused by the friction of rapid movement.

CREATED

Long Island, New York

MEDIUM

Oil on canvas

SERIES/PERIOD/MOVEMENT

Abstract Expressionist

SIMILAR WORKS

Hemlock by Joan Mitchell, 1956

Lee Krasner *Born* 1908 Brooklyn, New York

Died 1984

Warhol, Andy
200 Campbell's Soup Cans, 1962

Warhol's first break as a major figure in the New York art world came in the early 1960s when he exhibited a series of works representing Campbell's soup cans. The first series consisted of 32 individual works, each representing a single Campbell's soup can and each identical except for the different flavour indicated on the label. These works were hand-painted in acrylic on canvas. Warhol's series offered an ironic comment on the still-life tradition within Western art, which frequently incorporated food. However, Warhol notably replaced the food itself with the commercial packaging. Warhol developed his series by producing works such as *200 Campbell's Soup Cans*, in which he presented 200 soup cans all arranged cheek by jowl, as if on a supermarket shelf. Warhol's works challenged the individuality of artistic creativity so central to Abstract Expressionism by emphasizing the process of direct duplication. He also adopted the crude screen-printing technique used in advertising to diminish further any sense of the hand of the artist.

CREATED

New York

MEDIUM

Synthetic polymer paint on canvas

SERIES/PERIOD/MOVEMENT

Pop Art

SIMILAR WORKS

Still-Life #24 by Tom Wesselman, 1962

Andy Warhol *Born* 1928 Pittsburgh, Pennsylvania

Died 1987

Kienholz, Edward

The Future as an Afterthought, 1962

Ed Kienholz began his career as a painter in the 1950s. Influenced by the Neo-Dada works of Jasper Johns and Robert Rauschenberg (b. 1925), Kienholz started to attach objects to his works in the late 1950s and soon abandoned painting altogether. Instead he produced sculptures assembled from an assortment of found objects, usually the discarded detritus of modern life. Many of these assemblages are designed as critiques of society and tend to emphasize the bizarre, the macabre and the gruesome. For example, in *The Future as an Afterthought* Kienholz used a turned-wooden stand to act as a plinth. On this he mounted several toy dolls, all naked and strapped together. Two pedals attached to the assemblage suggest that the work might be rotated, though there is no mechanism to allow this. Below, on the base, is a single, and seemingly severed head. Kienholz's peculiar assemblage recalls the use of mannequins and dolls in Surrealism and, in particular, the works of the German artist Hans Bellmer (1902–75). His use of the doll, like Bellmer's, evokes a disturbing association between childhood play and adult sexuality, thus giving his works a nightmarish sense of sexual threat.

CREATED

Los Angeles

MEDIUM

Dolls, wood and sheet metal

SIMILAR WORKS

Odalisk by Robert Rauschenburg, 1955–58

Edward Kienholz *Born* 1927 Fairfield, Washington

Died 1994

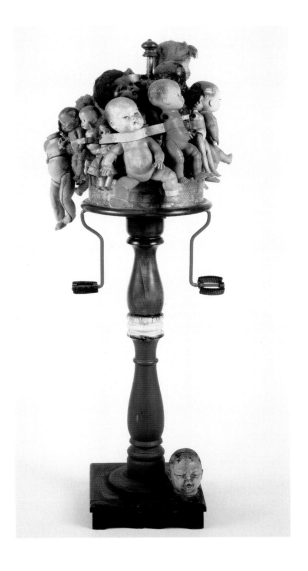

Noland, Kenneth

Blue Moon, 1962

Kenneth Noland's work is associated with the Post-Painterly Abstraction that emerged in the late 1950s and early 1960s as a response to Abstract Expressionism. Post-Painterly Abstraction is perhaps best characterized as an art of cool detachment, an art that distances itself from the energy and frenzy of a Pollock, or the spiritual intensity of a Rothko. Noland was much influenced by the work of Helen Frankenthaler (b. 1928) and, in particular, her technique of pouring liquid paint on to unprimed canvas so that colour seeped into the surface like a dye. Noland adopted this technique to produce works in which the surface is stained, rather than painted, and is virtually textureless. He also used simple geometrical forms and, in 1960, began a series of works characterized by sharply defined, hard-edged circular forms reminiscent of targets. *Blue Moon* adopts this bull's eye composition. Here a precisely delineated blue circle is surrounded by a darker blue square with rounded corners. The third form from the centre becomes almost completely square, whilst the fourth form is bounded by the edge of the canvas. Noland's canvases strove to reduce painting to pure colour, devoid not only of representation, but also of texture and materiality.

CREATED

New York

MEDIUM

Acrylic on canvas

SERIES/PERIOD/MOVEMENT

Post-Painterly Abstraction

SIMILAR WORKS

Blue Veil by Morris Louis, 1958–59

Kenneth Noland *Born* 1924 Asheville, North Carolina

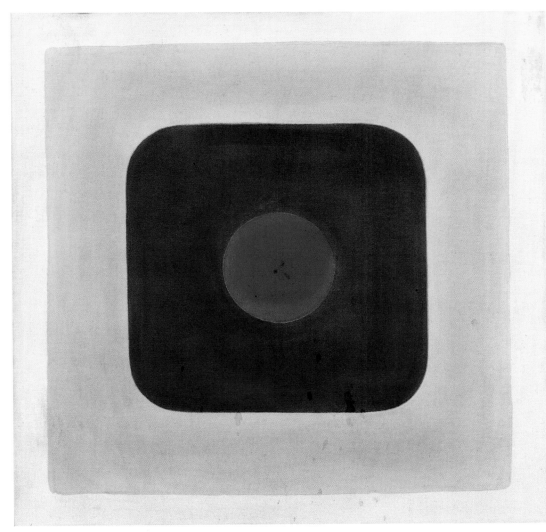

Gottlieb, Adolph

Looping #2, 1964

Like many of the Abstract Expressionists, Adolph Gottlieb was highly influenced by the Surrealists André Masson and Joan Miró (1893–1983). From the 1950s onwards, he used broad washes of colour, combined with simple, abstract forms to evoke emotional conditions. His work has thus been associated with the Colour Field paintings of Mark Rothko and Barnett Newman (1905–70), although his canvases make a stronger allusion to the landscape. From the late 1950s, Gottlieb's works, such as *Looping #2*, have been referred to as Bursts. In these vertical format canvases, Gottlieb combined two symbolic forms, a circle, floating above an undifferentiated mass of colour. Both forms imply extreme force, the contained energy of the sun contrasted with the dissipated energy of an explosion. In the context of the Cold War, it is easy to associate these works with anxieties about nuclear conflict. However, they should not be read too literally. Gottlieb's concern with the dematerialization of form also addressed more painterly concerns, not least of all the demands of the art critic Clement Greenberg, for artists to seek a purity in painting, and to emphasize the flatness of the picture plane.

CREATED

New York

MEDIUM

Oil on canvas

SERIES/PERIOD/MOVEMENT

Abstract Expressionist

SIMILAR WORKS

Number 10 by Mark Rothko, 1958

Adolph Gottlieb *Born* 1903 New York

Died 1974

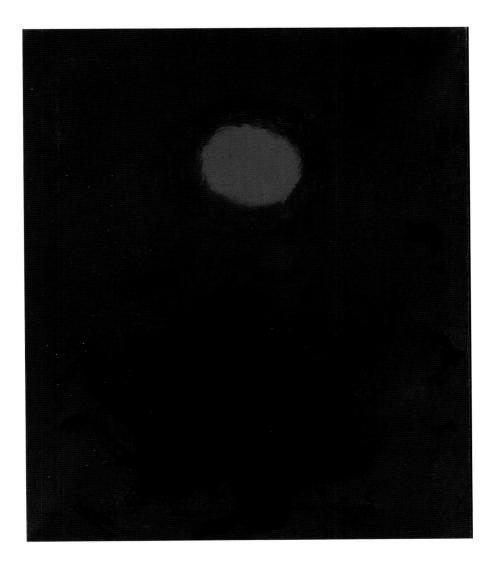

Lichtenstein, Roy
Whaam!, 1967

In his early career, Roy Lichtenstein worked as both a realist painter and as a commercial artist and designer. Like many of the Ashcan School painters, he incorporated popular culture into his works. Lichtenstein is best known for his adoption of the comic strip style, taking this throwaway culture of mass production and enlarging it into collectable, unique works of art that simultaneously celebrated and parodied their cultural sources. Many of Lichtenstein's images focused upon the melodrama of American comic strips and deal predominantly with romance and war, sometimes both. In *Whaam!*, Lichtenstein took a couple of frames from an adventure comic and enlarged them onto a huge canvas, retaining the half-tone dots of the printed original, along with the hand-written speech bubbles and word-sounds. He also produced large-scale poster reproductions of the work, as can be seen here. Lichtenstein's works, however, were not only parodies of popular culture. They also carried important political connotations, here highlighting the militaristic jingoism of Cold War America at a time when events in Vietnam were beginning to cause many Americans to re-examine the nation's status as a military power.

CREATED

New York

MEDIUM

Offset lithograph on paper

SERIES/PERIOD/MOVEMENT

Pop Art

SIMILAR WORKS

Saigon by Peter Saul, 1967

Roy Lichtenstein *Born* 1923 New York

Died 1997

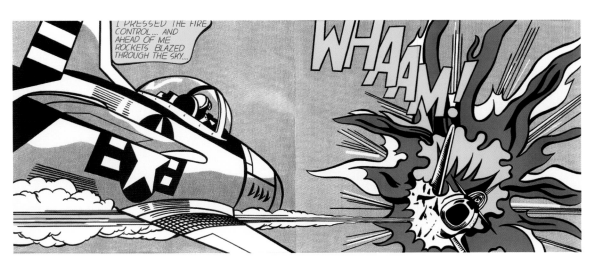

Morris, Robert

Untitled, 1970

For many avant-garde artists in post-war America, the idea that an art object might represent something exiting in the real world was anathema. The emergence of Minimalism in the 1960s further exemplified the sense that the art object should exist as an entity in its own right, devoid of any responsibility to refer to an external form or idea. In 1968, the artist Robert Morris attempted to take this idea a step further when he produced the first of what he referred to as his anti-form pieces. Morris produced quasi-sculptural works made from unconventional materials such as felt. In essence, however, these works resisted definition as sculpture as they were often made up of little more than piles of felt off-cuts thrown haphazardly on the floor. The existence of these pieces as art works was thus entirely dependent upon their presence in the gallery space. Once removed from this context, his work became little more than a pile of detritus. However, despite his avowed anti-art market stance, Morris also produced works in felt such as *Untitled*, works which, though dependent upon the cheap, throwaway material of felt, could indeed be preserved, displayed in museums and sold commercially.

CREATED

New York

MEDIUM

Felt

SERIES/PERIOD/MOVEMENT

Minimalist

SIMILAR WORKS

Untitled (Rope Piece) by Eva Hesse, 1970

Robert Morris *Born* 1931 Kansas City, Missouri

Estes, Richard

Sloan's, c. 1970

Of all the various movements that dominated early post-war American art, Pop Art had most successfully reintroduced figuration into painting. In the late 1960s, however, a new movement known as Superrealism emerged and served further to establish figuration as a legitimate form of avant-garde artistic practice. Superrealism's chief practitioners used photographs, often representing mundane urban scenes, as the sources for paintings that were enlarged to monumental proportions, using a projector, and finished in meticulous detail. In one sense this more realist-inspired approach resurrected academic painting practices. More specifically, however, it recalled the *trompe l'oeil* works of the late nineteenth-century painters William Michael Harnett (1848–92) and John Frederick Peto (1854–1907). Richard Estes' *Sloan's* is a key example of Superrealism. Here Estes presents a mundane scene of a New York street, with a yellow cab sharply cropped on the left. The effect is of a casually taken, barely composed snapshot. The work, however, is a highly finished painting produced with a slick, glossy surface to resemble its photographic source. Superrealism sought to combine the impersonality and stylelessness of Minimalism with Pop Art's emphasis on the mundane and everyday.

CREATED

New York

MEDIUM

Oil and synthetic polymer on canvas

SERIES/PERIOD/MOVEMENT

Superrealism

SIMILAR WORKS

'61 Pontiac by Robert Bechtle, 1968–69

Richard Estes *Born* 1936 Kewanee, Illinois

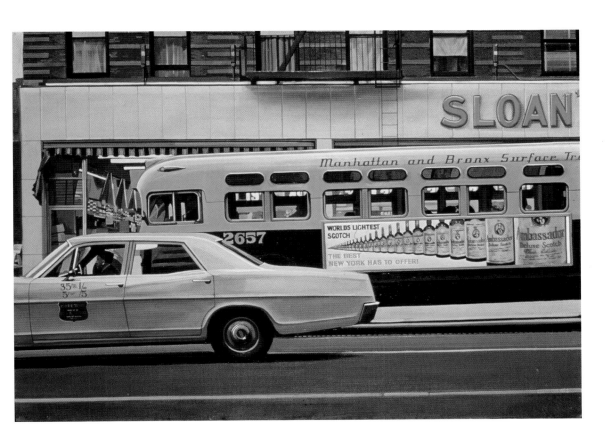

Poons, Larry
Skiny Slip, 1973

Larry Poons' interest in abstract painting was closely related to his first love, music. Throughout the twentieth century, many artists had sought to find equivalents between music and the visual arts, and painters, including James McNeill Whistler (1834–1903) and Vasily Kandinsky (1866–1944), had explored this relationship in their works. Some early twentieth century composers too, including Arnold Schoenberg (1874-1951) M. K. Ciurlionis (1875–1911), also forged successful careers as artists. Poons, following in the footsteps of many early abstract painters, sought to transpose musical experiences into visual representation. He first made his name in the mid 1960s when his work was included in an exhibition entitled 'The Responsive Eye'. This show launched Op Art, a movement that exploited the retinal effects that were frequently studied at the time in perceptual psychology. In the 1970s, however, Poons distanced himself from Op Art, focusing more on the textural quality of his large-scale abstract paintings. In *Skiny Slip*, for example, he has covered the entire canvas with dense layers of colour to create a vibrant, scintillating surface. Poons also regularly incorporated pieces of paint-soaked foam and rubber to add further density to these rich and tactile surfaces.

CREATED

New York

MEDIUM

Acrylic on canvas

SERIES/PERIOD/MOVEMENT

Abstract Art

SIMILAR WORKS

Dax by Ed Moses, 1974

Larry (Lawrence) Poons *Born* 1937 Ogibuko, Japan

Katz, Alex

Canoe, 1974

In his early career, Alex Katz was much influenced by Pollock, producing rapidly executed paintings highly dependent upon gestural brushstrokes. However, unlike Pollock, Katz based his works on nature, using trees and other landscape motifs as the basis of his art. In many ways Katz's work has striven to negotiate the terrain between abstraction and figuration. For example, many of the numerous figure studies he began producing in the 1970s, place great emphasis upon the flatness of the canvas, reducing the forms of his sitters to simple areas of colour. These works also recall the silkscreen printing technique widely adopted by Pop artists during the 1950s. In *Canoe*, Katz combines this emphasis on simple, flat forms, with a more detailed realism. The painting represents a canoe, floating in the still, blue waters of a lake and suggesting the leisurely activity of a weekend or vacation. However, the canoe has no inhabitants and sits frozen in time, giving the work an air of mystery. Katz notably creates a tension between spatial illusionism and abstract artificiality, contrasting the sharply defined hull of the boat with the smooth flatness of the water.

CREATED

New York

MEDIUM

Acrylic on canvas

SIMILAR WORKS

After Lunch by Patrick Caulfield, 1975

Alex Katz *Born* 1927 New York

Bourgeois, Louise
Eyes, 1982–89

Louise Bourgeois first turned to sculpture in the late 1940s, having earlier trained as a painter in her native France. She has subsequently engaged with a wide variety of materials including wood, marble, bronze and latex rubber and, more recently created installations using wire caging, mirrors and textiles. Bourgeois' primary concern has always been the body, although her works rarely show this in its entirety, more typically representing body parts in an ambiguous, metamorphic manner reminiscent of Surrealism. *Eyes* is one of Bourgeois' late works. It consists of two spherical forms, each carved in granite and placed side by side on the floor. Two tiny pupils break the surface of the spheres and stare upwards. In this way, Bourgeois plays with the notion of simultaneously seeing and being seen. However, Bourgeois' 'eyes' also resemble breasts, the pupils now becoming nipples, emphasizing female body parts as the object of the gaze, and thus creating further tension in the reading of the forms. The sensuousness of the smoothly carved material also invites tactile engagement, serving further to highlight the ultimate ambiguity of these forms. In 1995 a monumental version of this work was installed in Battery Park City in New York.

CREATED

New York

MEDIUM

Granite

SIMILAR WORKS

The Eye Has It by Richard Deacon, 1984

Louise Bourgeois *Born* 1911 Paris, France

Schnabel, Julian

Cabalistic Painting, 1983

Julian Schnabel's work has often been overshadowed by the hype that surrounded his rise to prominence during the art market boom in the 1980s, and the vastly inflated prices his paintings commanded. Schnabel was part of the Neo-Expressionist movement that emerged in the late 1970s as a response to both Post-Painterly Abstraction and Minimalism, and that sought to reintroduce the immediacy and individual emotionality regarded as typical of early twentieth-century movements such as Fauvism and German Expressionism. Schnabel's work is thus characterized by its aggressive handling of paint and its emphasis on extreme subjectivity, qualities encapsulated in *Cabalistic Painting*. Here Schnabel has adopted a bold, gestural, style, reminiscent of the British painter Francis Bacon (1909–92), incorporating rapidly executed white and ochre strokes of paint to suggest strange hieroglyphic forms surrounding a box or cabinet in the upper left. The meaning of the work is deliberately obscure and alludes to an overall sense of mystery. Indeed, even the title of the work implies a secret, mystical meaning, unavailable to the layman. Schnabel's work frequently incorporated unusual materials, such as the velvet ground used here.

CREATED

New York

MEDIUM

Oil on velvet

SERIES/PERIOD/MOVEMENT

Neo-Expressionist

SIMILAR WORKS

Study After Velazquez's Portrait of Pope Innocent X by Francis Bacon, 1953

Julian Schnabel *Born* 1951 New York

Segal, George
Man on Bench, 1985

George Segal started out as an Expressionist painter, only moving into sculpture in the late 1950s when he began to make mannequin-like figures from wire and plaster. His breakthrough came when he made his first life cast, using his own family and friends as models. Segal adopted a simple technique, covering the bodies of his models in bandages soaked with plaster. Once these had set he cut them from the model and reassembled them to make life-sized, hollow figures, which he then placed in ordinary environments, sat at a diner counter, getting on a bus, or as here, seated quietly on a park bench. Notably, he made no attempt to disguise the rough, textured surfaces of his figures, and left them a ghostly white. Segal's works defy easy categorization. In their emphasis on the ordinariness of contemporary American life, and with their discomfiting voyeurism, they draw heavily on the paintings of Hopper, whilst their recreation of real physical spaces, with real everyday objects included, recalls the proto-Pop Art objects of Claes Oldenburg (b. 1929). Segal's emphasis on the body itself also left its mark on later Superrealist sculptors like Duane Hanson (1925–96).

CREATED

New York

MEDIUM

Painted plaster and steel and wood bench

SIMILAR WORKS

Woman with Dog by Duane Hanson, 1977

George Segal *Born* 1924 New York

Haring, Keith

Boxers, 1987–88

Keith Haring first moved to New York in the late 1970s, where he met the graffiti artist Jean-Michel Basquiat (1960–88) and soon became heavily involved in the thriving alternative art community. Haring was keen to display his work outside of the conventional museum spaces and, in 1980, began to make white chalk drawings on the blacked out poster billboards in the New York subway. These attracted widespread public attention and helped to establish Haring's reputation. Throughout the 1980s, Haring received many commissions for public murals and sculptures, many of which were executed in the cartoon-like style he had loved as a child. *Boxers*, with its simple cut-out forms and bright, primary colours resembles a child's toy. At the same time, however, Haring's adoption of the boxing theme can be linked to the earlier works of both Thomas Eakins (1844–1916) and George Bellows (1882–1925). However, his playful and intimate figures seem to be locked in more of an affectionate embrace than mortal combat. Haring's career was tragically cut short in 1990 when he died during the AIDS epidemic, aged just 31. A large-scale version of *Boxers* has been installed in Potsdam Square in Berlin.

CREATED

New York

MEDIUM

Painted aluminium

SIMILAR WORKS

Dollar Signs by Andy Warhol, 1981

Keith Haring *Born* 1958 Reading, Pennsylvania

Died 1990

Close, Chuck

Cindy II, 1988

Chuck Close's monumental portraits are usually based upon photographs over which he draws a grid, dividing the photograph up into small squares. He then uses this original to 'square up' the finished canvas, painting each individual square in turn until the work is complete. Close's slow, meticulous technique is based upon traditional methods used by Old Master painters to enlarge drawings and sketches when producing murals. In his early works he also replicated the surface quality of the photographs used as source material. More recently he has experimented with textured surfaces based on the small dots of colour used in the printing industry, or the pixelation effect generated by electronic images. In *Cindy II*, for example, Close has represented the sitter as seen through a filter or pane of glass with a circular embossed pattern. The surface of the work is thus broken up into small dots of colour reminiscent of the pointillist paintings of the nineteenth-century French painter Georges Seurat (1859–91). In the late 1980s, Close began a series of portraits representing artists who frequently use self-portraiture in their work. This portrait, part of the series, represents the artist Cindy Sherman.

CREATED

New York

MEDIUM

Oil on canvas

SIMILAR WORKS

Untitled #211 by Cindy Sherman, 1989

Chuck Close *Born* 1940 Monroe, Washington

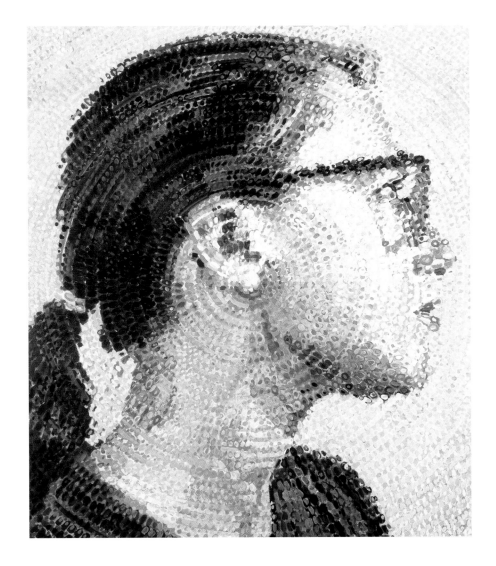

Rothenberg, Susan
Pin Wheel, 1989–90

Courtesy of Christie's Images Ltd/© ARS, NY, and DACS, London 2005

Throughout the second half of the twentieth century, many American artists struggled to reconcile the seeming opposition between abstraction and figuration. By the late 1970s, this tension was brought to the fore by a group of artists whose works were dubbed New Image Painting. Amongst these painters was Susan Rothenberg, whose early works were largely monochromatic canvases with rich, textured surfaces. Emerging from these surfaces, however, were schematic references to the physical world. Soon the human figure began to make an appearance in Rothenberg's canvases, though in a far from detailed manner. Rather, they seem almost immaterial, their twisted and contorted forms floating freely on the richly worked surface, as if flowing through liquid. In *Pin Wheel*, Rothenberg represents what appears to be a circus performer, his or her body twisted into a circle and framed by the vortex-like forms that make up the background. The head, seemingly detached from his body, is placed at the very epicentre of the work. Rothenberg's painting thus combines the highly wrought surfaces of Abstract Expressionism with the figurative tradition of the early twentieth century, producing works that bear more than a passing resemblance to the early paintings of Marc Chagall (1887–1985).

CREATED

New York

MEDIUM

Oil on canvas

SERIES/PERIOD/MOVEMENT

New Image Painting

SIMILAR WORKS

The Oak Tree by R. B. Kitaj, 1991

Susan Rothenberg *Born* 1945 Buffalo, New York

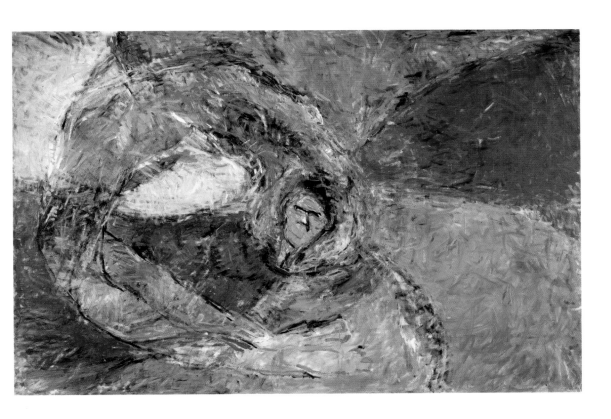

Serra, Richard

Zappa, 1995

At first glance, Richard Serra's sculpture *Zappa*, might appear to be characteristically Minimalist. Like Donald Judd (1928–94), for example, Serra uses non-art, industrial materials and produces extremely simple geometrical forms. Unlike Judd, however, Serra produces works designed to create a tension between the materials used and their specific setting. Here, his two forged-steel components do not sit comfortably in the middle of the gallery space, but are displayed leaning precariously against a wall. This instability - one senses that a gentle nudge could easily topple the sculpture over — seems to contradict the sheer weightiness of the components and strongly suggests the possibility of movement even in so static a work. Since the 1970s Serra has been involved in producing public monuments, many of which have similarly depended upon this sense of instability. He has also widely used Cor-Ten steel, a metal that rapidly rusts when exposed to the elements, so that the sculptures are in a permanent state of transition. Serra gained much notoriety in the late 1980s when a controversial campaign forced the removal of his famous monument *Tilted Arc*, from its prestigious site in New York's Federal Plaza. Serra refused to re-install the work on any alternative site.

CREATED

New York

MEDIUM

Forged steel

SIMILAR WORKS

Untitled by Magdalena Jetelova, 1991

Richard Serra *Born* 1939 San Francisco, California

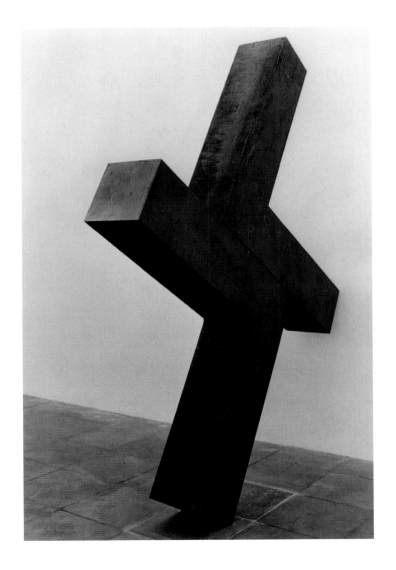

Author Biographies

Dr Mike O'Mahony (author)

Mike O'Mahony is a specialist in twentieth-century art of the United States and Europe. He studied at the Courtauld Institute where he completed his doctoral thesis in 1998. He presently teaches History of Art at the University of Bristol and has lectured at the major London galleries, including Tate Britain and the Royal Academy of Arts. He is founding editor of Art on the Line, an online international arts journal. He has written and contributed articles to many publications, including *The Atlas of World Art* and *The Oxford History of Western Art*.

Virginia M. Mecklenburg (foreword)

Virginia Mecklenburg has been curator at the Smithsonian American Art Museum since 1979, where she oversees the museum's exhibitions and acquisition programmes for twentieth-century American art, the Ash Can School and New Deal art. She has organised more than 20 exhibitions, including 'Edward Hopper: The Watercolours'. Other projects include directing the interactive video *American Abstraction, 1930–1945* which received the American Film and Video Association's Blue Ribbon Award. She has published on the art of George Bellows, Frederick Carl Frieseke, Robert Indiana and early American Modernists.

Picture Credits: Prelims and Introductory Matter

Further Reading

Berman, Avis, *Roy Lichtenstein: All About Art*, Louisiana Museum Modern Art, 2004Biel, S., *American Gothic: A List of America's Most Famous Paintings*, W W Norton, 2005

Brigstock, High (Ed.), *The Oxford Companion to Western Art*, Oxford University Press, 2001

Francis, Richard, *Jasper Johns*, Abbeville Press, 1990

Frayn, Michael, *Edward Hopper*, Taschen, 2003

Haring, Keith, *Dance*, Little, Brown, 1999

Honnef, Klaus, *Warhol*, Taschen, 2000

Hopkins, David, *After Modern Art*, *1945–2000*, Oxford University Press, 2000

Katz, Vincent, *Black Mountain College: Experimental in Art*, MIT Press, 2003

Madoff, Steven Henry, *Pop Art: A Critical History*, University of California Press, 1997

Marshall, Richard, *Ed Ruscha*, Phaidon Press, 2005

Mecklenburg, Virginia, *Wood Works: Constructions by Robert Indiana*, Smithsonian Museum Shop, 1984

Mecklenburg, Virginia, *Edward Hopper: The Watercolors*, W W Norton, 1999

Mendes, Bernard, *Willem de Kooning: Painting 1960–1980*, Hatje Cantz, 2005

O'Keeffe, Georgia, *One Hundred Flowers*, Phaidon Press, 1990

Rockwell, Tom (Ed.), The Best of Norman Rockwell, Courge Books, 2000

The American Art Book, Phaidon Press, 1999

Wagner, Anne Middleton, *Three Artists (Three Women): Modernism and the Art of Hesse, Krasner and O'Keeffe*, University of California Press, 1998

Wintz, Cary (Ed.), *Encyclopedia of the Harlem Renaissance*, Fitzroy Dearborn, 2004

Zurier, Rebecca, Robert Snyder and Virginia Mecklenburg, *Metropolitan Lives: Ashcan Artists and Their New York*, W W Norton, 1996

Index by Work

General Index